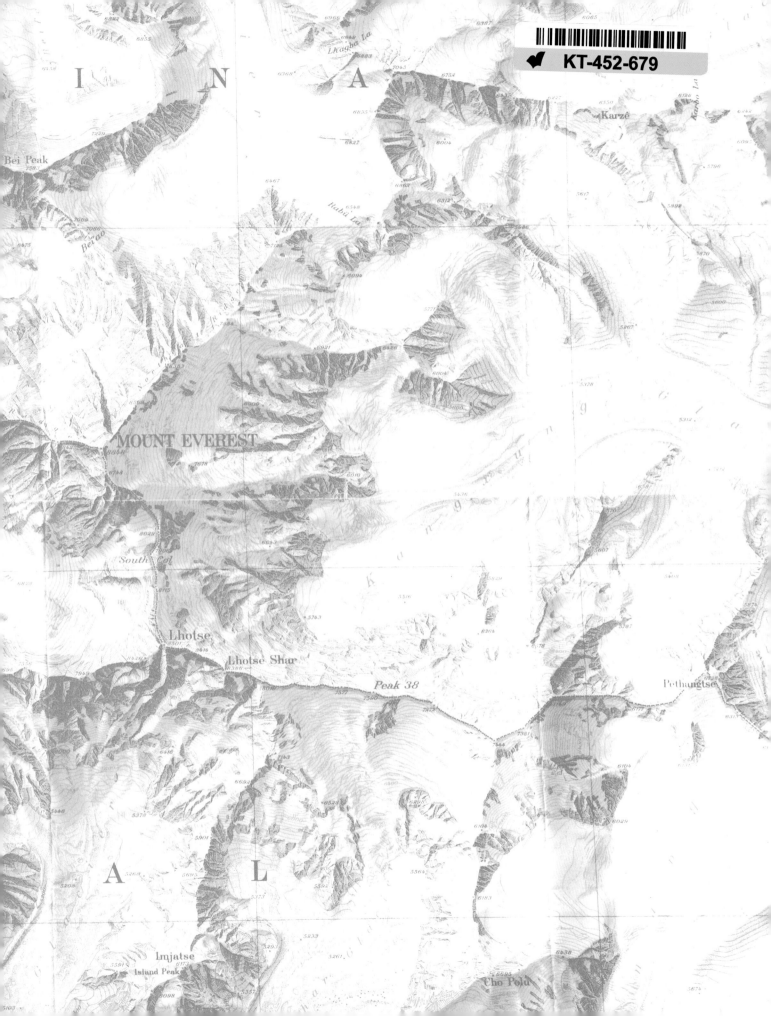

THE CONQUEST OF
EVEREST

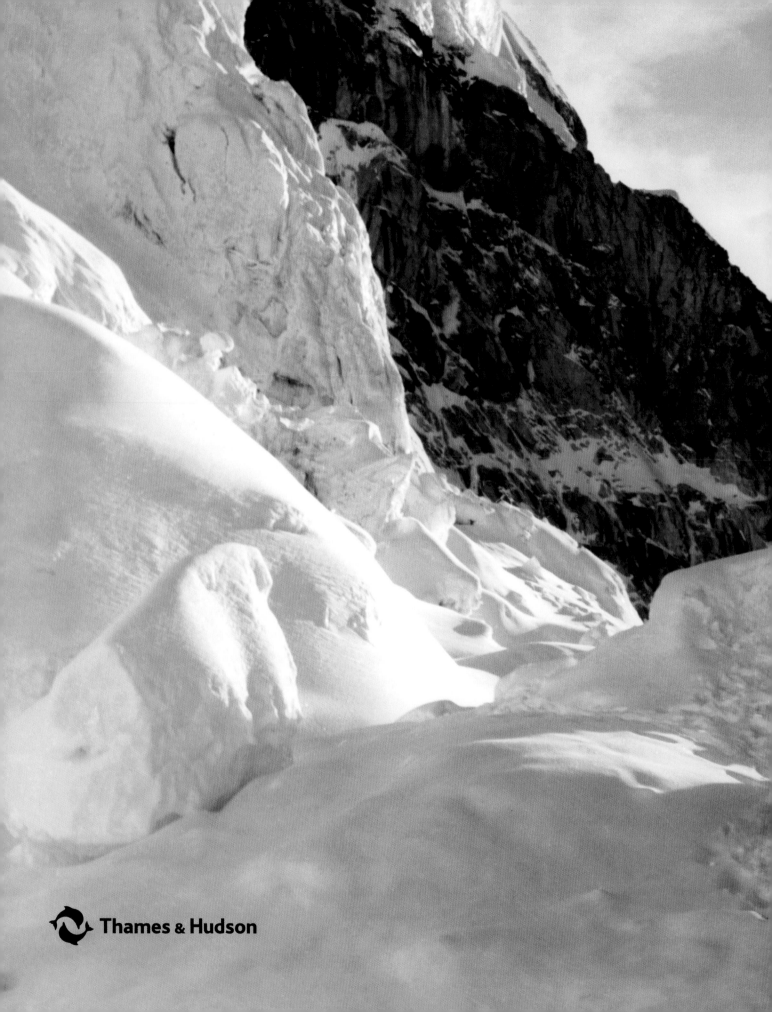

THE CONQUEST OF
EVEREST

| ORIGINAL PHOTOGRAPHS FROM |
| THE LEGENDARY FIRST ASCENT |

GEORGE LOWE

AND HUW LEWIS-JONES

with 163 illustrations, 62 in colour

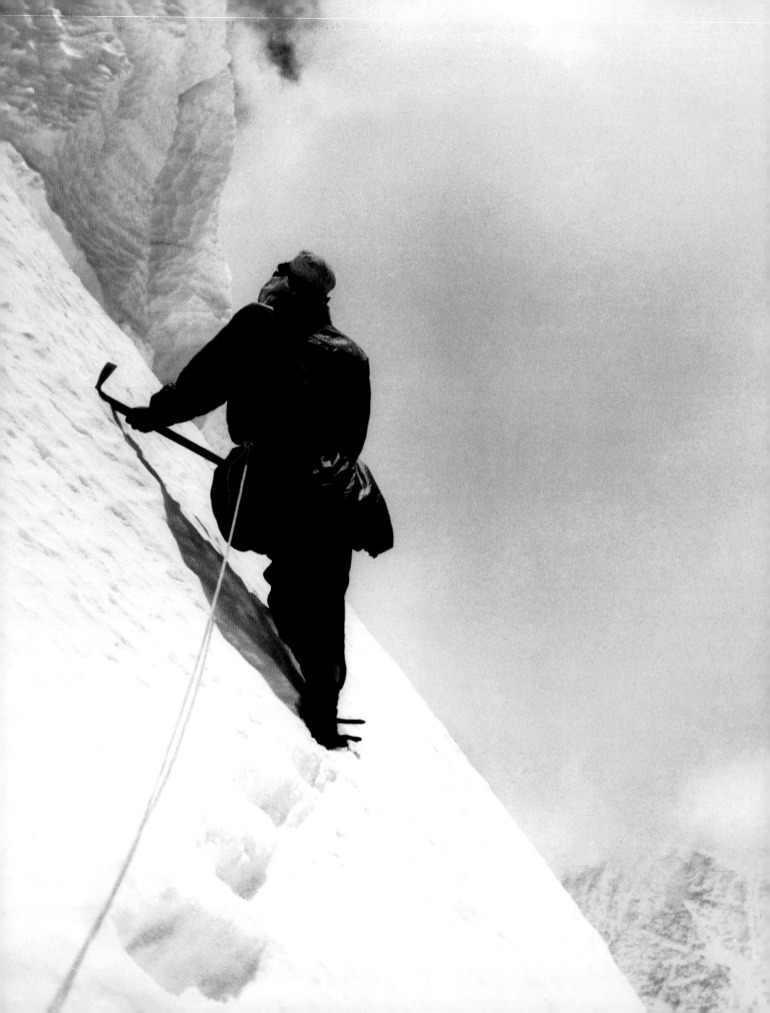

WITH PERSONAL REFLECTIONS FROM

SIR CHRIS BONINGTON

KENTON COOL

SIR EDMUND HILLARY

PETER HILLARY

TOM HORNBEIN

REINHOLD MESSNER

COLIN MONTEATH

JAN MORRIS

NORBU TENZING NORGAY

DOUG SCOTT

STEPHEN VENABLES

DEDICATION: For the men of the 1953 Everest expedition, who chose to act out their dreams in the daylight, and for their Sherpa companions who were so essential to its success.

First published in the United Kingdom in 2013 by Thames & Hudson Ltd, 181A High Holborn, London WC1V 7QX

The Conquest of Everest © 2013 Thames & Hudson Ltd, London

Photographs © 2013 George Lowe unless otherwise indicated

Designed by Liz House

British Library Cataloguing-in-Publication Data
A catalogue record for this book is available from the British Library

ISBN 978-0-500-54423-5

Printed and bound in Singapore by Tien Wah Press (Pte) Ltd

To find out about all our publications, please visit **www.thamesandhudson.com**. There you can subscribe to our e-newsletter, browse or download our current catalogue, and buy any titles that are in print.

PAGE **2/3** Our first tents at Camp II in 1953 were precariously positioned about halfway up the Khumbu Icefall. As we returned from higher altitudes, this old spot was a mess of crevasses and broken ice. There was no trace that we'd ever been there.

PAGE **4** Ed Hillary explores the steep ice of the Nup La during our secret climb into Tibet in 1952.

RIGHT Our Everest team also made the first ascent of an attractive mountain, just over 20,000 ft high, in the middle of the Imja Valley. It was called Island Peak and today is climbed by more people than any other in the Khumbu. This view is from our camp on the ridge, looking west to snow-clad peaks stretching as far as the eye could see.

PAGE **8/9** Old friends and climbing partners – me and Ed Hillary photographed during the Everest expedition. Our adventurous lives took us deep into the Himalaya.

PAGE **10/11** Wisps of clouds trail from the formidable rock pyramid of Mount Everest. From this angle, some 15 miles to the south-west, Everest appears as an impregnable challenge and half-hidden behind the ice-encrusted walls of Nuptse.

PAGE **12/13** Roped together, Ed and Tenzing make their way along the snow-covered glacier of the Western Cwm. Little by little we moved slowly upwards towards the summit.

PAGE **14** It is 11.30 a.m. on 29 May 1953. Tenzing stands on the summit of Everest and waves his ice-axe, on which are hung the flags of Britain, Nepal, the United Nations and India. On reaching this sacred spot, Tenzing placed a packet of biscuits, some chocolate and a handful of sweets into a hole in the snow as a gift to the gods who live on the summit.

PAGE **16** Behind the imposing ramparts of the Icefall is the Lho La, marking the great divide between Nepal and Tibet. Beyond is the summit of Changtse, the North Peak, while Everest itself rises up to the right, out of frame.

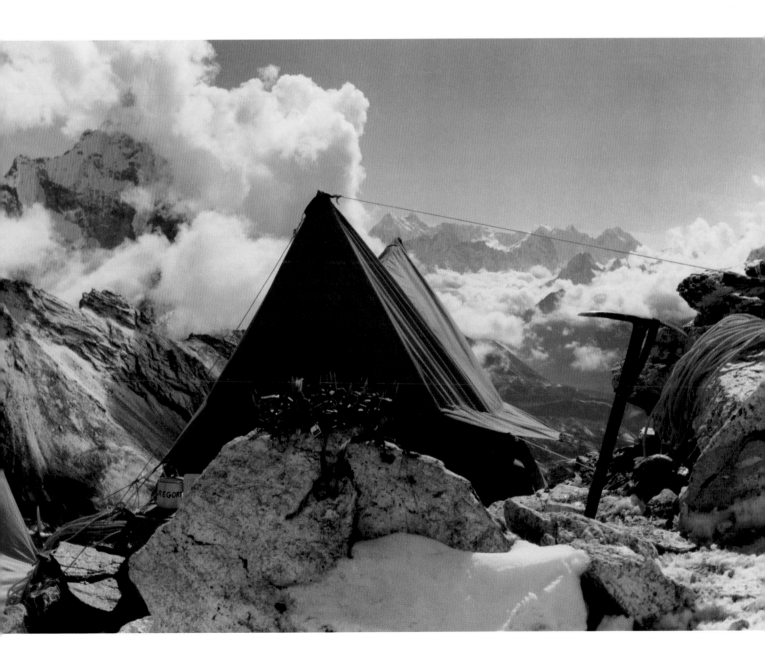

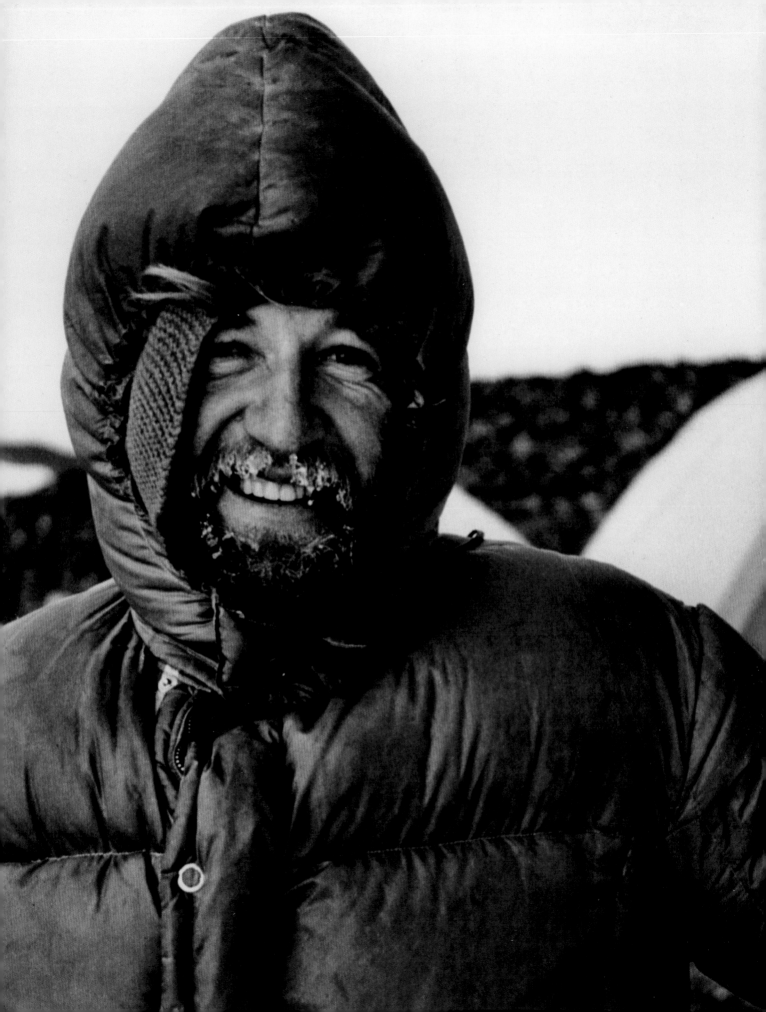

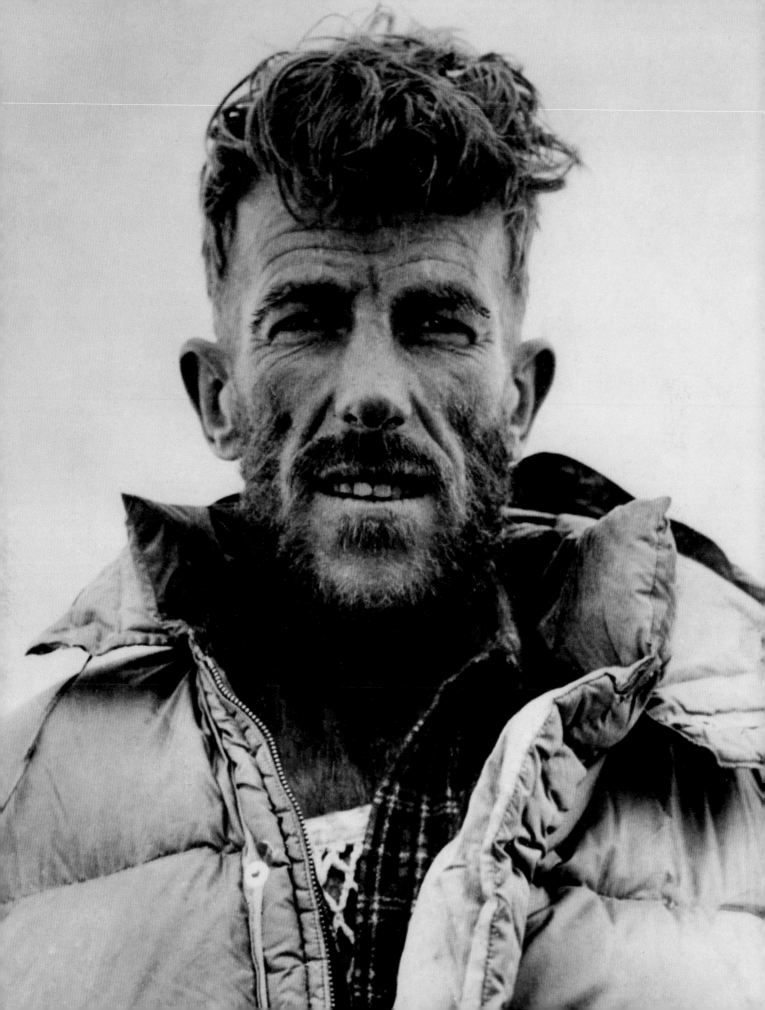

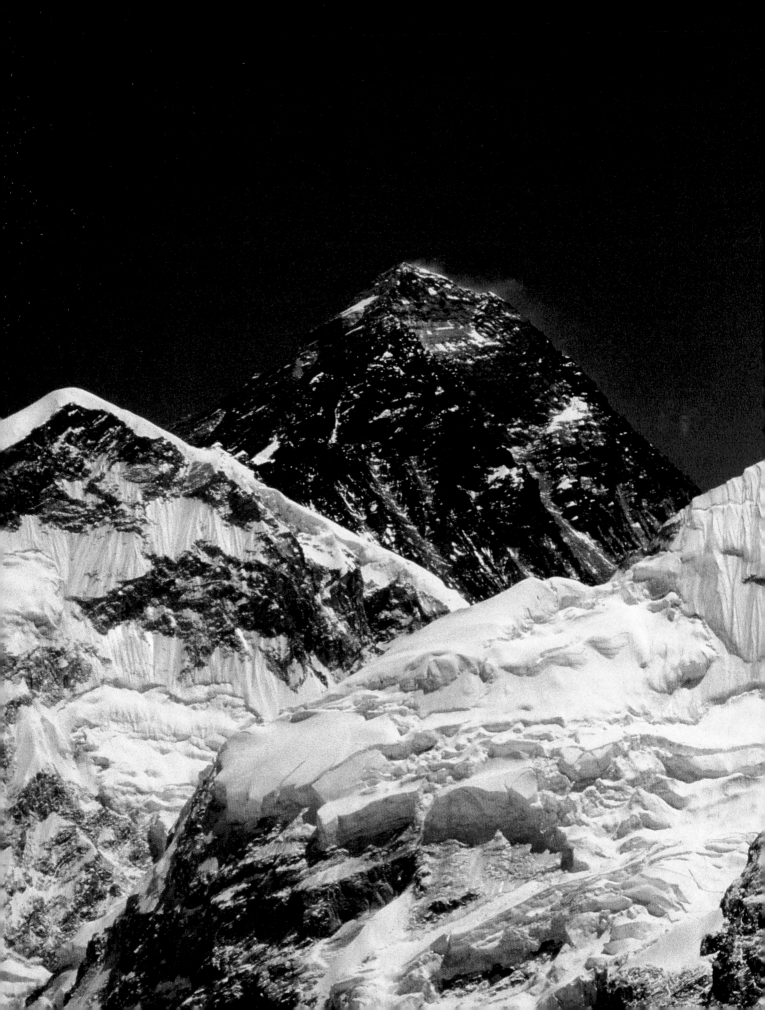

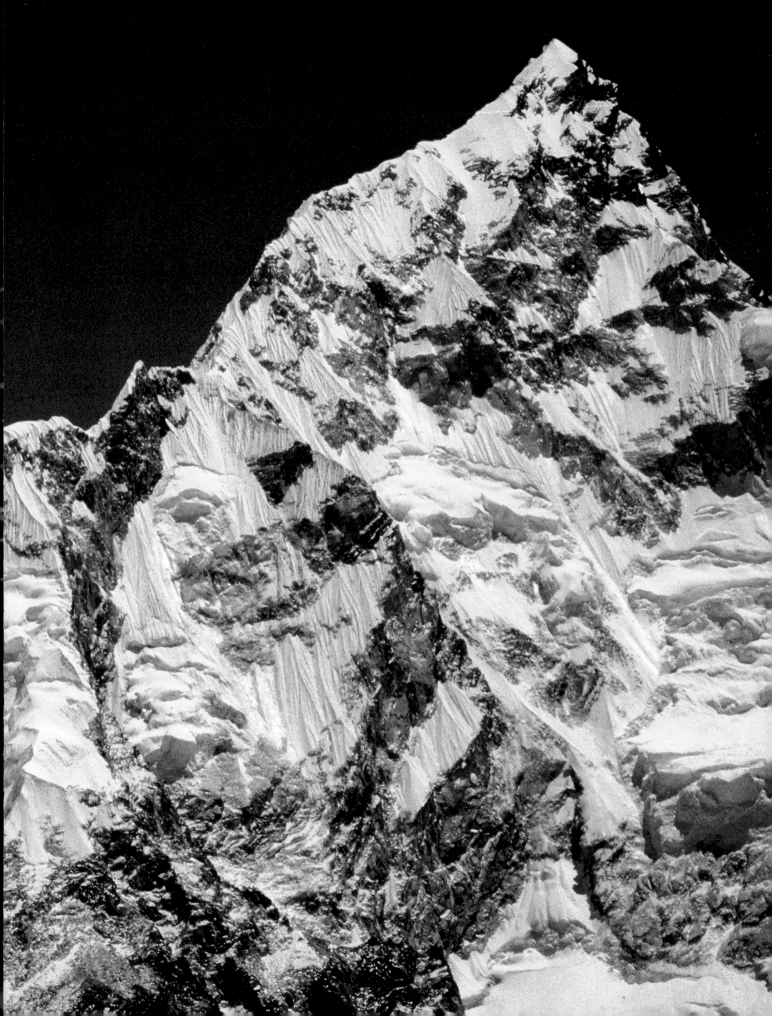

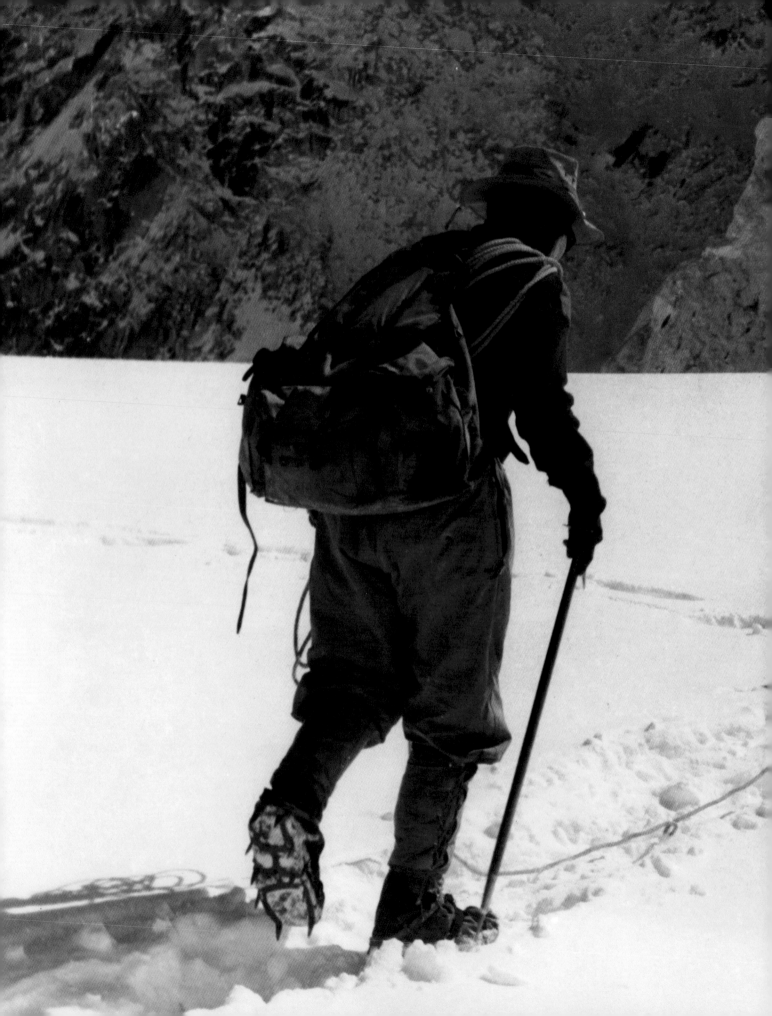

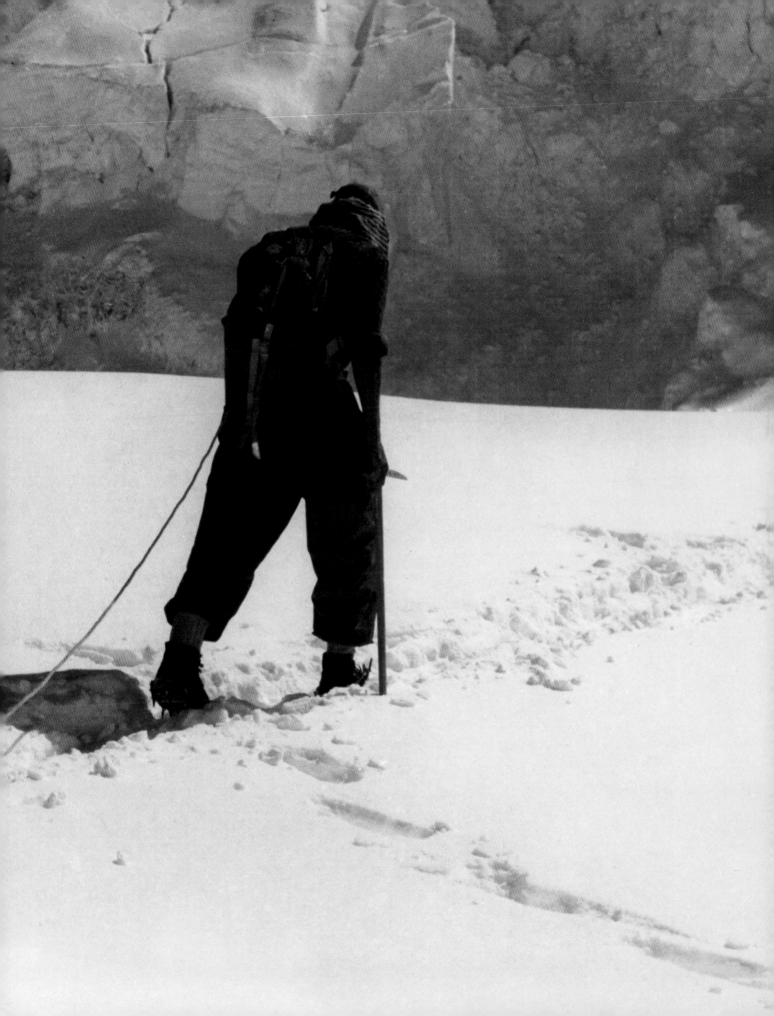

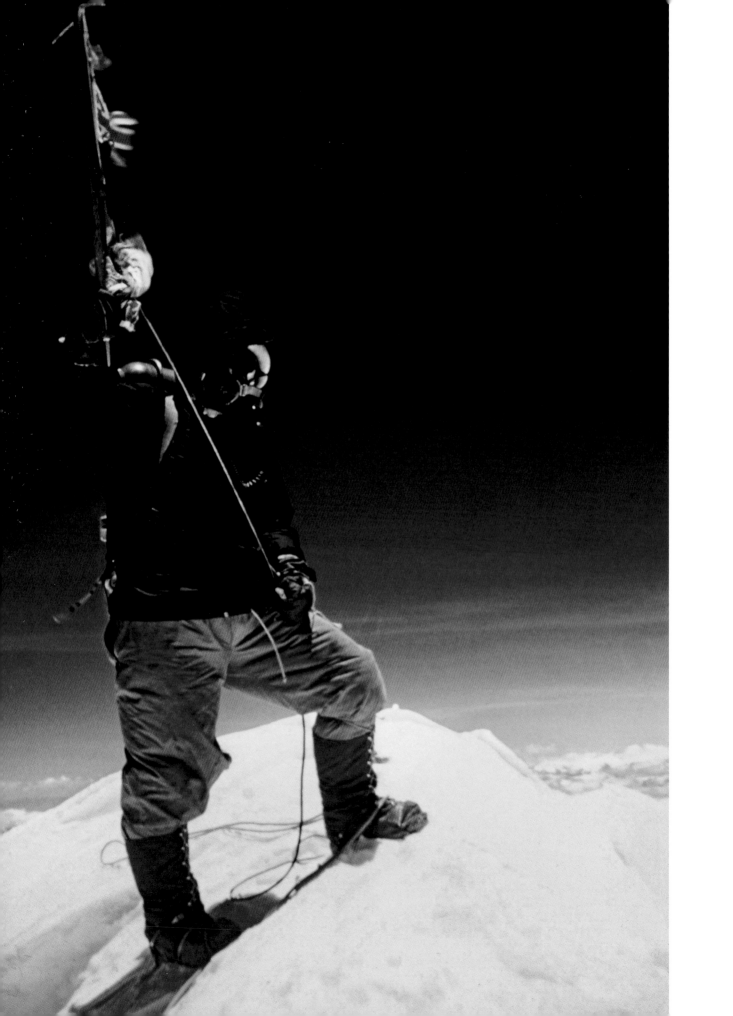

CONTENTS

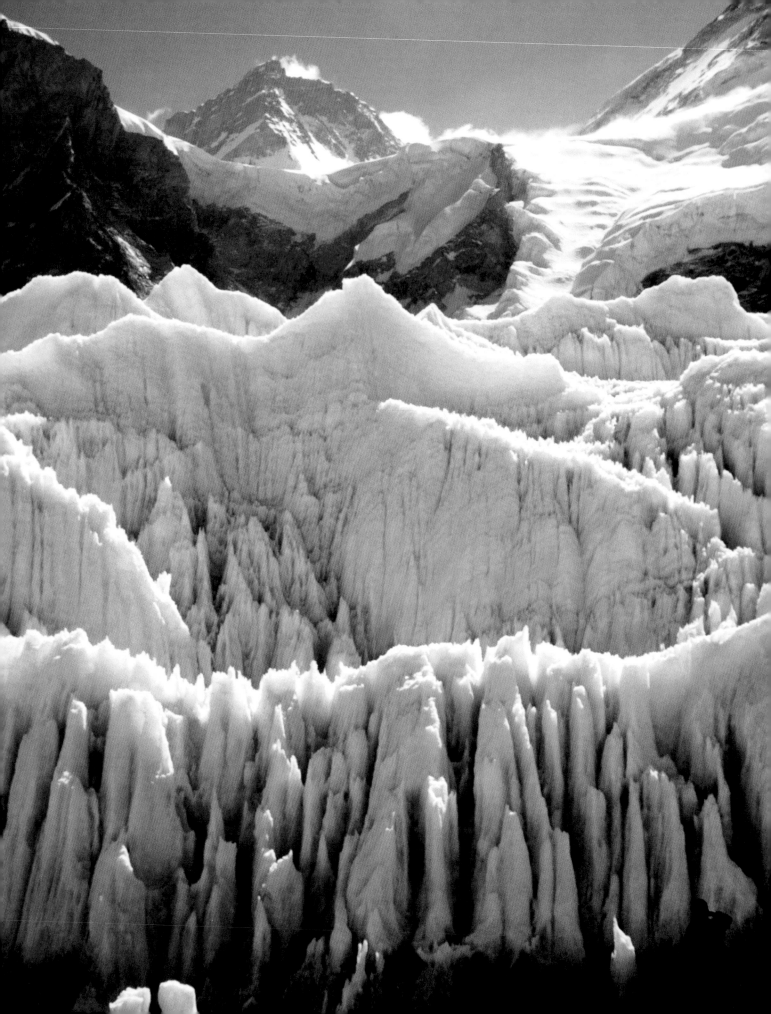

*It is not the mountain
we conquer but ourselves.*

Sir Edmund Hillary, 1989

*What is the use of climbing Mount Everest? ...
If you cannot understand that there is something
in man which responds to the challenge of this
mountain and goes out to meet it, that the
struggle is the struggle of life itself upward and
forever upward, then you won't see why we go.
What we get from this adventure is just sheer joy.
And joy is, after all, the end of life.*

George Mallory, 1922

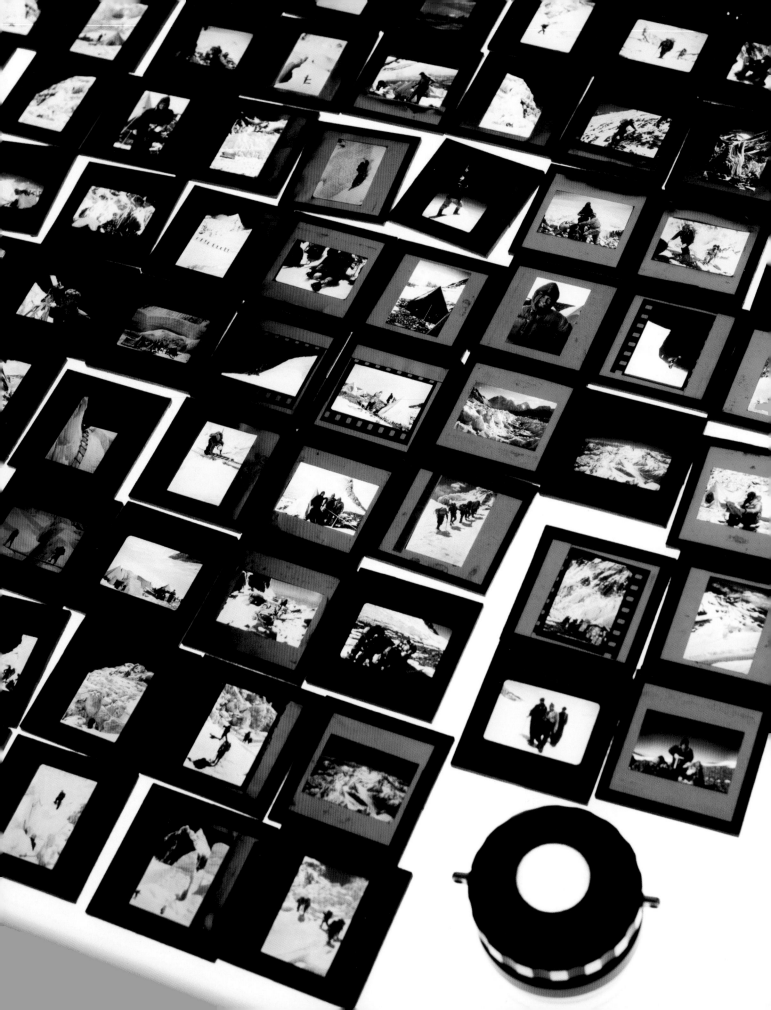

EDITOR'S NOTE

HUW LEWIS-JONES

This project was first suggested during celebrations of the fiftieth anniversary of Everest's first ascent. George Lowe's dear friend Sir Ed Hillary was quick to support the idea of creating a book about their time together in the mountains, immediately offering to write our foreword (p. 23) despite so many demands on his time. It was probably one of the last things he wrote – a final gesture to a lifelong friend.

In the years that have followed, George's own health has declined, but the book was always there, always something to work on when the time was right, when he felt up to it – a hope that someday it would be complete. George is now approaching his ninetieth birthday. The Everest 'boys' George Band and Mike Westmacott have passed away most recently. Of the climbers of 1953 only George remains.

Folded neatly in a duffel bag under the stairs at George's home are down-jackets and woolly jumpers. Elsewhere, there are small wooden boxes brimming with glass slides, tattered photographs, dusty piles of newspaper clippings, bundles of letters, diaries and maps. An ice-axe rests in the umbrella stand by the door. And on George's desk is a small lump of grey rock. Blink and you could easily miss this most treasured object: a shard from the summit of Everest. It is marine limestone, and once formed part of the sea floor, millions of years ago, before the pressures of the Earth pushed it skywards. Ed had tucked a few pieces into his jacket pocket and on reaching the South Col on the descent gave George the first. In return, George handed his exhausted friend a mug of warm lemonade, then bundled him into the safety of their tent. Later, at home, Ed would also give one of these special stones to his mother and she kept it in a silver locket, hung close to her heart.

As a historian, it's not often that you have the chance to meet your heroes. George has been called the 'forgotten man' of Everest, his achievements overlooked as eyes are drawn to the triumph of the summit, or to the disasters and controversy on the mountain of more recent years. He is passed by, perhaps, because he played his part so well. He was a master of his craft, on ice and snow, and a central figure in ensuring the success of the final pair – Ed and Tenzing – who would step up on to the summit that day in May.

This is his story. If this book achieves anything it will be to encourage a new generation to look back at the expedition of 1953 and see the daily successes of a team of modest men who made history; men who came back to tell the tale and lead enriched lives. Chief among them was George Lowe – funny, generous with his time, positive in his approach to life and humble in his success. Our horizons are widened by their achievements.

LEFT Original glass-mounted slides from the 1953 Everest expedition gathered on a lightbox. All the photographs taken higher than the South Col were on 35mm colour film. Since then innumerable black-and-white enlargements and prints have been made from these colour transparencies.

George was the founder and first Chairman of the Himalayan Trust in Britain, furthering Ed's work for the Sherpa of Nepal, and it is hoped that this book will help raise more money to support their future: specifically the Lowe Scholarships, which will provide funds for bright students from the poorest homes in the Solu Khumbu. As a former teacher, this is very close to George's heart.

This book has been a true gift. In the making, I acknowledge special appreciation for George's wife, Mary, his sons, the wider family, and friends around the world and in the climbing community who came forward to help with this task – a tribute to this wonderful man. Thank you George.

❧

Mount Everest, the highest mountain in the world, attracts attention like no other. From its southern approaches it dominates the Khumbu region of Nepal, far to the north-east of Kathmandu. Triangulated as Peak XV in 1856, the mountain was named soon after in honour of Sir George Everest, a former Surveyor General of India, though of course the mountain had been known about for centuries.

To the Nepalese she is Sagarmatha, to the Tibetans Chomolungma – Goddess Mother of the Earth – the jewel of the Himalaya, a range that stretches for over 1,500 miles (2,400 km) from Kashmir to Assam. It is generally agreed that the main summit is a formidable 29,029 ft, or 8,848 m, though the mountain is actually slowly growing taller each year – by some 5 mm, scientists suggest – uplifted as the Indian tectonic plate pushes northwards into Asia.

First seen by a non-native in 1849, the earliest attempt to climb Everest followed over seventy years later. The successful 1953 expedition was the ninth attempt on the mountain, leaving aside three solo endeavours and an abortive, unofficial Russian venture. Up to the end of 2011, at a reasonable reckoning, there had been 5,640 successful ascents by 3,450 individual climbers. At the beginning of 1953 there had been none. Some 223 people have now died in pursuit of the summit. Despite this, the mountain seems to have lost none of its allure.

She is a mountain that has been much photographed, and many members of the original 1953 expedition were interested in photography. Though climbers Alfred Gregory and George Lowe are best known for their images, George Band, Charles Wylie, John Hunt and Ed Hillary also took memorable shots – not least Ed's iconic one of Tenzing on the summit, which quickly became one of the most famous photographs in the world (p. 14).

There were two Kodak Retina II cameras, a Kodak Retinette, a Contax, a Rolleiflex and a Leica on Everest in 1953. There was even a medium-format Super Ikonta supplied by the picture editor of *The Times*, who was concerned that the 35mm film used by the others would not be up to the job. He had no reason to worry – the majority of the pictures were excellent – and in fact it was the Ikonta that proved tricky to use, its bellows awkward in the cold and challenging conditions above Base Camp.

After experience in the New Zealand Alps and the Garhwal Himalaya, George was used to handling his Retina II in tough conditions and by Everest it was second nature. During the night, when forty degrees of frost and more were normal, he slept with it in his sleeping-bag to keep it warm. High on the mountain, in strong winds and extreme hardship, he carried it round his neck, tucked inside his down-jacket, but ready to shoot at a moment's notice. At high altitude in snow he always kept it simple – shooting almost everything with a shutter speed of 1/100 s and an aperture of f/8 with a normal ultraviolet filter.

A trove of original and often unpublished photographs and other rare materials from the Lowe collection are brought together here for the first time. Stunning landscapes, candid portraits and action shots capture the day-by-day moments of this historic expedition as never before. This is a unique testimony to a superlative human achievement, for 2013 is an extraordinary anniversary year in the story of Everest.

Naturally, we celebrate sixty years of endeavour since the pioneering first ascent in 1953. It is also fifty years since the American expedition climbed the West Ridge and made the first traverse of the mountain; twenty-five years since the first ascent of a route from Tibet up the South Buttress on its eastern Kangshung Face; and thirty-five years since the incredible first ascent without supplemental oxygen. It is a great honour that climbers from these ventures have also lent their voices to our book.

Many nations now lift up their eyes to this summit and we share in the joy and the challenge of this remarkable place. And yet, all this is just a small pulse of human activity in the millions of years since the mountain rose from the sea.

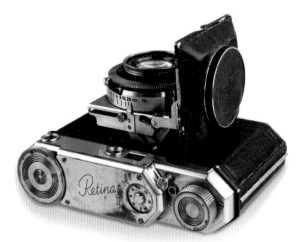

RIGHT George's trusty Kodak Retina II – a companion on all his New Zealand climbs and later travels in the Himalaya and Antarctica. This camera took many of the images that appear in this collection.

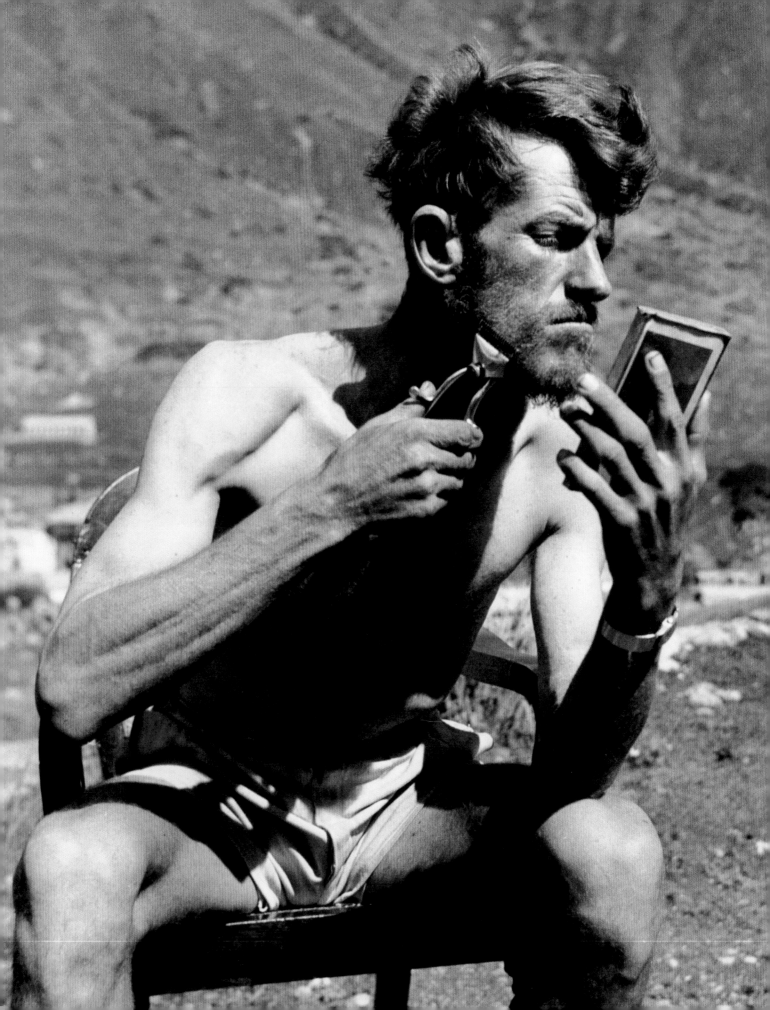

AN OLD FRIEND

SIR EDMUND HILLARY

I first met George Lowe in the Southern Alps of New Zealand just after the War. George was a primary school teacher, but spent two months of every Christmas holiday as a junior guide at Mount Cook. We just seemed to click and became friends almost immediately.

George was tall and strong and very fit, and I admired his very effective mountaineering ability. But most of all I enjoyed his sense of humour – I don't think I have ever laughed harder or longer than when I was with George in a mountain hut. In those early years, one great experience stands out. With a couple of good friends we made the first ascent of the mighty unclimbed Maximilian Ridge of Mount Elie de Beaumont. It was a fantastic climb, with George leading all the way, and my respect for his ability increased accordingly.

A group of experienced New Zealand climbers were making plans to undertake a Himalayan expedition and they had asked George to join them. George suggested they ask me too and I was duly invited. It was George who set off the spark that drew me to these great mountains. The original plan, rather ambitious at this stage, had been an attempt on Mount Everest, but most of the team dropped out until there were only four of us left and we turned our attention to lesser objectives – the many unclimbed peaks in the Indian Garhwal Himalaya. We had a very successful time too.

In 1951 the famous British climber Eric Shipton had obtained permission to cross Nepal and investigate the possibility of climbing Mount Everest from the south side. Two of our team were invited to join his small group and we travelled together up the great Khumbu Icefall on the south side of Everest. With Eric I climbed to nearly 20,000 ft on the Pumori Ridge, and to our amazement we looked up the icefall into the Western Cwm and even higher up the Lhotse Face to the South Col. We realized that a potential route did, in fact, possibly exist to the summit of Everest.

We returned to Kathmandu only to find that the Swiss had been given permission to make two attempts on Everest in 1952. But the Royal Geographical Society in London decided they would also send another expedition to the Everest area in the same year, for training and acclimatization. George Lowe and I proved the fittest pair in the team and climbed many peaks together. Our outstanding effort was to attempt the heavily crevassed head of the Ngojumba Glacier and force a way up to the narrow Nup La pass, which crossed the divide into the East Rongbuk Glacier in Tibet. We descended down to the old Everest Base Camp and climbed to the foot of the North Col. The weather started deteriorating, so in heavy snow we rushed back to the Nup La to find many of the crevasses concealed beneath a thick layer of snow. The five of us got roped together

LEFT Ed Hillary has a first wash and shave after a month in the hills, following the expedition to the Garhwal Himalaya.

and started off down. I was leading and kept plunging into crevasses, but George was close behind and kept jerking me to safety. Somehow we reached the foot of the icefall.

We soon learned that the Swiss had failed in their first attempt after a great struggle. Their second assault in the post-monsoon season proved very cold and windy, so they failed again. So now it was up to us in 1953. George made a formidable contribution to the expedition. He pioneered much of the route on the Lhotse Face and led the way up the South-East Ridge for Tenzing and myself. We reached our highest camp at 27,900 ft, then our support team left their gear and returned back down to the South Col. They had made a magnificent effort and given Tenzing and myself our chance to reach the summit. We succeeded in doing this on 29 May 1953.

ఇం

George continued on to adventure after adventure. With Vivian Fuchs's British expedition he crossed from one side of the Antarctic continent through the South Pole to McMurdo Sound. We went again together to the Himalaya many times. He helped me with my books, too. In the years after Everest I was a bit sick of writing and I had a helluva lot to do with my beekeeping and lectures and everyone wanting me to present prizes or give after-dinner speeches. He was a master at sorting out the photographs and his skill with our ciné film speaks for itself. We all turned to George in our various ways and no matter the challenge he always got the job done.

He saved my life a few times over the years, too. Down in Antarctica, I remember when we were trying to get our ship, *Theron*, clear of the ice and I was standing with George on an ice floe, cutting a channel. A steel cable fouled the propellor just as a rope-end flicked and locked around my ankle. Quickly, yet calmly, George managed to knock it free before it came tight. A moment later and I would have been sucked under.

It's hard to sum up the rest, or do justice to so many years of cheerful comradeship. All the while through this adventurous life of ours, he actively maintained his educational activities – for a number of years he was headmaster of an English-language high school in Santiago, Chile, and later became one of Her Majesty's Inspectors of Schools in the United Kingdom. He was always first to encourage new mountaineering projects and was greatly respected not only for his adventures but also for his guidance and leadership. But how best to describe your feelings for your oldest friend?

Well, for all the renown that Everest brought me, I've always hated the danger part of climbing, but there is something about building up a comradeship that I still believe is the greatest of all feats – and sharing in the dangers with your company of peers. My memories of the mountains have always revolved about the good times, about the people I liked and laughed with, the tough jobs we did together and the feeling that everyone was giving of their best. It's the intense effort, the giving of everything you've got, doing things big and small with people you admire. To put it simply – George was a great man to have on an expedition. (2007)

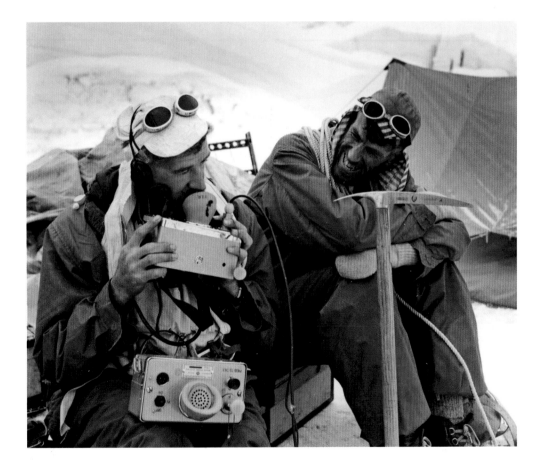

ABOVE On Everest, Ed laughs as George relays a message to the lower camps on the wireless radio set. As George recalls, one of them was making a rude joke at the time.

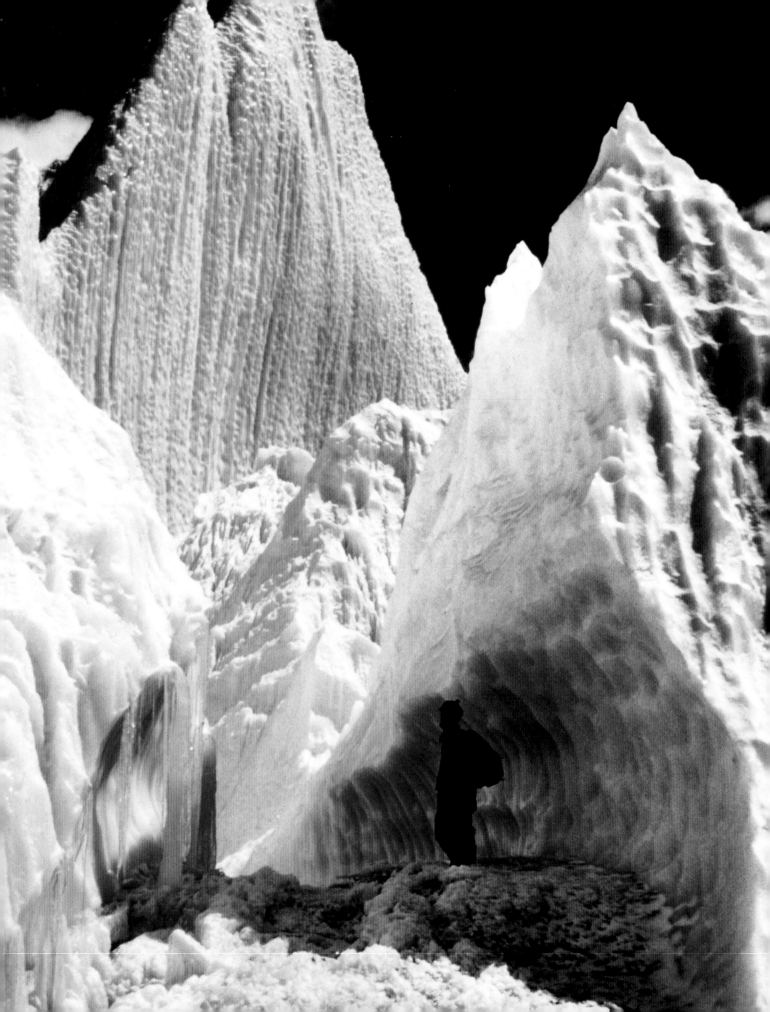

SUPREME ACHIEVEMENT

SIR CHRIS BONINGTON

O ften pieces of news are so momentous that we'll always remember where we first heard them – for me, it was the first ascent of Everest in 1953. It was on a bleak parade ground on a grey, watery day at Royal Air Force Hednesford in the English Midlands. I had recently started my national service. Despite the falling rain, our commanding officer announced with pride that Everest had just been conquered by Ed Hillary and Sherpa Tenzing Norgay. Standing to attention, we tried not to react, though I knew many of us were smiling at this wonderful news.

It was an achievement as remarkable as it was unattainable to me back then. Though I was already a dedicated climber, Everest was far from my aspirations – I was dreaming of the rock climbs in Snowdonia I would tackle in my next leave. My focus has always been on the immediately achievable and at that time the Alps and the Himalaya were all hidden in the future.

Everest would come to fill a large part of my climbing life, as it has done for many others. The highest point on earth has a magnetic attraction. From the earliest days in 1921, with the first reconnaissance from the north side, followed by the tragic attempt by Mallory and Irvine in 1924, to the race for the summit from the Nepalese side – which the Swiss so nearly won in 1952 – the ascent of Everest would play out as a saga of mountaineering triumph and disaster.

The story since 1953 has been equally dramatic, with pioneering ascents of the major ridges and faces. It's an evolution that all great mountains have experienced. Mont Blanc seemed as unattainable, before Jacques Balmat and Michel Paccard clambered to its summit in 1786. Its mystique would give way to guided trips – now a hundred a day climb it in the summer season. And every year some die; that element of risk is part of the attraction of climbing.

Though much had been achieved on Everest before the British came in 1953, the difficulties were still huge. The leadership of John Hunt, who understood the importance of planning and logistics, undoubtedly contributed to their success. On a siege-style expedition, a high level of teamwork – and the sacrifice of personal ambition by many of its members – is vital to the ultimate result. These unsung heroes lay the foundations for those who summit.

With the passage of time, it would be a mistake to underestimate the achievement of the 1953 Everest expedition, and the fact that so many have now climbed there shouldn't cloud the enormity of this feat. We should not forget the difference between following in someone's footsteps and blazing the trial. Success in 1953 was by no means a foregone conclusion. The team encountered appalling weather and they were running out of time – as May slipped by, they still hadn't reached the top of the Lhotse Face. George Lowe emerged as the hero of this vital part of

LEFT Near Base Camp the beautiful but unstable pinnacles of the Khumbu Icefall present a daunting obstacle to anyone wanting to gain access to the Western Cwm and make an attempt on Everest.

the climb, spending eleven days forcing the route up to the South Col. He had to battle with deep snow and savage winds, cutting steps in the ice for much of the way – these were the days before modern ice tools. It was this effort by George that enabled the South Col to be reached in the nick of time. Capturing that weather window before the arrival of the monsoon, Hillary and Tenzing were then able to push on to attain the summit.

<p style="text-align:center">℅</p>

Their supreme achievement did little to stop the human desire for this prize. Everest's siren song continued. The Swiss returned in 1956 to make the second ascent and the first ascent of Lhotse for good measure. The Chinese climbed the North-East Ridge from the North Col in 1960. The year 1963 saw the first American, Jim Whittaker, reach the summit, while his colleagues Tom Hornbein and Willi Unsoeld made an incredible first ascent of the West Ridge and also the first traverse of Everest, descending by the South Col.

The next great challenge came in the 1970s, with the long siege of the South-West Face. The Japanese were first, with a recce in 1969 and a full attempt in 1970. This was followed by the International Expedition of 1971, a German attempt the following spring, my own British party in the autumn and another Japanese expedition in 1973, but a steep rock wall, known as the Rock Band, had stopped us all. The problem was finally solved in the autumn of 1975 by a British expedition, which I led. Nick Estcourt and Paul Braithwaite forced the Rock Band, the barrier that had defeated all previous expeditions, and in doing so sacrificed their chance of going for the summit.

Many more expeditions followed, but the important trend was towards much smaller and lighter ones. The ultimate, undoubtedly, was Reinhold Messner's solo ascent during the monsoon in 1980, when he was the only man on the entire mountain. I believe this ranks as the most remarkable ascent in the history of Everest and the only genuine solo ascent. A Polish expedition made the first winter ascent in good style by the South Col route in 1980. Peter Boardman, Dick Renshaw, Joe Tasker and I attempted the first ascent of the North-East Ridge from the Raphu La in 1982. In contrast to our 1975 assault, we wanted to reduce this one to the bare minimum.

Pete and Joe very nearly pulled it off, but tragically vanished high on the unclimbed section of the ridge. Pete's body was discovered in 1992, within yards of an easy traverse to the standard route on the North-East Ridge. He was lying in the snow as if he had fallen asleep, perhaps

from extreme exhaustion. After a total of six attempts the route was finally completed to the summit by a large Japanese expedition using 4,000 m of fixed rope and supplemental oxygen. It could be argued that the last new route on Everest was that of the Anglo-American expedition of 1988, which assailed the South Col from the Kangshung Glacier. Stephen Venables eventually reached the summit on his own, without oxygen, and then bivouacked high on the ridge on the way down.

I finally reached the summit of Everest in 1985 by the traditional South Col route, with an expedition making the first Norwegian ascent. This was the last year that the Nepalese authorities allowed only one expedition on each route. We had the Western Cwm to ourselves. Though we'd used oxygen and followed the classic route it was still one of the great moments of my life, as much for the quality of the experience and the lifelong friends made as for the achievement of standing on top of the world and enjoying the view of the mountains falling away beneath my feet.

I reached the summit just in time, for in 1986 it all changed, with the development of commercial expeditions bringing a growing number of people on the mountain every year – sometimes more than 150 people going for the summit in a day, following a line of fixed rope all the way to the top. I wouldn't want to go there now, but I don't begrudge the person who probably couldn't get there by any other means and for whom reaching that crowded summit is still one of the great moments in their lives.

The pioneers have packed up their gear and gone elsewhere, tackling technically challenging new routes, alpine style with small teams or climbing solo. Though Everest remains a universal symbol of human will and ambition – and its first ascent, the clearest and strongest statement in the history of mountaineering – I'd like to think that the impulse to explore will always lead us to new ground. There are still thousands of unexplored ridges and faces across the high ranges of Central Asia to summon mountaineers to their own summits of achievement. Yet these mountains need not be the preserve only of the extreme climber. There are countless peaks, most of them nameless, in the 6,000-m range that can offer adventure to climbers of all abilities and the kind of satisfaction that need not always be measured in altitude. This is the sort of pioneering that George Lowe and his fellow mountaineers revelled in during the 1950s. It's what I love doing now in the autumn of my own climbing career, accepting that the peaks I attempt will get ever smaller and easier, but my appreciation of their beauty and my enjoyment of the friendships shared will always be the same.

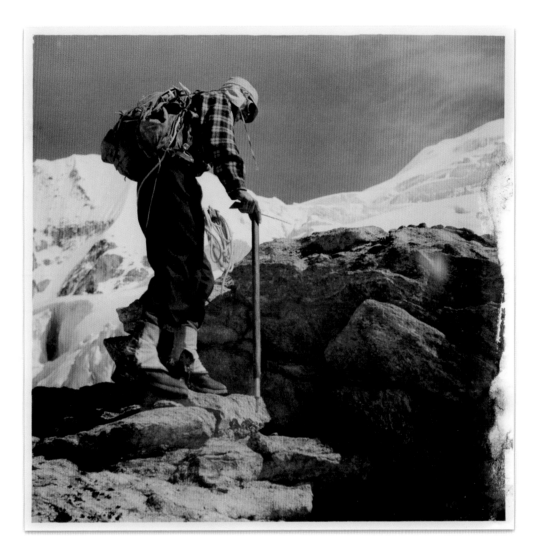

1 | BECAUSE IT IS THERE

The medium of some men is paint or stone or boats, or a schoolroom
or engines or paper and ink; that of a few is rocks and snow and
the uphill movement of limbs. This is the only answer I know to
the very reasonable query: 'Was it after all worth the labour?'

Wilfrid Noyce, 1954

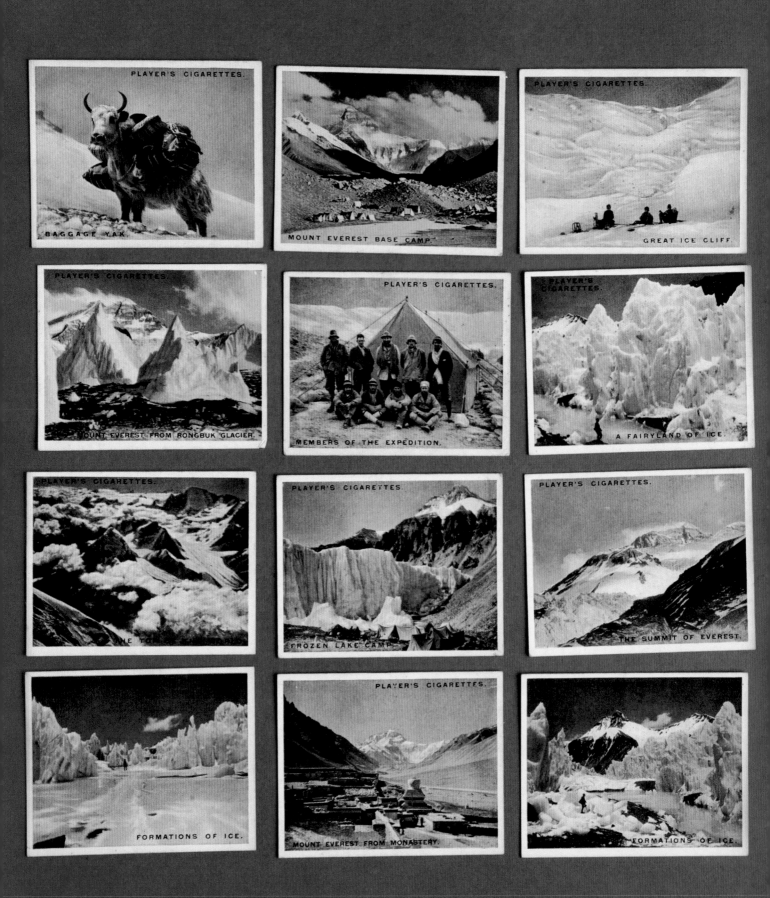

The men who tried Everest before the Second World War were giants in our eyes. Finch and Bruce, Norton and Somervell, Mallory and Irvine, Smythe, Wyn-Harris and Wager, Shipton and Tilman – their names a roll call of adventure, or the line of a hymn perhaps, sounding in my mind. I retraced their routes and followed their accounts, imagining my own way through the snows to the highest of places. I dreamed what it would be like to walk among them. These men were the pioneers and they offered their best. We admired them for this above everything else.

For we mountaineers, then, it had started over three decades before, with the first reconnaissance in 1921. Eleven expeditions – British climbers and Sherpa porters – went before us, through the immense maze of valleys and glaciers stretching northwards from Everest's flanks in Tibet. With access denied after the War, when the Chinese seized control of this sacred land, our task was to investigate the southern approaches hitherto hidden in northern Nepal. It was a new chapter of exploration. We took to it gladly. Our fears were mixed with anticipation and delight.

Our contribution to the story of Everest in 1953 would not provide a conclusion to its majesty or appeal. But when we climbed it in 1953 we really did believe that the story was complete. In our innocence, how wrong we were. The world – especially the British world – was watching, and our climb drew attention like no other before. It was a start rather than a finish.

I was one of the fortunate ones. I was able to come back down safely. Others before and since have not been so lucky. But why climb at all? I'll try to speak to the *why* before I get on to the *how* we did it. For me, it was always fairly simple – the mountains were a deep source of real happiness. They dispense a lion's share of sorrow too, but it's the joy that always wins out. As has been said so often, we climb because we like it. If someone feels the need to scrutinize the pleasure it brings further than this, well, that person may never accept the simplest why of mountaineering. But, I do doubt whether any one of us went to Everest in 1953 expecting to enjoy the climbing as much as on the mountains, hills or crags closer to our homes. Altitude, and its effects on our bodies, would be the biggest test, not the precise technicalities of the climbing.

Yet to solve a problem that had long withstood the persistence of others, that of course is a fairly irresistible challenge to most men. It was this essential urge buried within that George Mallory touched on when giving his now famous off-the-cuff reply to the question of why – 'because it is there'. It was this standing challenge, this human impulse to explore, that led him to return to Everest. 'Suffice it to say that it has the most steep ridges and appalling precipices that I have ever seen,' Mallory wrote to his wife, Ruth, 'I can't tell you how it possesses me.'

It was exactly this deep feeling, this possession, that drew him up the mountain for a third time, before tragically disappearing with his partner Sandy Irvine high on the North-East Ridge in 1924. They were last seen going strong for the top, two tiny dots moving on the summit ridge, before the clouds obscured everything from view.

Many others sought the sacred summit without success, but their ambition encouraged us to try where they had dared. 'It stands to reason that men with any zest for mountaineering could not possibly allow Mount Everest to remain untouched. The wish and will to stand on the summit of the world's highest mountain must have been in the heart of many a mountaineer.' So wrote Sir Francis Younghusband in 1921, as those first

LEFT The 1924 Everest Expedition, as seen in these Player's souvenir cigarette cards. Pioneering the northern route from Tibet, these men were heroes to me. I was lucky to climb into Tibet in 1952 and follow in their footsteps.

PREVIOUS Ed Hillary moves up the ridge in a virgin valley below the slopes of Mukut Parbat, during our first expedition to the Himalaya in 1951.

expeditions were leaving England. For Mallory, a climb was a spiritual journey: 'To struggle and to understand', never the second without the first. Yet Everest would call for something more, something above and beyond. In 1922 he paid this tribute to his worthy adversary: 'How can I help but rejoice in the undimmed splendour, the undiminished glory, the unconquered supremacy of Everest.'

Yet, I still prefer his simpler turn of phrase – let's repeat it – 'because it is there'. For me, Everest was never really about the superlatives, or about an idea of man battling with nature to win some gallant and great fight. I let others use that language back in 1953, and they were free to do so. For me, it was simply about wanting to be there. The deep desire that I had to go and try – making the most of the opportunity to be part of something significant and to give my very best. I could do nothing more.

Our attainment of the summit was not the end of the story of Everest, then, but a new beginning. Did we conquer Everest during that summer of 1953? No, we did not. We carried in our minds the hopes of all who had gone before us. We were given the chance to succeed because of their efforts. Somervell and then Norton alone had clambered to about 28,100 ft in 1924, and that height was reached again in 1933 by Smythe, Wyn-Harris and Wager. The Swiss guide Lambert and the pride of the Sherpa, Tenzing, would reach the same height on the southern side in 1952. We were encouraged by what they had achieved. Each of us had our own personal ambitions, of course, but the greater goal of the highest point in the world was intimate to us all as a team. Nothing but the top was good enough; and all of us would play a part.

⁊

The mountain bus was an ungainly affair, a big, brown, rubber-tyred creature with a high wheelbase, transporting us along rough tracks from the hotel, across the floor of a valley, through a wilderness of boulders, over dry stream beds and right up to the side of the glacier, there to disgorge its load of climbers and tourists for Mount Cook. It was not long before I was regularly conducting parties of sightseers on their first visits to the glacier, cutting steps, guiding them to some interesting point after alighting from the bus. But always I enjoyed the rattling bus ride, too, for the view of the valley and mountains was superb. This was New Zealand at its very best.

One day I noticed a long-limbed, keen-faced young man sitting alone on the rear seat. Dressed in old tweed trousers with puttees around the ankles, a tartan shirt and a sweat rag circling his neck, all topped by a battered brown ski cap, he carried an ice-axe and a small rucksack, and his green eyes roved with a curious excitement over the scenery. I joined him at the back of the bus, and we talked easily about the mountains. The excited, ever-interested look never left his eyes. He had been a wartime navigator on bombers, was four years my senior, and was now working for his father who kept a bee farm in Auckland.

'My father runs a fruit farm,' I told him, 'with beekeeping as a sideline. As a matter of fact we get our queen bees from a chap in Auckland – someone called Hillary.' 'That's us', said the young man. 'My name's Ed Hillary. Small world, isn't it?' We joked a bit about the coincidence, but just as we were getting to know each other the bus jolted to a stop. Hillary had a rendezvous with a climbing friend at a hut somewhere up the glacier. We exchanged addresses and shook hands.

'Let's do a climb together, maybe next year', he said. Then he hitched up his rucksack and strode away across the ice, his long,

gangling frame easy and relaxed. I began shepherding my glacier party. The day's work was just a shade distracted by a wishful anticipation of mountain expeditions on which I would partner this amiable new acquaintance.

This was Christmas time, 1946. I had landed a holiday job at the Hermitage Hotel, just at the time when the mountain guides were returning from the War. Looking back, I suppose this was my lucky break. Having done enough window cleaning and shelling peas in the first few weeks there to last me a lifetime, I had managed to persuade the guides to let me help them open up and restock the mountain huts. Before long I was helping take parties of tourists on to the glacier, and bringing them back safely.

Neither they nor I had ever before seen a glacier, but by keeping a superior silence about my ignorance I found the tourists were soon regarding me as an experienced professional, a gargantuan error which I made no attempt to correct. Yet, in time I was assisting the chief guide, the legendary Harry Ayres, and it was Ayres who Hillary had engaged to teach him how to climb. So I was lucky again. Harry was on the front of the rope, Ed in the middle and I brought up the rear. We were both learning our ice-craft from the very best.

By the following winter climbing season, with the Mount Cook territory still absorbing my interest, a college friend of mine Geoffrey Milne and I felt competent enough for bigger and better things than the modest exploring we had thus far achieved. Our target lay in the northern corner of South Island. We planned to make the first winter ascent of the 9,400-ft Mount Alarm. With us on the journey went Ian Mackersey, a young reporter, and Theo Hills, a teacher. Exactly one month before our venture, Hillary, with his brother, Rex, and a friend had attempted Mount Alarm, but turned back. Instead, they traversed the celebrated 'Tappy' (the 9,465-ft Tapuaenuku) and achieved the second winter ascent of that mountain. In due course we tackled Mount Alarm, reached the summit and on the next day, hugely exhilarated, completed our ascent of 'Tappy'. We later also managed the grand traverse of Mount Cook in just fourteen hours, then a record time, although the thought had never entered our minds. I remember Mick Bowie, another of the great guides of the day, smiling when we returned to the hotel looking rather worse for wear. 'What kept yer?', he chuckled.

For those who are unfamiliar with New Zealand conditions it's worth saying that, even with today's modern kit, these mountains are extremely difficult. Altitude alone does not make a mountain, and in fact around 10,000 ft of Mount Cook or Mount Alarm is roughly the equivalent of the 14,000-ft Matterhorn in Switzerland, or the 20,000-ft peaks of the Himalaya, where the snow line begins a good deal higher than in New Zealand's mountain areas.

Cook is like no other mountain. It always seems grander and more inviolate, more detached from the valley. Clouds seem to drift continually past or round its piercing icecap, never over it. For Geoff and me, the traverse of the summit ridge of Cook held a fascination apart. The feelings, often imagined, of treading 'that glorious aerial ice-ridge', were more finely tuned and highly strung than any of our other ambitions at that time. And in the actual doing of this climb none of the emotions and expectations we dreamed of lost any of their lustre. The prospects of a long walk together up at 12,000 ft, yet still on solid earth, had always caused mutual excitement. It is more than a mile and a half from low peak to middle peak and on to the highest peaks, and then rarely done.

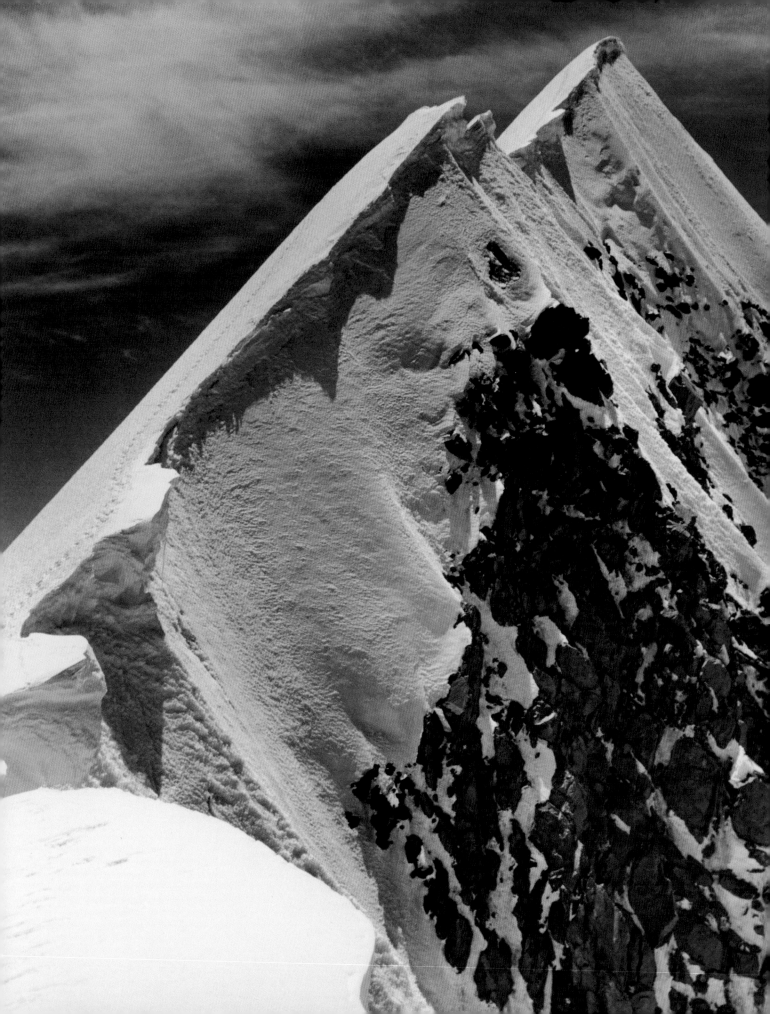

During the next two seasons I was meeting Ed Hillary quite often, though it was not until 1951 that our plan for a bigger climb was realized – and then it was the result of a dreamy speculation while we were incarcerated in a mountain hut a year earlier, cut off from the world by a violent storm. We had gone, Geoff and I, to the refuge hut called Haast, which lies on the lower slopes from which the attempt on Cook is made. We reached Haast about the same time as Hillary and his companion, a donnish young man named Bruce Morton.

Then the storm broke and there was nothing for it but to sit tight and hope for the best. Lounging around the hut, the four of us decided to team up for the climb if and when the weather cleared. But the snow streamed down and blew incessantly, and we were besieged for nearly five days. For a time we amused ourselves playing draughts with a board drawn on a large calendar, our draughtsmen fashioned from chunks of parsnip and carrot. Meanwhile the snow just kept falling, and soon it was mounting around the walls and coming up to the windows. Between games and primitive cooking we daydreamed about the potential joys of climbing in the Himalaya, which in those days was still a distant if not unattainable Mecca for comparatively inexperienced climbers. By the end of the second day our talk was soaring to a more daring level as Hillary and I asked each other, 'Why *not* the Himalaya?'.

The fact was that New Zealand mountain training fitted a man more appropriately for a Himalayan expedition than any testing ground in the Swiss Alps. The structure of South Island terrain, with its high plateau country in the east and its deep-cut valleys in the west, was not so dissimilar from the Everest region, and many of our problems were strikingly similar: we carried heavy loads, we faced ice rather than rock difficulties, we had

no comfortable railways to help the initial stages of ascent, and we had few Alpine amenities. With the planning of food, stores, bases and routes, our New Zealand climbs were 'expeditions' in the proper sense.

And so, around Christmas 1950 and into the New Year, five of us set off on a South Island summer journey deliberately designed with the problems of the Himalaya in our minds. My four companions were Earle Riddiford, a barrister, Bill Beavan, an engineer, Edmund Cotter, a clothing salesman, and Hillary. Most of our pre-expedition planning was done by letters, for we were separated in various parts of New Zealand until Christmas Eve, when we made our mountain rendezvous in a hut on the eastern side of Elie de Beaumont, the most northerly of the country's 10,000-ft peaks, and our newest goal.

Of all the mountains I have seen or perhaps will ever see, Elie de Beaumont has most of the kind of majesty that can properly be called awesome. It is 'big' and difficult, with a long jagged ridge that plunges dramatically down into tangled forests and wild bush a few miles from the sea. For a mountain of its height it offers the difficulties, resistance, perils and beauty of anything to be found in the Himalaya. High-angled glaciers, hard as diamonds, are draped in every mountain fold. With its rivers, forests and contorted geography it was a triumph to reach even the foot of Elie de Beaumont – a seven-day trek in the blazing December sunshine, negotiating three uncrossed passes before starting our real assault.

Over these high passes we were each humping loads of 70 lb and in some steep sectors it meant double or triple journeys, splitting the load – five thoughtful ants toiling relentlessly hour after hour, climbing day by day, placing our loads on ever higher ledges.

LEFT The High Peak of Mount Cook (12,316 ft), as seen from the summit ridge. I climbed this splendid grand traverse for the first time in 1949. Cook is the king of New Zealand's Southern Alps, a great mountain from which sweep blades of ice, buttresses of rock and great ice-cwms, tumbling innumerable tons of ice into glaciers thousands of feet below, some almost reaching sea level.

On New Year's Day we were in position to make an attempt on the great ridge. Ed Hillary, who at this stage was not as toughened as he was soon to become, had a tendency to labour at the rear, usually just behind me. His progress in leadership, however, was given an unexpected forward thrust during the morning when we were half-way up the ridge. A sudden storm, blowing in from the sea, forced us to retreat. It was early in the morning, just before dawn, nobody was inclined to talk much, and I was leading, with Ed close behind, head down and panting a little with the effort to keep up.

With my pack pressing hard, I stepped on a small boulder that proved to be unfirm. Overbalancing, I began to fall, quickly recovered, and then stumbled a yard backwards and downwards until a loud agonized yell from Ed indicated that the power-packed heel of my climbing boot had landed with cruel exactitude across his toes. 'The climb is bloody difficult enough without *that*', said Ed, ruefully examining his bruised foot. 'Next time I'll lead.'

While in the mountains we were often troubled by a parrot called the kea – a naughty, thieving bird found only in New Zealand. One day Ed, at his unselfconscious and hilarious best, announced his determination to shoot one of these creatures and bring it back for supper. 'Shoot – with what?' I inquired. 'I thought of making a bow and arrow', Ed said. He then went to work with his ice-axe, cutting a sizeable shaft from a thicket, tied a pair of bootlaces together and eventually fashioned a massive if somewhat unorthodox bow. From the thicket he also hacked a few straight sticks for arrows; he built a camp-fire and proceeded to harden the arrow tips in the blaze.

I watched as he sat crouched over the fire, a wild, untidy cave dweller with shaggy hair. 'You look like prehistoric man,' I told him, 'but with rather less chance of making a kill using *that* instrument.' Hillary rose, stretched his long arms and legs, made a 'prehistoric' grimace, and walked off with his new weapons. I saw him creeping around some rocks, absorbed as any schoolboy up to mischief. To the astonishment of all of us, he returned in half an hour triumphantly brandishing a bird. With all their feathers, the kea are quite big. Plucked, they're just tiny. We cooked the poor thing in our pressure cooker and each had an inadequate, indigestible mouthful.

A different brand of surprise faced us the next day. From the outset Bill Beavan had complained that he was far from on top of his form, and there was no doubt he was sickening for something by the time we began camping under a large overhanging rock. On about the third of the month we were planning to set off before dawn on the main climb to the summit, and it was over breakfast at one o'clock that morning (a vast meal which had to suffice for the whole day) that Bill became obviously ill. Ed and I first noticed the spots on his face. Bill ripped open his shirt and we saw a still more spotted chest. Bill Beavan had unaccountably caught chicken-pox.

'Leave me a couple of days' food and water', said Bill quixotically, 'and I'll be all right here under the rock while you finish the climb.' A nagging suspicion of mean-spiritedness troubled the rest of us for a while, but was soon submerged, I fear, with the prospect of completing the most exciting ascent we had done so far. Hoping for a gallant refusal from Bill, we offered to stay with him, and were relieved when he firmly insisted the expedition must continue. So we made him as comfortable as possible under the rock and set off.

I climbed with Ed Hillary on my rope, with Earle and Ed Cotter together on a rope behind us. We were on the Maximilian

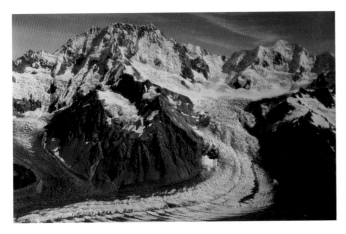

Mount Cook and Mount Tasman (11,473 ft) are low by comparison with Himalayan peaks, but the icefalls and glaciers fed from them are as challenging as any found in the Everest region. I took this shot as we flew over the Haast Pass on 30 March 1947.

on the slow, slow climb often reminds you of the tensions in driving a very fast car – there is nothing to discuss, plenty to do, continually learning to adjust yourself.

You climb, you emerge at the top of an ice slope, you bring up your second man on the rope, you cut steps, finger the rocks, and nimbly climb again; every now and then there is an excited shout of relief or triumph; you are afraid, the man behind is also afraid, and you each know about the other but you do not think about it, and you say nothing.

There was little time for resting at the summit, for it was essential to get off the mountain before dark – too dangerous to remain without protection if a storm should blow up. Now, however, a new problem loomed. For several hours Ed's usual exuberance had been noticeably dimmed. By the time we had reached the top of the ridge he announced he was not feeling well. 'If you keep plugging on in front', he said, 'I can still follow.' And thus we completed the journey to the summit. The descent was not easy, and by the time we were down, with darkness almost upon us, Ed Hillary was in a feverish condition. He too had chicken-pox.

Ridge, a jagged highway that could be seen in profile at various points, and, like all first ascents, was full of interesting problems. It meant non-stop climbing for thirteen hours, with no further food or drink after our giant breakfast during the small hours.

The marathon ended between three and four in the afternoon. We reached the summit and looked across at Mount Cook and down on a magnificent panorama of the places across which we had trekked seven days earlier. It was true that this peak had been reached by others before us, but only from the other side of the mountain where the going was much easier. The territory we had covered was virtually unknown, with the ice folds and new glaciers to test our skills and confidence.

On a new mountain, or a new ridge, every ascent is endlessly fascinating – the climbers never certain what lies on the other side of a rock face, never knowing if they are soon to be forced into retreat; the intense concentration, without waste of words,

❧

Less than five months later in 1951 I was on my way for the first time to the magic Himalaya. Fitter than at any time in my life, I thought with amusement about the old fears that with my abnormal left arm I was destined to be partially disabled, physically 'not much use'.

As a nine year old I had shattered the bone just above my elbow, falling headlong off the veranda steps at home. For almost two years afterwards I was in constant trouble – the arm

would not mend. The complications involved a long series of operations, the arm being continually rebroken, set, rebroken and set again, usually on the dining-room table with my face buried in a chloroform-soaked flannel. Seven times they tried to realign the bones. From then on, and to this day, my left arm developed virtually without muscle. Although its movements were restricted, I found myself silently resolving that I would disprove the doctor's damnable prophecies about my being a 'cripple for life'. Despite this, I've actually always thought of myself as a very lucky lad.

I was not even a climber until well past my twenty-first birthday, at which point I was still terrified by heights. Though a determined fellow, I was always somewhat hampered by a broad stream of cowardly feeling which gripped my entrails whenever I was called on to show even a slight degree of athletic initiative. And this nervous dislike of heights, together with the results of that school-days' accident that smashed my arm, was without a doubt the real cause of my embrace of this dangerous pastime. I wanted to be able to take responsibility for myself and to face up to my weaknesses.

No surprise, climbing was a pastime sensibly shunned by all other members of the enormous family to which I belonged in the farming community of Hastings on New Zealand's North Island. I was not merely the seventh of eight children, I was the seventh child of a seventh child. My dad was a fruit grower, and times were tough following the War, but both my parents were always cheerful and positive, and encouraged us to be the same.

I was eighteen when I bought my first camera, a Kodak, but I'd already been interested in photography for some time. Playing truant in the Fifth Form, I'd set out for school on my bicycle but never get there. Instead I'd call in on an old friend

The 1951 New Zealand Garhwal Expedition – Ed Hillary, Ed Cotter, myself and Earle Riddiford – as we left home. Earle didn't agree with our having an ice-axe in this press photograph, so looked unusually sullen.

who had gone into film processing. He'd left school to work for the aviator Piet van Asch, who was shooting large-format aerial photography across New Zealand. It was pioneering work and I was engrossed by what they were doing. I managed to join van Asch on a few of his flights and photographed the mountains from above. Gazing down on the summits, playing truant in an airplane, that's some feat I thought! Other days, I just sat silently in their studio above the Post Office and watched, for whole days sometimes, and at night all I could think of was photography. So much so, I failed that year at school and had to repeat.

But, if anyone had told me I would be photographing and shooting a film near the very peak of Everest in just a few years time, and wagered a thousand pounds on it into the bargain, I would certainly have accepted the bet. I was still learning

photography and still afraid of heights! All the same, the popular concept of 'fearlessness' is often misplaced. Without fear you will not, I believe, go very high on a mountain. The more you fear something, the bigger it appears. Naturally, the fear must be handled, mastered, controlled – the 'self', if you like, conquered. But the harebrained 'fearless' are always unreliable and generally unsuccessful.

In my journal around this time I find a little quote: 'Death is a gift – without it we wouldn't value life'. I still think that a certain amount of threat to life and limb is necessary to complete our range of experiences. During our first big climb together, Ed Hillary told me: 'I don't think a climb is really worthwhile unless you have been scared out of your wits at least twice'. And it was with this thought ringing in my ears that we turned our attentions to the Himalaya in June 1951.

Our party consisted of Earle Riddiford, Edmund Cotter, Hillary, and me, and we needed about £1,300 for the four months' expedition. We were known as the New Zealand Garhwal Expedition. My entire savings at this time totalled £150, but Hillary was putting £400 into the kitty, and with help from the New Zealand Alpine Club and the Canterbury Mountaineering Club, and by borrowing an extra £100 or so, I calculated it would be possible to scrape along until September. I will not go into the daily detail of these climbs, which, although they exceeded our wildest hopes, were mainly significant for the – to us – dynamic outcome.

We began with small ambitions, setting out to explore one of the 20,000-ft peaks of the Indian-Tibetan border. We had been told that if we succeeded with a single mountain of this height the expedition could be counted satisfactory. By the end of August, however, we were a quartet of highly elated climbers, having achieved, with the portering aid of four Sherpa, not merely the summit of Mukut Parbat (23,760 ft) but also five other mountains exceeding 20,000 ft. Mukut Parbat was then, I believe, the fifteenth highest mountain to have been climbed, though I didn't learn that fact until some years later, when a German characteristically produced a volume listing all the mountains ever negotiated.

On the way out of the Himalaya we returned to the village of Ranikhet, an old hill station. We were a happy group, ready to sail home and sink ourselves into the comparative modesty of New Zealand's mountains. At Ranikhet's small hotel we collected our mail, a sizeable batch of letters to be scanned before a good dinner. And in this parcel of correspondence was a flimsy envelope, formally addressed to the New Zealand Garhwal Expedition. It was a telegram – from the celebrated British mountaineer Eric Shipton – which turned four amiable New Zealanders, relaxing in the hill station lounge, into four tense tigers, caged, self-seeking, eyeing each other with jealousy.

Shipton, with a group of British climbers, was then about to explore the south side of Everest. He was aware that our New Zealand party had met with success in the Himalaya and his telegram said, in more or less these words: *Invite any two of you to join my party if you can get own permission enter Nepal, bringing own food and supplies.* Any two of us. Wonderful. The chance of a lifetime. Shipton stood high indeed in our estimation. It was like getting a telegram from mountaineering's Angel Gabriel.

Any two of us, but which two? Shipton would have gasped if he could have observed the immediate effect of his offer. Into a quiet sitting-room of a mountain hotel he had thrown a hand grenade – not killing anybody but blasting our emotions, churning us collectively and individually, and transforming us

above all into a set of stony egotists. We sat up for hours, long past midnight, arguing and battling for position. Up to this point we had worked and climbed – as New Zealanders often do – without an acknowledged leader, a good co-operative team. Earle Riddiford, however, had done a lot of the initial planning, at which he was most efficient, and it was Earle who read the contents of Shipton's telegram. We were all shaken by Earle's first words. 'Well, *I* shall be going,' he said coolly, 'and I will decide by the morning who will go with me.'

I burned in silence as he spoke. Ed Cotter would dearly loved to have gone, but he soon retired from the controversy with more or less grace, knowing anyway that he did not possess the essential cash to spend several additional weeks in the Himalaya. For that matter I was also broke, but without knowing or caring where the money might come from I was violently possessed by the conviction that I had a moral 'right' to be considered on grounds of fitness alone.

Hillary was a natural choice for two reasons – he could afford the extended trip, and he was now powerfully fit. Earle could certainly afford it, though he was probably in lesser physical condition than I was, or at any rate I thought so. The battle continued. Two, three, four o'clock in the morning came and went. Eventually we retired to bed, but no one slept a wink.

In the end it was settled that Riddiford and Hillary should take advantage of the opportunity. Ed Cotter and I were racked with envy, flatness and disappointment. We watched the two set off on their journey to the border, where they would pick up their supplies. When they were out of sight we returned to our rooms, dejected, packed our bags and rucksacks, and went to board the train for Bombay. From there we sailed home to New Zealand, still a joyless couple.

Thanks to Ed Hillary, my own opportunity came one year later, in 1952. On his recommendation I was invited to join the British expedition under Shipton to climb Cho Oyu (26,850 ft), sixth highest in the world and the formidable next-door neighbour of Everest. There were ten of us on Cho Oyu, and the venture was a tough rehearsal for the Everest expedition of the following year.

Throughout my long friendship with Ed – and I count myself as his longest friend – he was always competitive. On that expedition we explored some 60 miles around Everest and then began the long journey, on foot, having run out of food in getting through Nepal, back down to India. Ed always had a great passion for bananas, and on the journey down the rivers to the Indian border, we bargained with the local people to buy some. With almost no other food, we began to compete to see how many we could eat. I gave up at around 120 in one day and Ed forced himself on to consume 134. On reaching the Indian border the price of bananas increased considerably and Ed asked the Anglo-Indian guard on the train, 'What's a fair price for bananas?' The guard put his hand in his pocket and pulled out his book of railway timetables. He replied: 'The cost of a train fare to Benares …'. We both collapsed in laughter.

Of the ten men on Shipton's Cho Oyu expedition, five were eventually selected for the 1953 assault on Everest. Of the five, two were New Zealanders: Hillary and – I thanked my lucky stars – me. We had done enough to prove our worth on snow and rock. Yet, as an amateur photographer of average enthusiasm, I was not then expecting to assume the role of an Everest cameraman.

RIGHT On 2 June 1951 we set out on the ten-day walk through the foot-hills to Badrinath. We traversed a series of deep, forested valleys and high mountain passes. From here the Himalayan peaks of Nilkantha, Kamet, Nanda Devi and many others are seen in their true perspective, and they looked colossal.

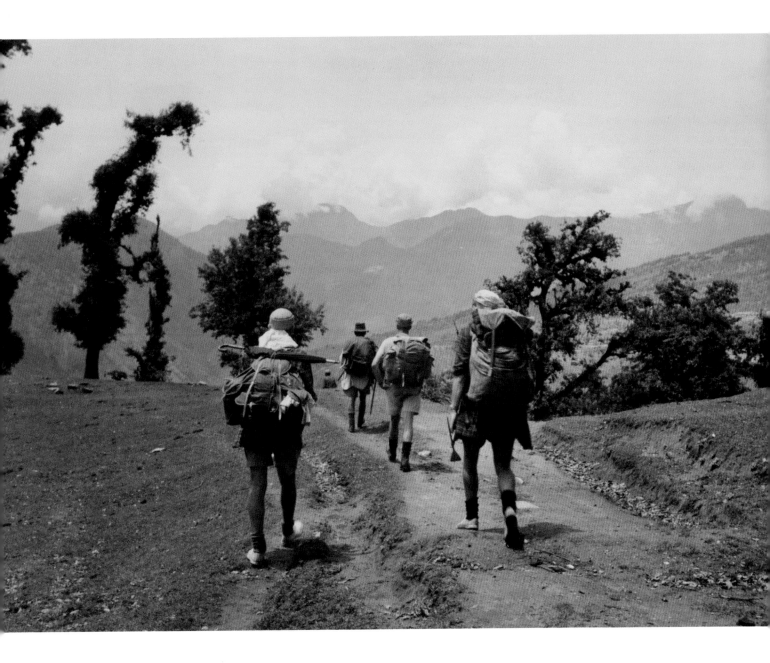

PORTFOLIO

BECAUSE IT IS THERE

ABOVE Ed Hillary and me at the Malte Brun Hut, near the upper Tasman Glacier, New Zealand, in January 1951, from where we made many climbs together.

RIGHT Elie de Beaumont (10,200 ft) is a very difficult climb from this side, and our objective was the striking Maximilian Ridge. Just to reach the foot of this climb took many days of exploring three high passes, carrying heavy loads.

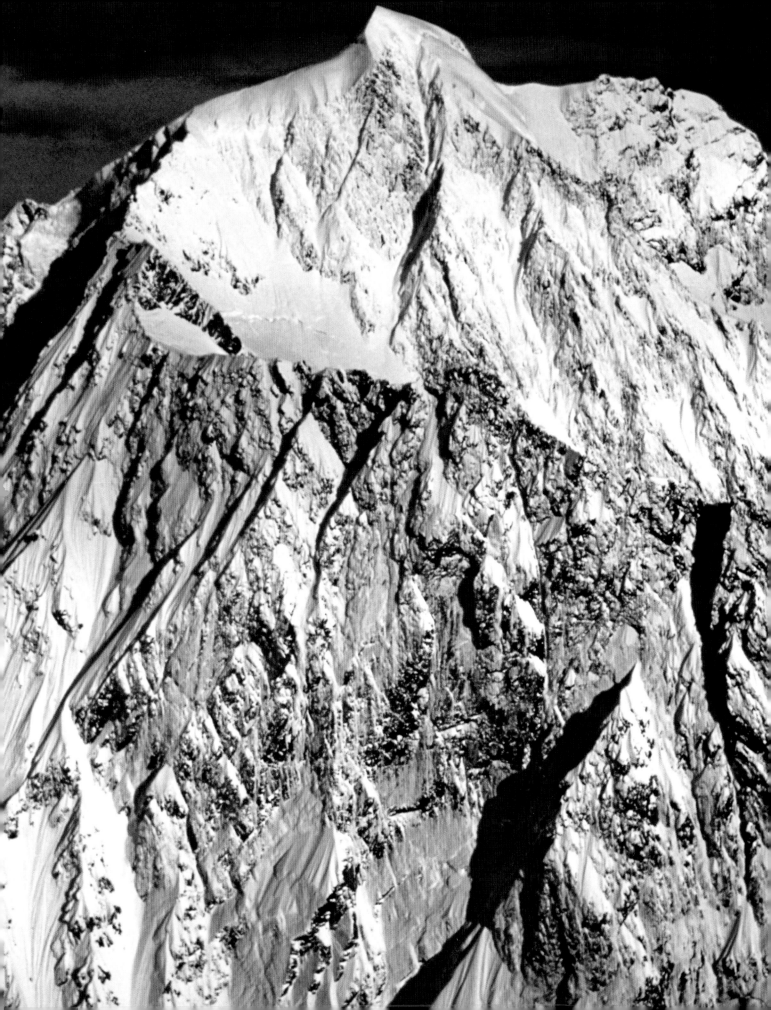

LEFT We began our ascent of Elie de Beaumont in typical New Zealand fashion – through days of sunshine and heavy rain, with mixed scrambling on rock, then snow and steep ice, humping heavy loads up remote valleys and across wide glaciers.

RIGHT Ed Cotter begins his climb up the ridge, as our companions Earle Riddiford and Ed Hillary wait patiently below as I frame up my shot.

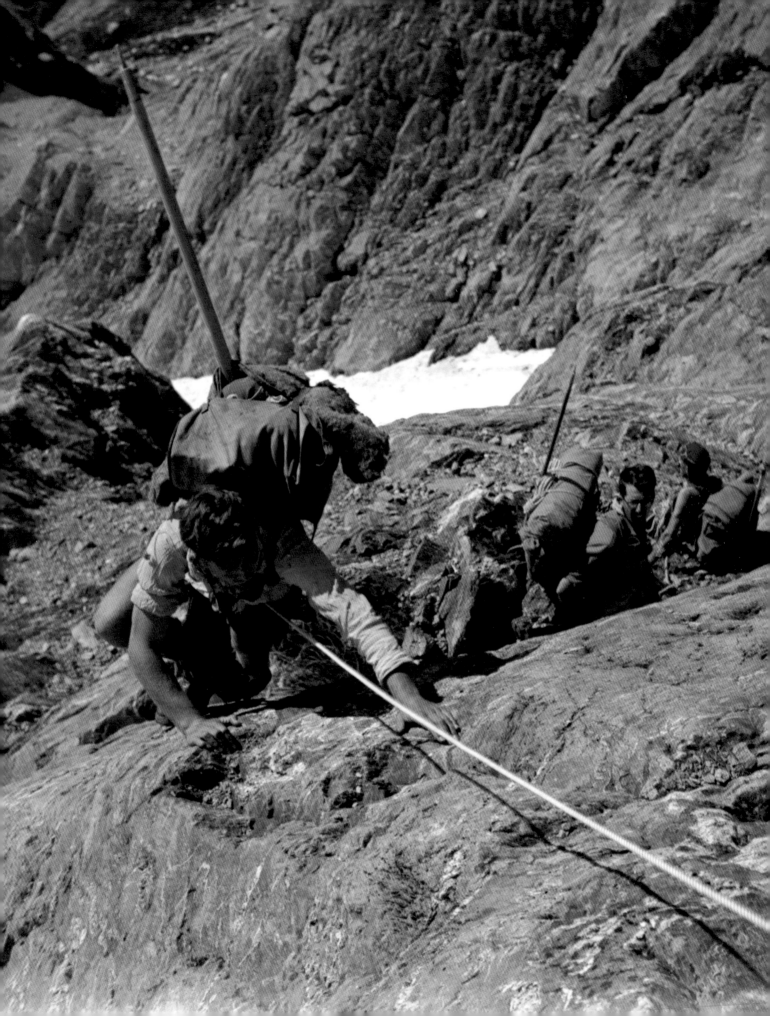

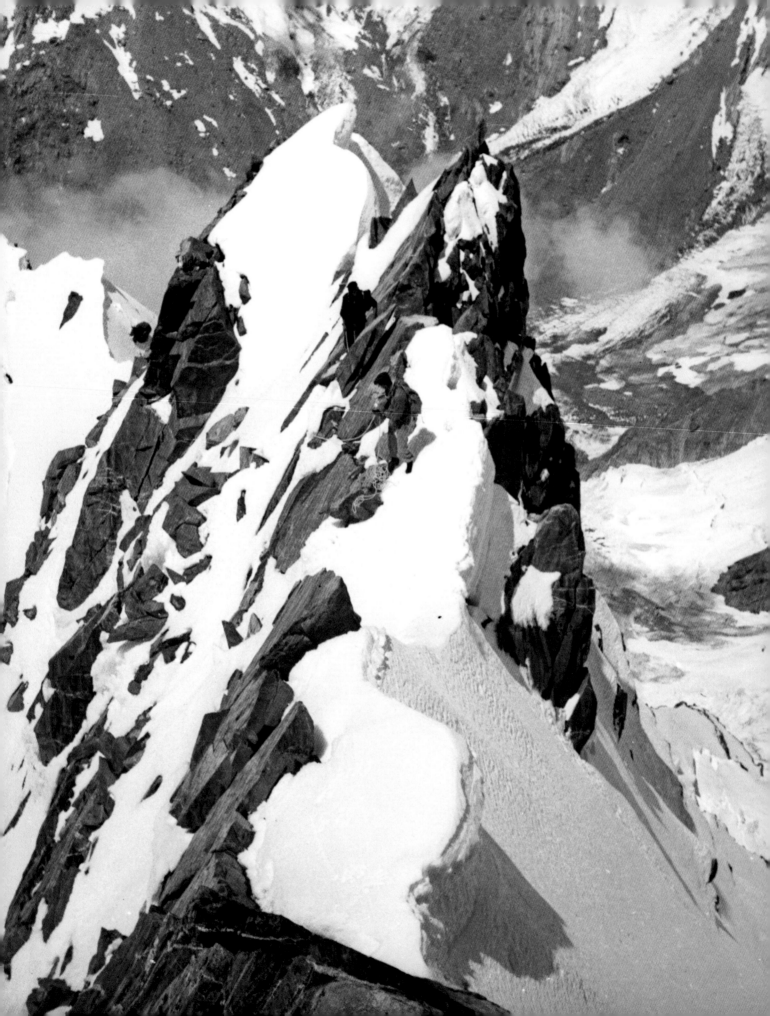

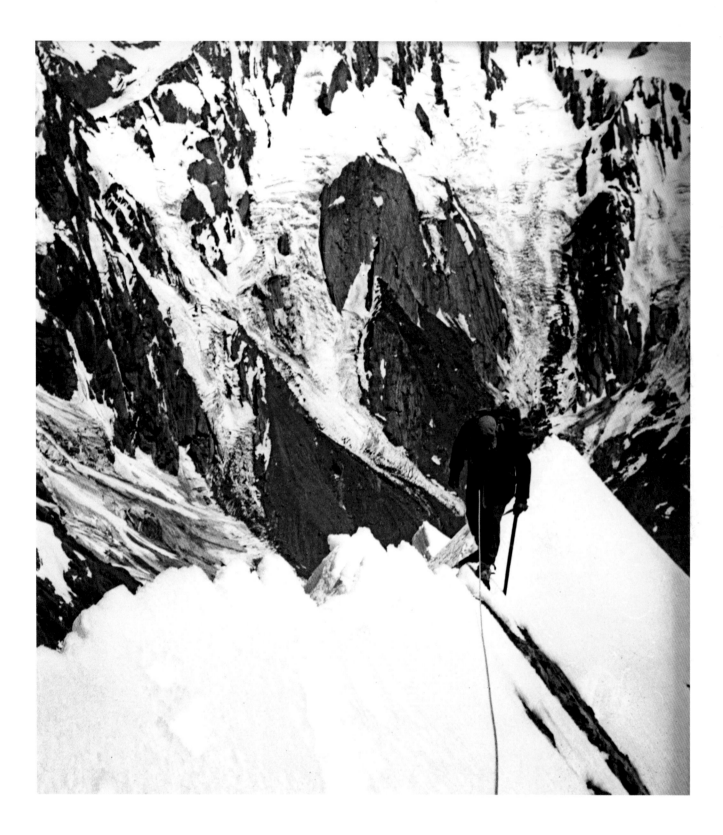

LEFT AND ABOVE On the first ascent of the Maximilian
Ridge of Elie de Beaumont in January 1951: in the
left photograph, Riddiford is in front, gathering in
the rope as Cotter climbs up to meet him; above, Ed
Hillary moves up the summit ridge to me, as I bring in
the rope on a belay round my axe, just out of shot.

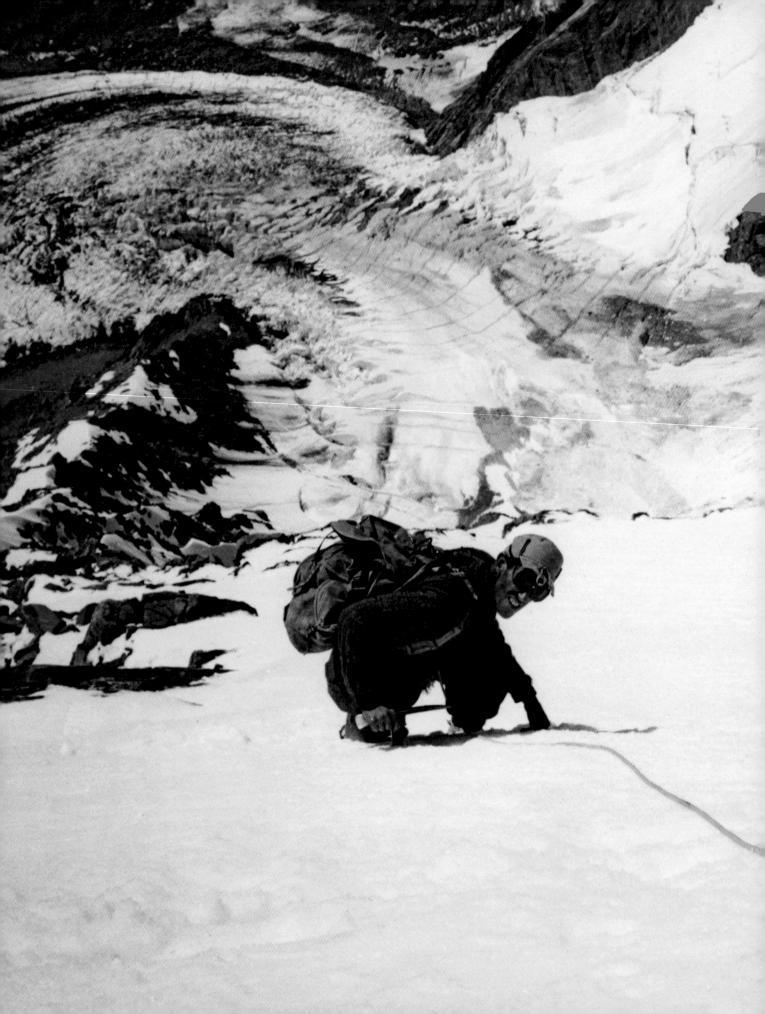

LEFT On our first ascent and traverse of
Elie de Beaumont, Ed Hillary works his
way up a steep snow-face, approaching
the summit ridge, with the Whymper
Glacier a great distance below.

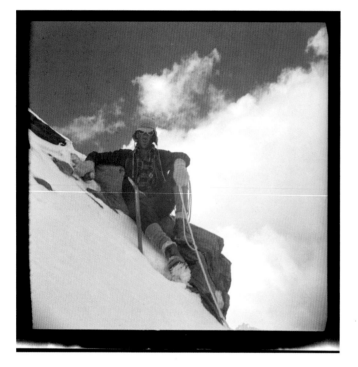

ABOVE Ed Hillary takes a breather, just
below the summit of a 22,180-ft peak
in the Garhwal Himalaya in June 1951.
We were in a virgin valley; there were
about twelve great peaks and only one
named – the 23,760-ft Mukut Parbat
– some of rock, some pure ice, and all
then unclimbed.

RIGHT Ed moves up the ridge above our
Camp II, below Mukut Parbat's towering
cliffs in July 1951.

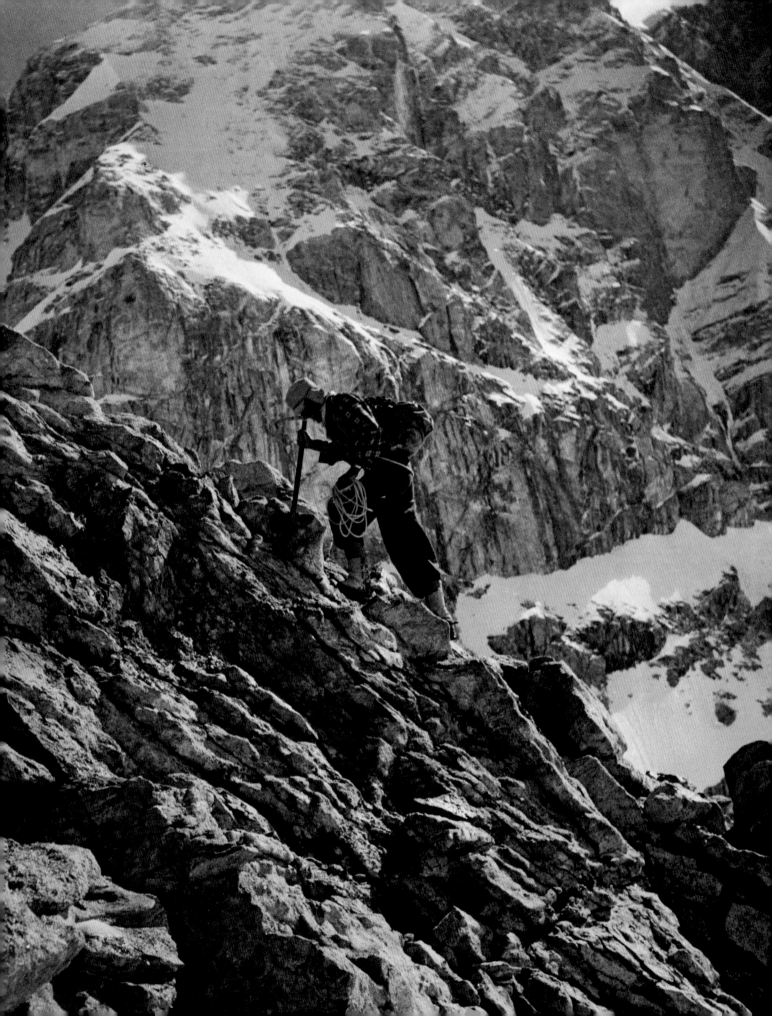

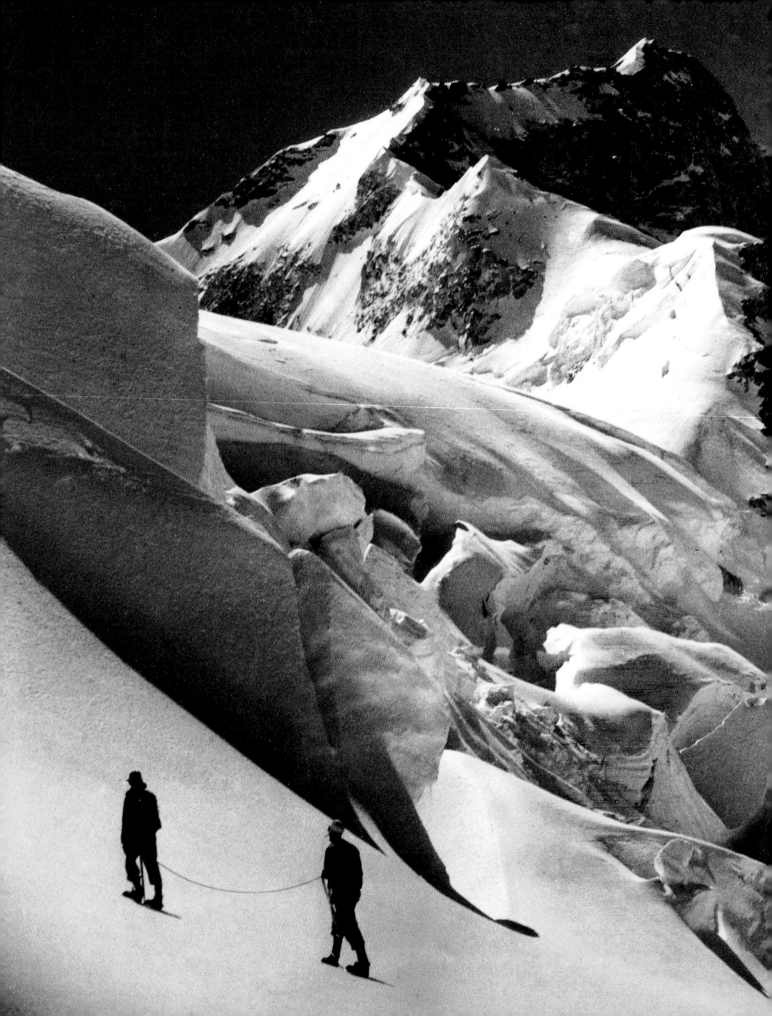

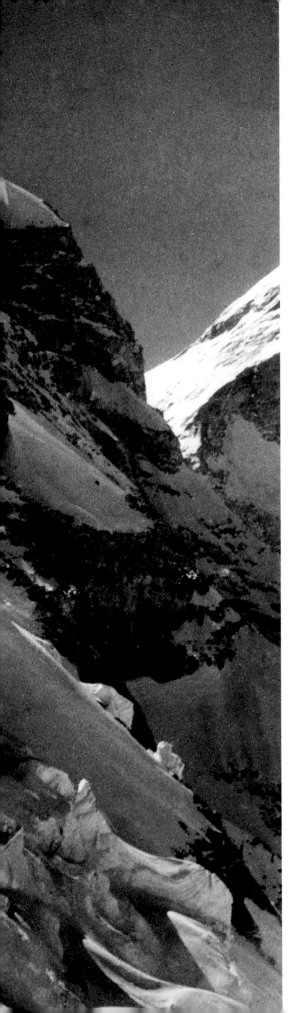

LEFT Riddiford and Cotter are coming out
from the icefall between Camps II and III.
Above them is our major goal, the summit
of Mukut Parbat with its dramatic snow-clad
west ridge. We placed our Camp III on the
small snow terrace directly above them.

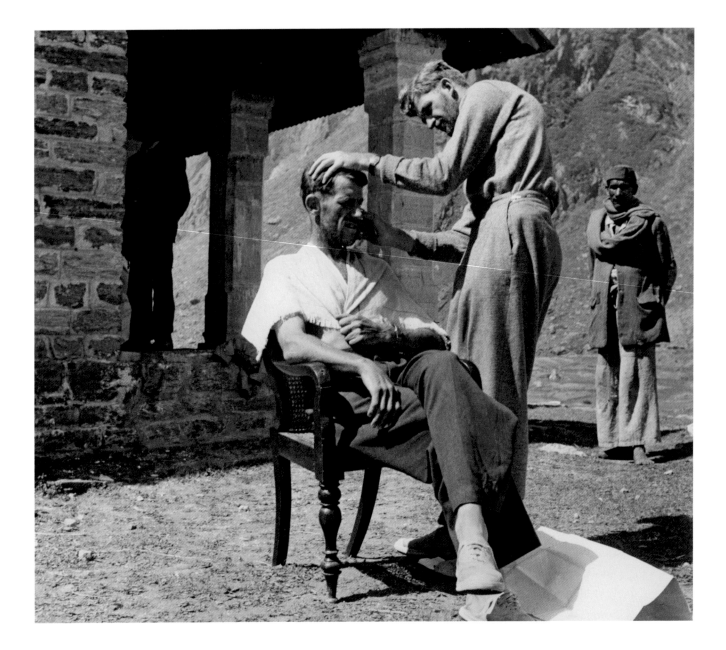

ABOVE At Mana, a village just below the Tibetan border, I give Ed
a well-needed haircut after our first great Himalayan adventure in
1951. It had been a very successful trip, with seven new peaks
climbed, and on our return to Ranikhet we received a cablegram
inviting two of our party to join Eric Shipton's reconnaissance
expedition to the Nepalese side of Everest.

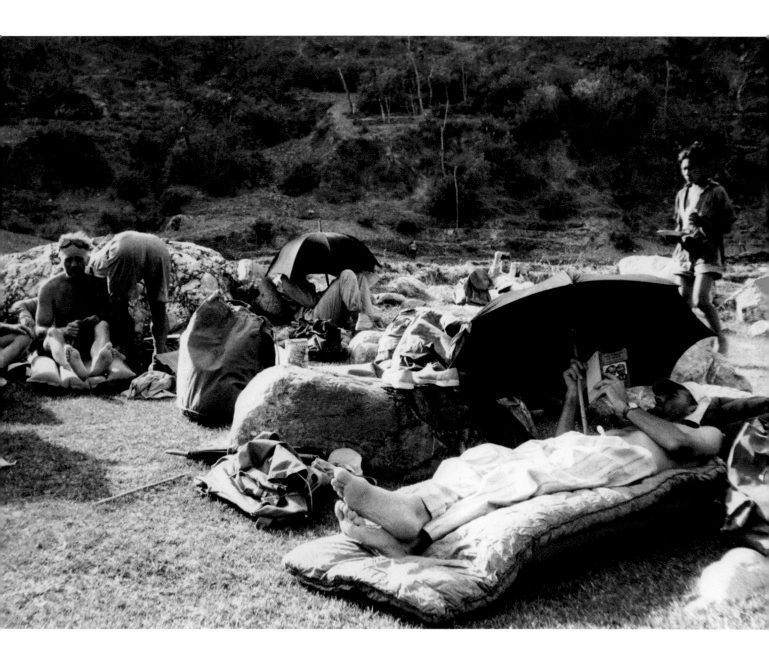

ABOVE Lazing in his pyjamas, Ed enjoys a
Sherlock Holmes adventure in the shade
of his umbrella during our approach march
for the 1952 expedition. On the left, Eric
Shipton looks on.

LEFT It was hot work for the 1951 Everest reconnaissance team. Shipton, Michael Ward and Bill Murray seek refuge from the sun, wallowing under their umbrellas in the cool waters of the Arun River on their approach march.

FOLLOWING, LEFT AND RIGHT The 1951 reconnaissance was stopped by a giant crevasse just below the Western Cwm. Shipton, Ward and Sherpa Pasang are in the first picture, with Shipton just out of shot in the next. The slope above them avalanched the first time they almost reached the top of the Icefall. Bill Murray considered the crevasse the largest he'd ever seen – at one point it was up to 300 ft wide, splitting the glacier almost in two. The team withdrew to fight another day.

PAGE 62/63 Thanks to Ed Hillary, my next opportunity in the Himalaya came one year later, in 1952, when I was invited by Shipton to join the British expedition to climb Cho Oyu, the formidable next-door neighbour to Everest and the sixth highest peak in the world.

We had found a possible way up from the north-west side of Cho Oyu, but with a severely stretched supply chain Ed and I only reached 22,500 ft before we were turned back by dangerous ice-cliffs. Shipton suggested that we might like to have a go at crossing for the first time a pass to the east of Cho Oyu called the Nup La. We agreed without hesitation.

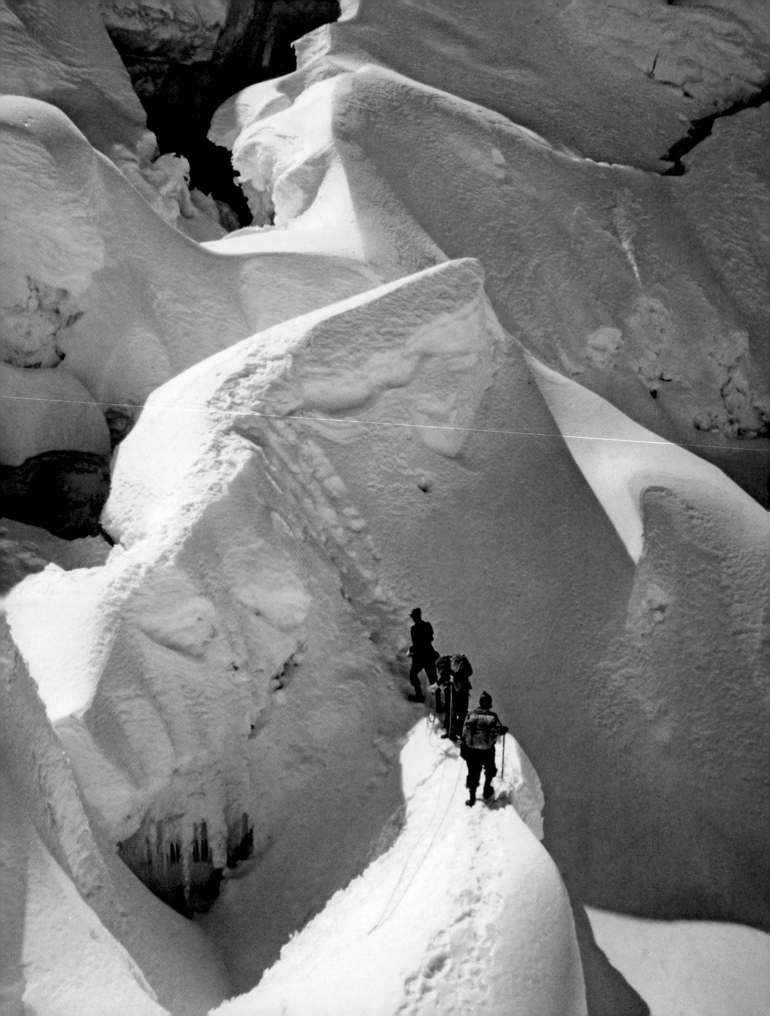

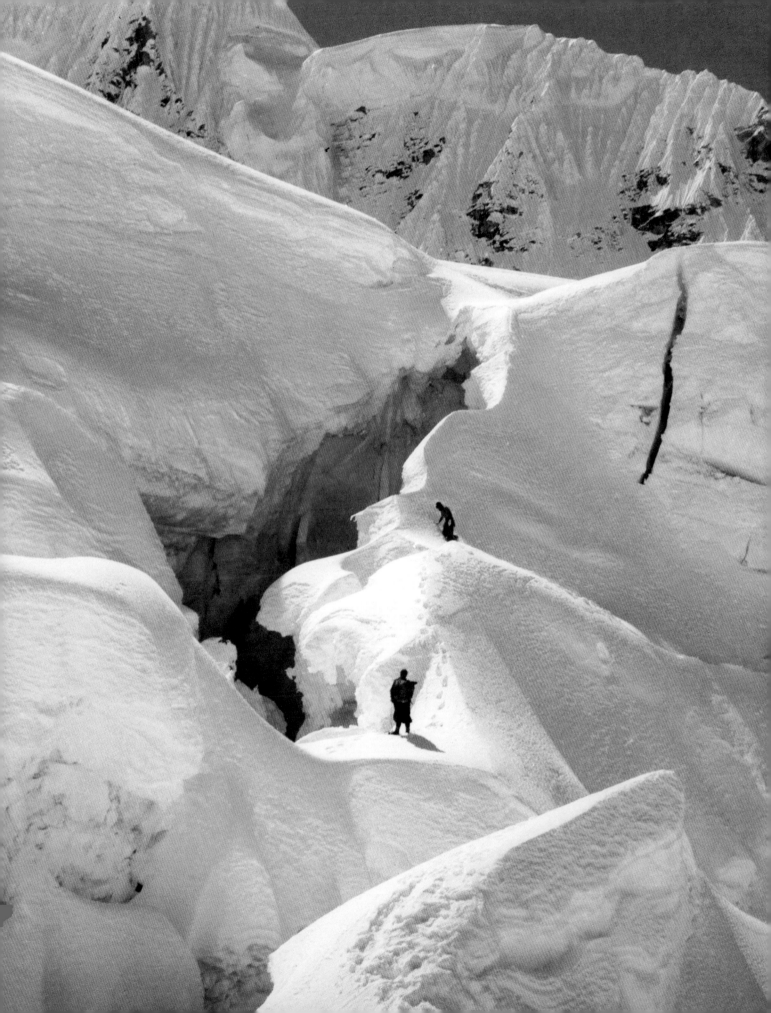

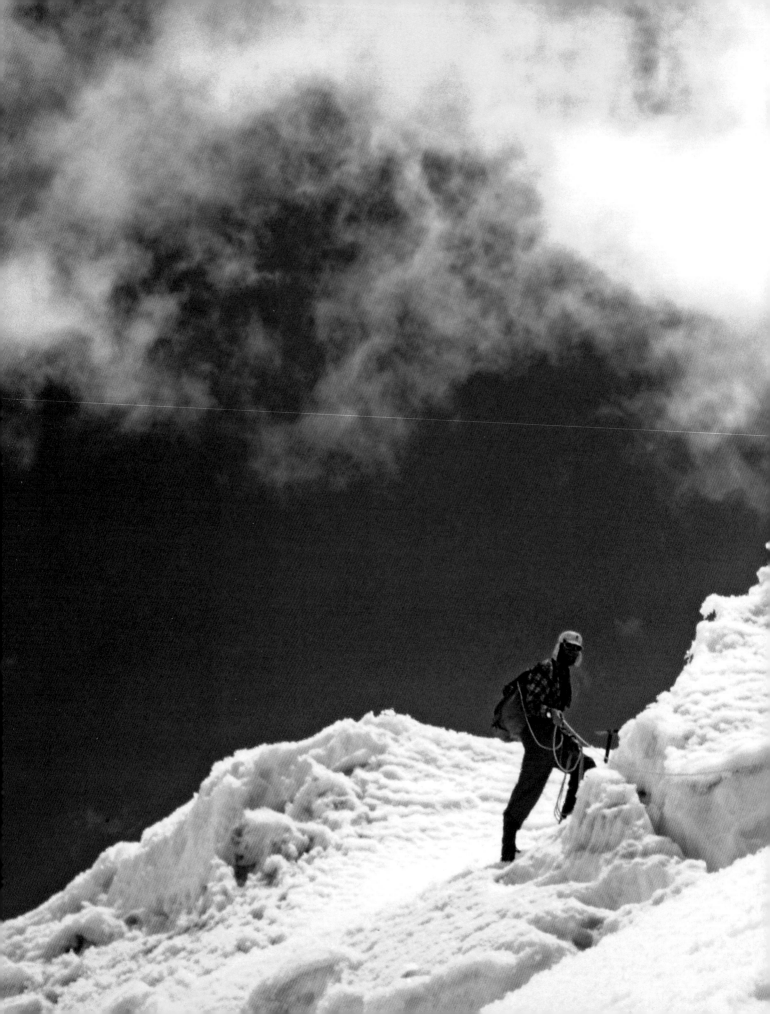

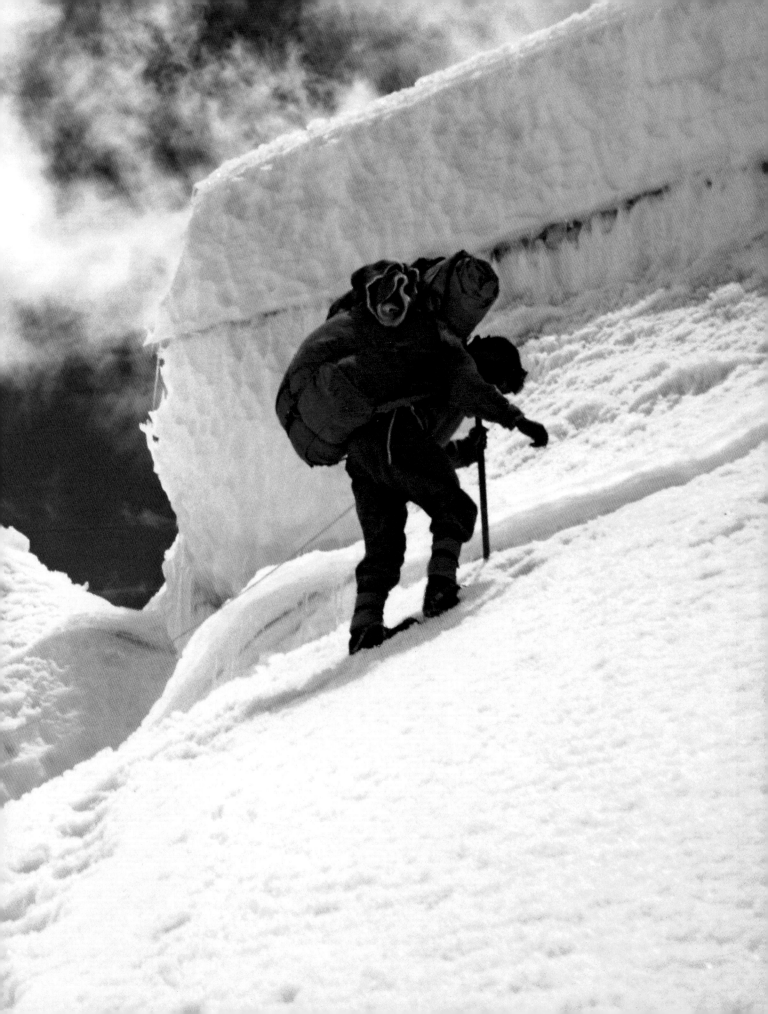

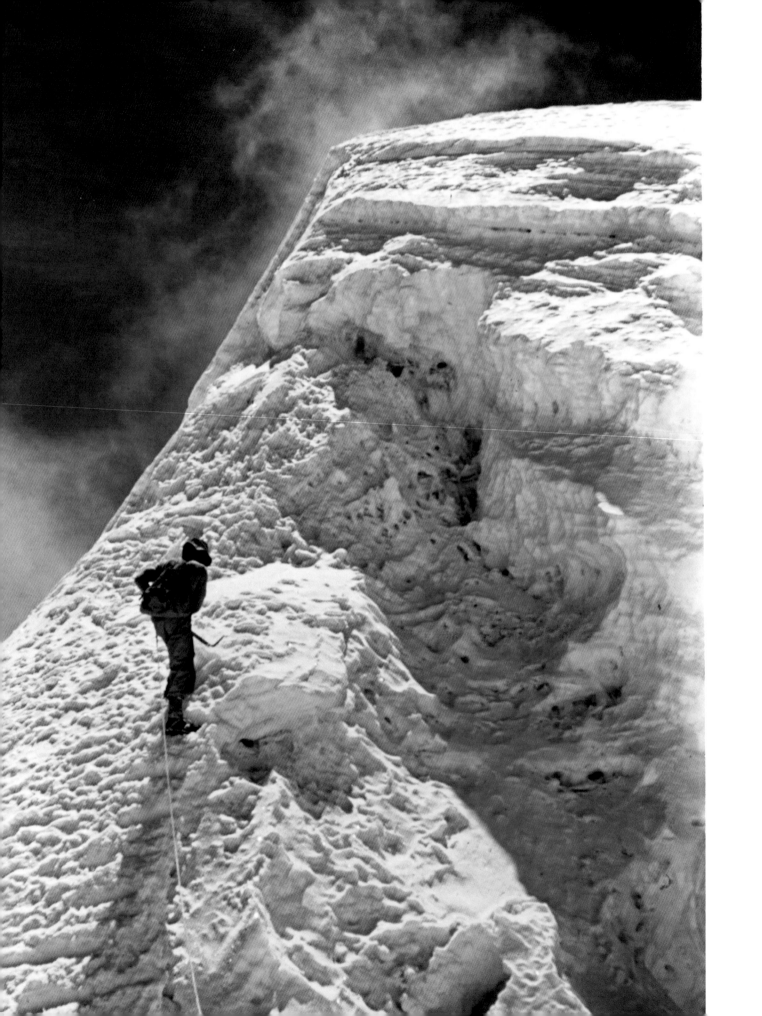

LEFT The icefalls of the Nup La were simply immense. It took us six days to cover just 4 miles. The experience remained, in our estimation, the most exciting, exacting and satisfying mountaineering that we had undertaken.

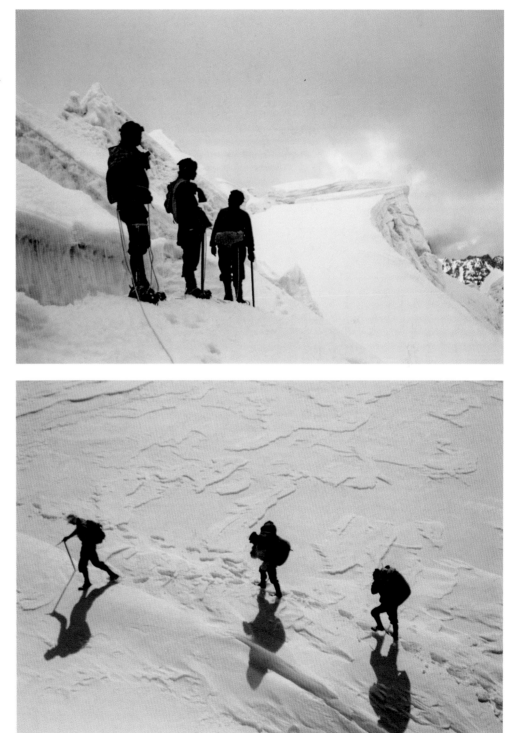

ABOVE RIGHT In June 1952 we crossed the Himalayan divide from Nepal down on to the glaciers of Tibet to explore secretly the north side of Everest. Our three Sherpa porters, Ang Puta, Tashi Puta and Angye, pause near the top of the Nup La. It was a thrilling moment for us all.

RIGHT Next we had to cross a labyrinth of invisible crevasses with our heavy loads. Ed fell down one until the rope held him 12 ft down. He had to climb and cut his way out to safety.

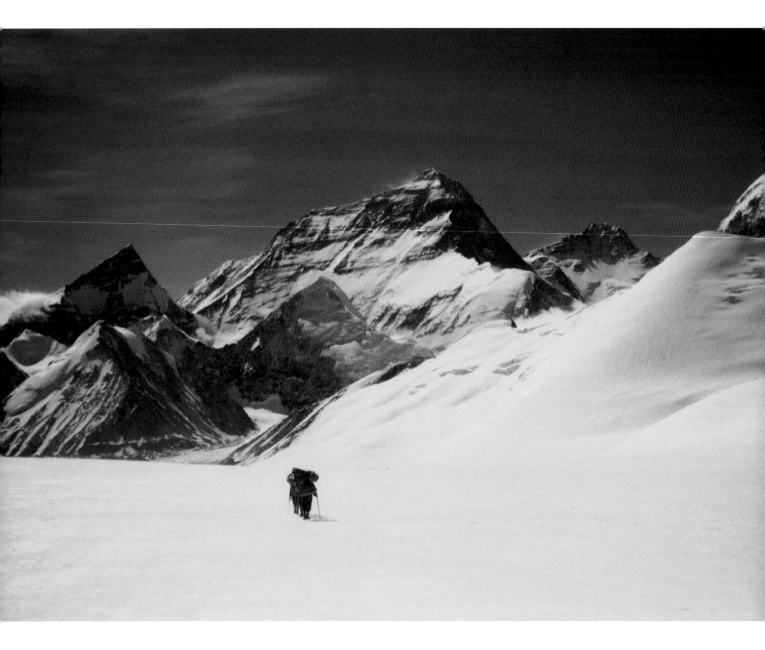

ABOVE On the Rongbuk Glacier: there was Everest, proud
and aloof against a wind-streaked sky, and the glacier was
a shining pathway sweeping up to the foot of the mountain.
We had managed to explore over halfway round its flank
ridges and came away with a unique set of colour slides,
of which this is one.

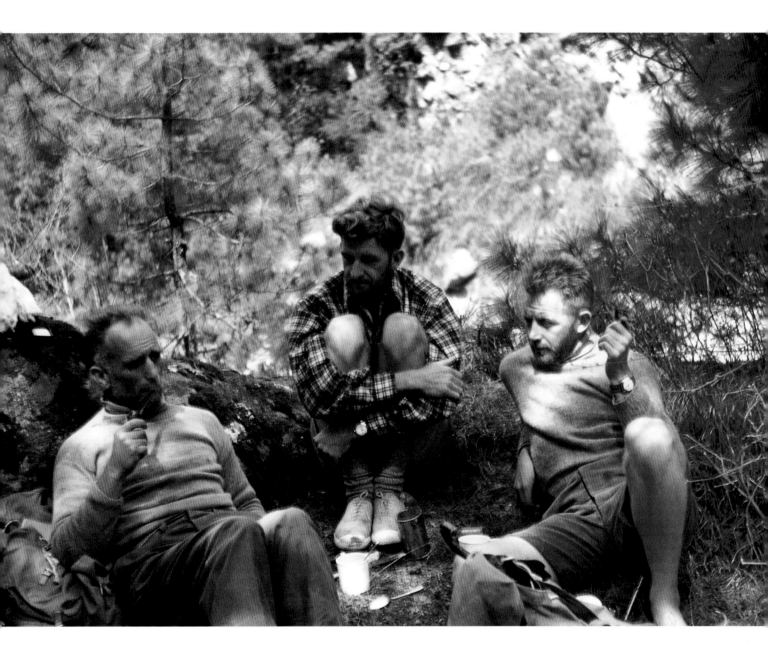

ABOVE Our next adventure was to get into the Barun Glacier – an unexplored ice stream between Everest and Makalu. Makalu (27,838 ft), the fifth highest mountain in the world, had never been approached, and reaching the head of the Barun and looking into Tibet from there would, for us, complete a circuit of Everest over its highest passes. Ed and I set off with Shipton (on the left) and Charles Evans (right, with me in the centre), with just what we stood up in, plus a sleeping-bag, lilo and down-jacket; I had a few exposures in my camera. In fact I had less than I would have had for a weekend tramp in New Zealand.

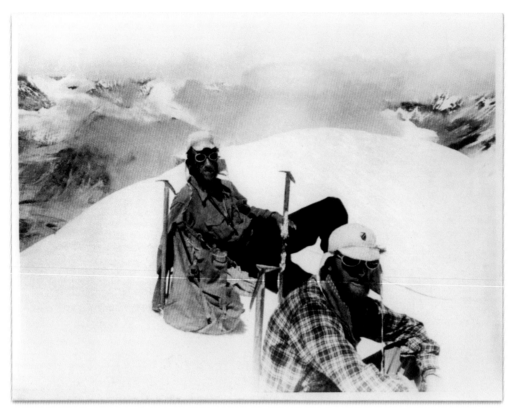

LEFT Ed Hillary and I rest on the summit of a 21,100-ft peak during our adventure with Shipton to the south of Everest in June 1952.

BELOW LEFT Earlier that month, Ed (seen here) and I stood on the Rongbuk Glacier, looking towards the north side of Everest. The sharp triangle of North Peak is on the left, Everest is in the centre, and peeping out on the right is Lhotse.

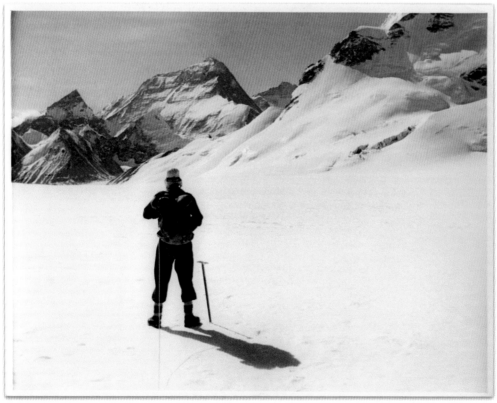

RIGHT Roped together, with Ed at the front and me behind, we look east from the summit of a 22,500-ft peak, our gaze raised to the lofty spire of Makalu, with clouds filling the Barun Valley below us. The following day we retreated, wading in knee-deep new snow, falling up to our shoulders in masked crevasses and generally having a bleak time. The monsoon was really on us and we got out and down to grass level and then hitched our belts, very seriously this time. We were going to try to follow the Barun Glacier and river to its junction with the Arun River, almost 20 miles away, through gorges galore and formidable jungle. But this sort of thing was bread and meat to Eric, who thought that this way of finishing a trip, by exploring to the very end, was the choicest delight.

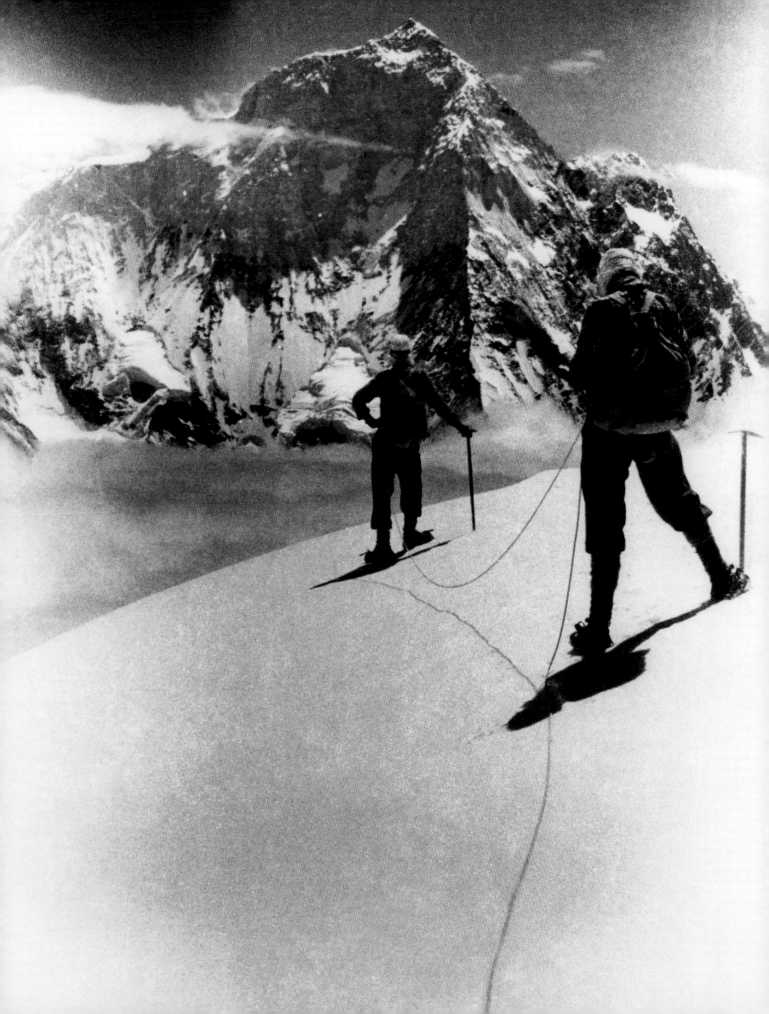

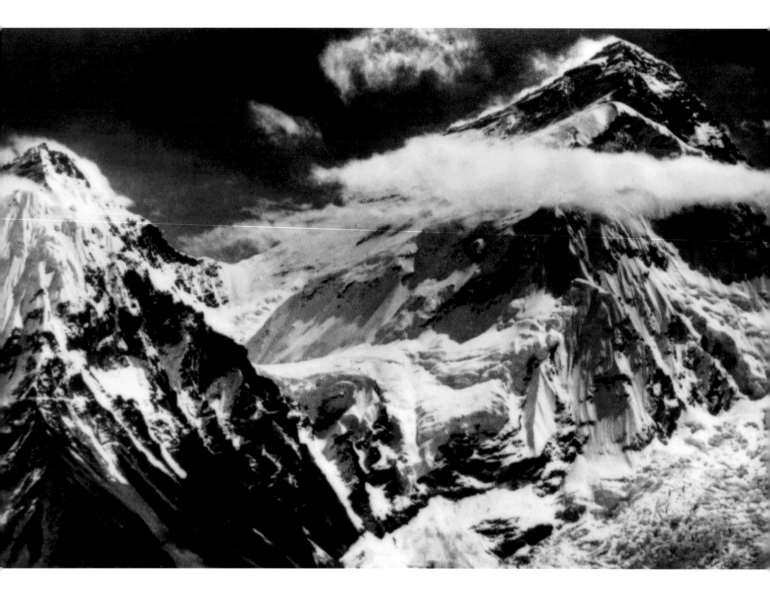

ABOVE On 30 September 1951 Shipton and Ed clambered up to 20,000 ft on a buttress of Pumori and were rewarded with this wonderful view. On the left, they could see across the Lho La to the North Peak and North Col in Tibet. The whole of the North-West Face of Everest was visible, and with their powerful binoculars they traced the routes taken by all previous attempts to climb the mountain.

The summit of Everest is proud in the centre, towering above the clouds and with the great Icefall at its feet. To the right is Lhotse, and straight across from where they stood Nuptse looked superb, a 'gigantic tumble of terraced ice'. Glimpsing far into the secret valley of the Western Cwm, they were able to scout a practicable route up to the South Col. You can see Ed standing on the far right of this shot.

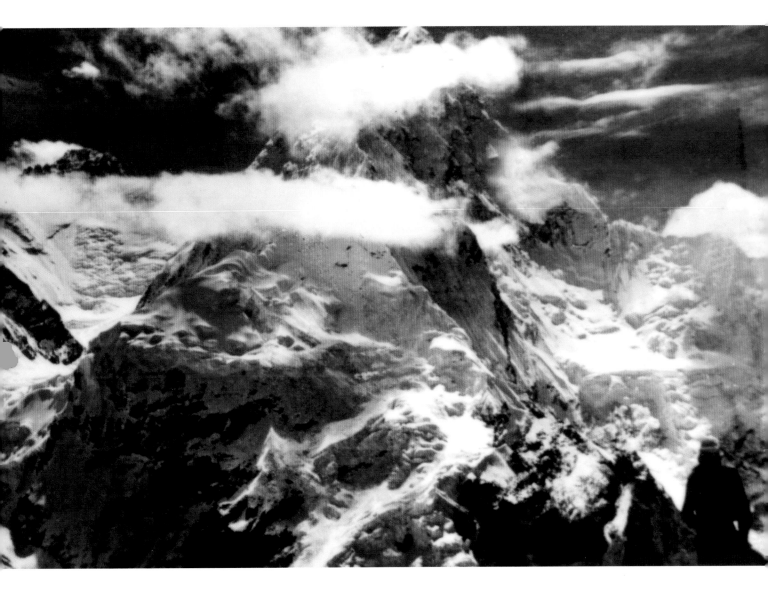

2 | CAMERAMAN ON EVEREST

*Still, I think the immense act has something about it human and excusable;
and when I endeavour to analyse the reason of this feeling I find it to lie, not
in the fact that the thing was big or bold or successful, but in the fact that the
thing was perfectly useless to everybody, including the person who did it.*

G. K. Chesterton, 1908

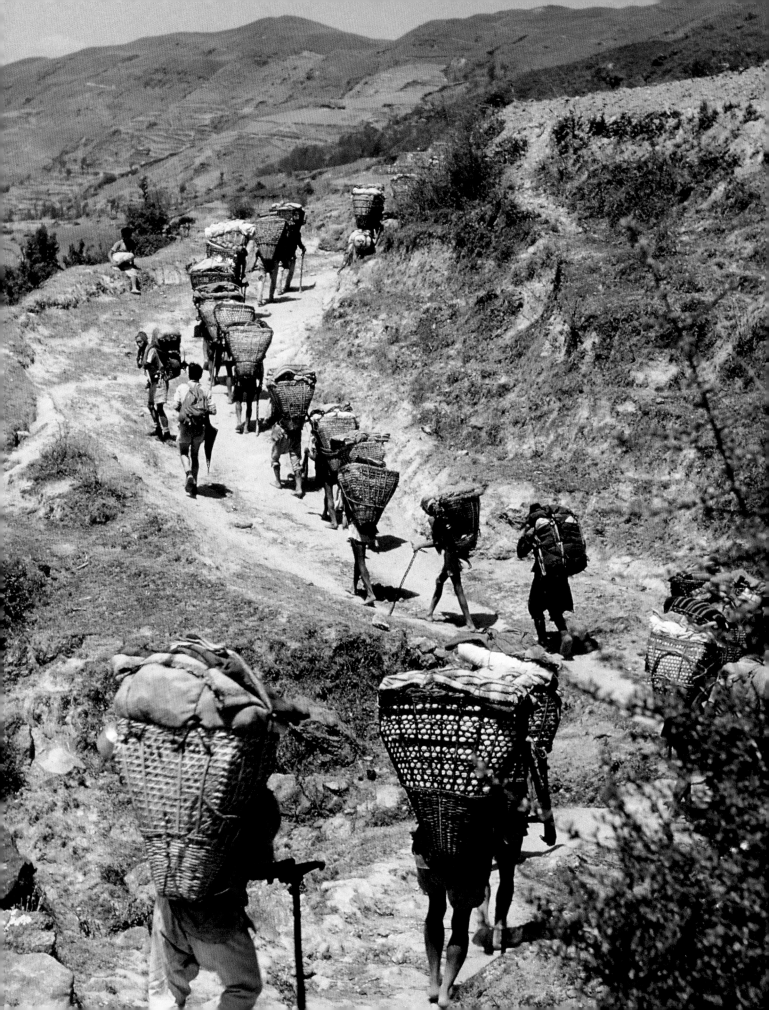

I made no secret of my amateur status as a photographer. During my climbs at home or abroad I enjoyed taking pictures, grew interested enough to do my own processing, and in terms of keenness and competence was content to remain in the 'good amateur' category, concentrating on black-and-white stills, without experience of or much enthusiasm for the more high-falutin' pleasures of the ciné camera. It was our successful 1953 Everest Expedition that created a minor myth about my prowess, and within two more years I was assigned as official photographer to the grand Commonwealth Trans-Antarctic Expedition led by Vivian Fuchs; in the space between the two explorations I seemed to have graduated through an almost accidental apprenticeship into a new profession.

A marked feature of all the big Himalayan ventures up to that time was that the filming invariably petered out and came to a halt before the real business of ascent took place. Almost every group succeeded in making a beautiful picture of the approach, with a variety of pleasant bits and pieces shot on the lower slopes of their mountain; but whenever the true pressure was on – and this applied especially to Everest – everything, including photography and photographers, was sacrificed to the prime task of climbing the mountain.

On Everest we were a party of thirteen men, not counting the army of Sherpa. Under the leadership of the inspiring John Hunt there were ten climbers, of whom I was one, and three people with specialized duties – a doctor, a physiologist and the ciné cameraman, Tom Stobart. Our job was to put two men safely on the summit of Everest for the first time in history, and to get them there under conditions where every ounce of weight, every breath of oxygen, every step and every movement of a limb was a human factor of perpetual importance.

Although I had encountered and climbed with some of the Everest party, there were several I was meeting for the first time, but I had heard so much about them that it was like seeing old friends. Charles Wylie and Michael Ward I took to immediately; the others were much quieter. Wilfrid Noyce was rather reserved, slow of speech and, I thought, probably prosaic and undemonstrative (how wrong I was to think him prosaic: he was a poet and anything but a commonplace, unromantic man). George Band was the baby of our party, though a large one – 6 ft 3 in topped by a panama hat, he looked like a dedicated missionary. He was still at Cambridge University and was accounted as the most outstanding of the younger British climbers. The person I knew least about and met last of all was John Hunt. He greeted me most warmly and said how much he was depending on *me* – his assault on personal susceptibilities was impossible to resist. I was taken aback, as I had heard that he was a crisp, machine-like martinet colonel, and when Ed Hillary and I leapt from our tent on the first morning and sloped ice-axes with military precision, our antics fell rather flat.

The seventeen-day march from Kathmandu across the Nepalese valleys to the wall of the Himalaya was full of the sort of sharp and delightful contrasts to be found in climbing mountains. It was springtime as we walked the 170 miles to Thyangboche Monastery at the foot of Everest, and almond trees and rhododendrons bloomed; in the clear mornings the peaks, incredibly high, stood out beyond.

On the third evening of our march three of us went for a short stroll to watch the clouds rolling over the distant range. Later, John Hunt and Michael Westmacott came by with small nets and began chasing butterflies. They were collecting, I think, for a museum. I was amused to watch them stalking up to a

LEFT Through our various journeys by air, sea, rail and, ultimately, on foot, we converged on Kathmandu, the capital city of the Kingdom of Nepal, in early March 1953. From Kathmandu, some 350 porters accompanied our party on a seventeen-day march into the Khumbu. In total, something like thirteen tons of equipment and supplies were transported to our Base Camp.

PREVIOUS During the 1953 expedition I put my exposed film into little canvas bags, which were sent by runner to Kathmandu for onward dispatch to *The Times*' offices in London. Our black-and-white film was processed there, while the colour films were developed by our suppliers Kodak and Ilford.

thorny shrub with their nets poised: it seemed incongruous that these hardy mountaineers should be such crackpot-looking butterfly-catchers, but before long I too had joined the hunt and was enjoying the fun. At sunset the clouds over the mountains rolled away and we all ran to see the peaks turn gold in the setting sun. We ate curried rice, tinned steak, boiled potatoes and peas in the big communal tent and then took our sleeping-bags outside and lay identifying the stars and planets.

At the end of March we reached Thyangboche Monastery, one of the most beautiful sights in all the Himalaya, where we set up camp in a grassy meadow allocated to us by the lamas. All around the sanctuary were mountains of the most fantastic shapes. At the head of the valley stood Everest, clear and almost black on one side, and streaming with a plume of snow and cloud on the other. It looked immensely high and formidable.

At Thyangboche we broke into three parties and set off to climb and explore, to get acclimatized to higher altitudes and to try test runs with the open-circuit oxygen sets. I went in John Hunt's party with Alf Gregory and Tenzing. I had travelled with 'Greg' in 1952. He was a tremendous climber and a good photo-grapher too. We quickly became friends. This time, he'd been put in charge of organizing all our still photography and we worked together on the mountain as we both went higher. We'd often take the same shots – it was our plan to make sure that if either of our cameras or film failed or were lost we'd have our bases covered. We joked that once reunited with our film in London we wouldn't really remember whose shots were whose. I was flat-tered by this as he really was at the top of his game. Of Tenzing, well, so much is now known. He had been to 28,000 ft with the Swiss attempt on the mountain in 1952, and from the beginning he was treated by John Hunt as one of the potential 'summiters'.

Our party went up the Imja Valley, where we explored a glacier and climbed a hidden peak of just under 20,000 ft. From a camp at 18,000 ft we all tried for the first time wearing and using the oxygen sets. A set weighed 35 lb and was comparatively complicated, and I was most interested to see if the advantage of having the oxygen would outweigh the disadvantage of the weight of the equipment. I had walked up to 18,000 ft for the first time and was feeling lethargic and had a headache. I did not want in the slightest to push on to 19,800 ft. However, with Tenzing, I fitted on the mask and checked the bottles and flow rates, connected up and switched on. We set off together, each adding 3 litres of oxygen every minute to our natural intake. Instead of puffing and panting I breathed deeply and evenly and stepped up without the feeling of fatigue that one has before becoming acclimatized. It was a great relief to know the outfit really worked.

With every breath I heard the economizer give a little gasp and send a puff of gas into the mask. The tiny valves in the mask flip-flopped with each breath and I felt wonderful. With the mask and tube and goggled eyes, Tenzing looked a rare speci-men of the scientific age, and I felt I did too.

Twenty-five minutes later and 500 ft higher there was a sudden explosion and roaring of air, and I nearly fell over with fright. Tenzing was clawing at his frame: his reducing valve had blown out. I closed the tap on his bottle and took off his set and we saw that we could not repair the valve. Tenzing went down, and I pushed on.

I soon forgot the incident and began to marvel at the boost that the set was giving me. Whether it was so or not, I don't know, but I had a feeling of power and rhythm with the oxygen flowing. There was a slight hiss from the bottle and the mask

RIGHT Members of the 1953 Everest expedition on the first day of our approach march. Back row, from left to right: Stobart, Pugh, Noyce, and Evans. Middle row: Band, Ward, Hillary, Bourdillon and Westmacott. Front row: Gregory, Lowe, Hunt, Tenzing and Wylie.

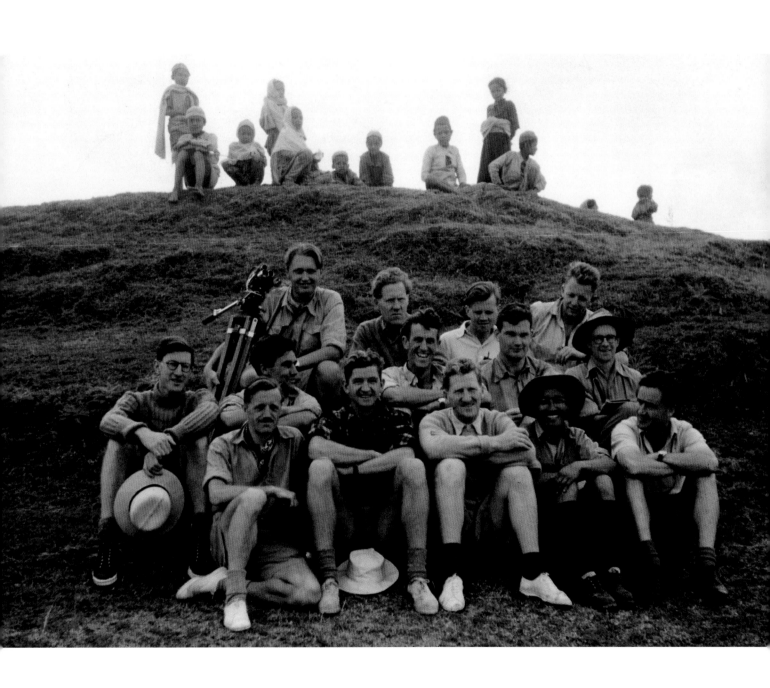

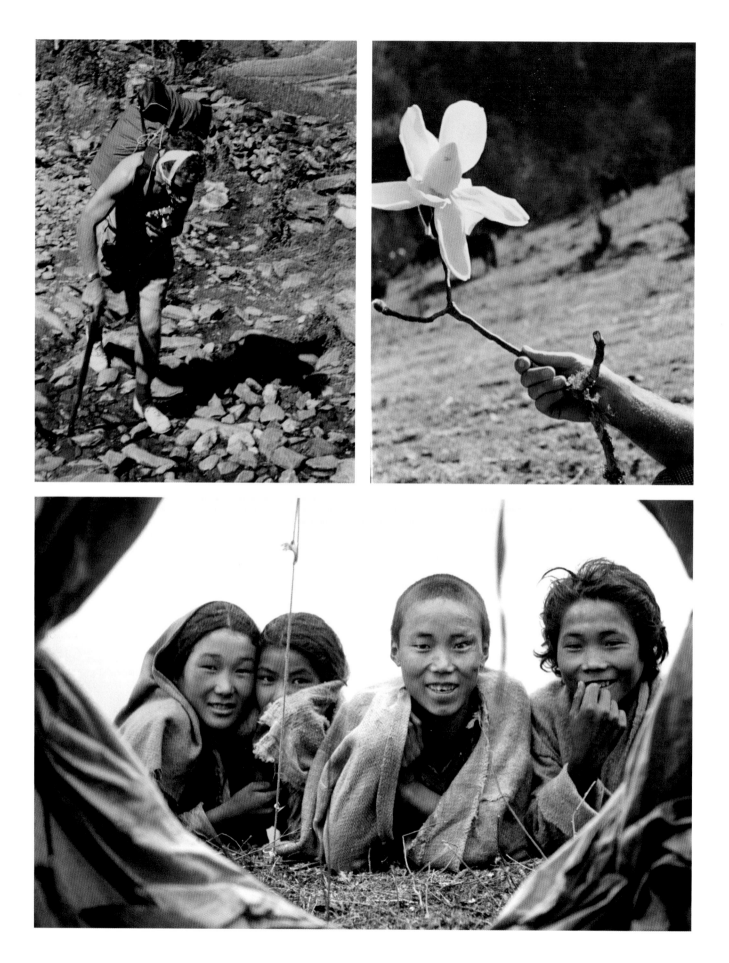

kept the cold from my face. Drops of moisture dribbled out of the mask outlet and froze soon after hitting the ground.

The top of the hill looked far away when I stopped to increase the flow rate to 6 litres per minute, and I was amazed to find myself on the rocky summit after just ten minutes. On 6 litres I felt like running and could climb at sea-level pace. I sat down for a minute to drink in the high flow rate and enjoy the view. The return, unaided to conserve oxygen, was not uncomfortable, although I noticed the weight of the set where before I had not. Hunt and Gregory, and lastly Tenzing, did the run with good apparatus. We all climbed to 18,000 ft in about an hour – Tenzing actually did it in fifty minutes, which for any altitude is rapid climbing.

Tenzing was very fit; he moved beautifully and was well used to high altitudes. He was unspoiled, although even then he had received considerable publicity because of his climbing. He was a good companion who fitted in with everyone. He had an infectious sense of humour and a desire to yodel and whoop when he was happy. He spoke a few words of English and taught me some Hindustani and a little Tibetan. There was in him a natural elegance and a gentle manner; he was not forthright, but a dreamer, and after Everest he was bewildered and often unhappy at the complications of fame. He has said, sadly, and I think honestly: 'I wish sometimes that I had never climbed Everest.'

❧

Unluckily for Tom Stobart he caught a mild dose of pneumonia, so it was soon made plain that any photographic achievements higher than 20,000 ft would have to be performed, if at all, by one or other of our mountaineers. At the beginning, Tom had hoped for porters to carry his equipment, which included five or six cameras and oxygen facilities for himself at higher altitudes; but it was a vain hope, for by the time he went into the Khumbu Icefall, the first big section of the climb, there was certainly no chance for an inessential mountaineer to be prancing around with cameras recording the activity of the rest of us. The Icefall, no place to dally, was a dangerous, difficult climb demanding all our skills and concentration. Already, then, at 20,000 ft, it began to look as if photography was out of the running despite the pictorial importance of the climbing. Tom was understandably dispirited.

Soon we were pushing still higher. The role of those lower down was to fix the route, putting in pegs and ropes, and ferrying up supplies, generally reducing the strain on those of us who were subjected to the greatest degree of tension on the mountain. Realizing he would miss these vital stages without help, Tom asked John Hunt if one or more of the climbers could also make an effort with the ciné cameras. I think he hoped that four climbers might each take one, but as things turned out I was the only one to show much interest. Several days earlier, in fact, I had been playing office boy to Tom's directorship, helping to reload his cameras, writing down picture data, studying his technique – and forever inquiring what he aimed for, what kind of exposures he used for this and that, how he proposed to make the picture whenever he fired a shot.

Then, when the time came to take over some of his equipment, I told him: 'Give me a few elementary instructions and I'll do my best to carry them out.' Stobart at once passed on two good unwritten laws in which he firmly believed. 'First, make sure you use a tripod', he said, 'for every possible picture occasion – otherwise your film will have so much "shake"

ABOVE LEFT Shorts and gym shoes were enough for the march, for it was sweltering at times. Here John Hunt is wearing oxygen apparatus, trying to get used to its cumbersome face mask.

ABOVE RIGHT The forests were rich with gnarled, scarlet-blossomed rhododendrons, and the paths were often covered with white magnolia flowers, heavily scented, fallen from the trees.

BELOW Sherpa children look into the open doorway of our tent, fascinated by our strange equipment and, no doubt, our even stranger appearance.

it will be quite hopeless for big screens. On the other hand,' he added, 'if there's any really exciting action in front of your eyes, don't worry about camera "shake", don't worry about exposures, don't worry a damn about anything … just point the camera and shoot. Provided the stuff is dramatic enough, audiences will accept any amount of technical fault.'

All the same, even with this advice, the prospects for successful filming were not particularly bright. Stobart had long ago discovered, in the photographic 'cold chamber' in London, that the movie camera just would not operate efficiently, or indeed at all, at extremely low temperatures. We agreed that a hope-for-the-best policy was the most encouragement we could give ourselves, and off I went with two cameras. One was my own Kodak Retina II, loaded with colour film (Kodachrome). The other was one of Tom's four small movie cameras, also loaded with colour – an ordinary auto-load Bell-Howell machine with a single lens, of the type used by millions of amateurs the world over at that time. I kept both cameras tied with cord slung around my neck, day and night.

The movie camera alone weighed 4 lb. Each magazine of film added 8 more ounces, and I was usually carrying ten magazines at a time. Our normal mountain load for each climber was 30–50 lb, though even on the South Col I found it possible, if wearisome, to handle 55 lb including the camera equipment. The weight problem grew worse as we climbed higher. My first groping efforts (it was the first time in my life I'd held a ciné camera) were carried out in the Icefall. By the time we were into the Western Cwm, and later still on the Lhotse Face where for ten days I was leading the spearhead of the climb, and yet again on the South Col towards the summit, I began to appreciate the exact physical significance of every extra ounce.

In fact there was no need for any fanciful photographic effort on my part. The climbing of Everest is its own spectacle, and I took simple shots, trying all the time to make my two-fold record of men in the act of climbing, and of the whole process of inching up the mountain, fixing ropes and establishing camps and supply depots. I did not have to wait long before temperature troubles arrived. The movie camera began running slower and slower until it threatened to stop altogether.

Then I discovered the secret of making it work even in the worst of our icy surroundings. One day, nearing the Lhotse Face, I was convinced the thing was running slow. I decided to take a chance. As every enthusiast knows, there is a small button on the side of the camera case which provides for the setting of the shutter – 16, 24, 32 and up to 64 frames per second. So that evening I set the shutter to run at 32 frames per second, and very soon I became fairly adept at judging the correct speed by the noise, the actual note, the camera made. Later in the expedition I was sometimes using 48 – all in order to ensure that the result would somehow come out at 24 frames.

Luckily for me, and for the Everest film, the gamble came off. Apart from these tricks I did nothing unorthodox except sleep with the camera equipment inside my vest each night to keep it warm. But screwing the button to a higher than normal setting was without a doubt the real advantage, for the cold air then slackened off the mechanism to – providentially – its more-or-less correct speed.

Even the day when this trick failed to work, the film effect was strikingly successful, and is one that hits me afresh whenever I see the Everest film. On the Lhotse Face I was fortunate enough to get some really distinctive shots of a Sherpa cutting steps in the ice. At this height the effect of the rarefied atmosphere is

to slow down all one's bodily actions. Every working act, every movement of leg and arm is slowed. You may *think* you are doing things at normal speed, but the belief is an illusion; it is also the symbol of gravest danger, for with mental and physical processes thus dimmed and the actor unaware of the fact, that is the moment of peril when a fatal slip is most likely.

The Sherpa was seen in the film cutting his steps with the fascinating, graceful, yet tense slow motion that is the characteristic feature of an action performed on Everest. The truth was that I shot the whole of his activity with my shutter set too fast, greatly exaggerating the reality. Back in London while we were being honoured all over town, I occasionally caught myself in a mood of shameless nonchalance when I was congratulated about the quality of this piece of the film. There was no denying, however, that I was proud of my shooting, both still and ciné, and of the percentage of film that was found usable. I felt myself to be a real photographer at last.

I have often been asked which of the two expeditions, Everest or Antarctica, I enjoyed the more. I find this a difficult question to answer simply as each was so different. Everest was shorter in time: for three months we concentrated every ounce of energy in forcing our way upwards to place two people on a single point; the Trans-Antarctic expedition lasted three years and required a dogged, plodding tenacity, in order that sixteen people might cross a flat, monotonous plain.

❦

The assault proper began in early April with four of us – Ed, me, George Band and at times Mike Westmacott – tackling the cataract of ice that debouched from the high hanging valley known as the Western Cwm. Working in relays from Base Camp, we established a series of camps with supply depots up the Khumbu Icefall and into the Cwm, then coming back down to recover and rest, while a party made a higher reconnaissance using the closed-circuit oxygen equipment – from which they recoiled with heat exhaustion because of over-heating of the soda-lime canisters. This led Charles Evans to remark: 'We know it's impossible to reach the South Col *without* oxygen; the purpose of this reconnaissance is to try to reach it *with* oxygen.'

Ed, with Tenzing, arranged an energetic test on open-circuit equipment to see if its use at lower altitudes gave them any real benefit. On 2 May they left Base Camp at the crack of dawn to climb to Camp IV, Advance Base. They came back the same afternoon in a great blizzard, tired but not exhausted, as they certainly would have been without oxygen; Ed swung off his set and proclaimed it was 'bloody marvellous'.

Their times were: 6.30 a.m., set out from Base Camp at 18,000 ft; 8.00 arrived at Camp II, 19,500 ft; 8.50 at Camp III, 20,500 ft; 10.50 at Camp IV, 21,000 ft. This was a terrific set of times as our normal programme was to go to Camp II the first day in three hours and rest; Camp III the second day in two and a half hours and rest; Camp IV the third day in three hours, often more, and then rest. This outstanding run singled out Ed and Tenzing as the fittest and most energetic pair, and one that obviously went well as a team. Tenzing's performance altogether fitted neatly into John Hunt's ideal – his hope that one of the summit pair would be a Sherpa, that one from the East and one from the West would top the mountain together.

As we went higher, John was refining his plans for the summit teams. By now I had realized it was unlikely I'd get a chance to have a crack at the summit with Ed, but I didn't feel

any jealousy. There was simply no time to feel anything other than excitement, and exhaustion, with all the things that needed to be done – and at this stage there was still so much of the mountain yet to climb.

After Camp V the immediate crux of the matter was the Lhotse Face, the wall of ice that leads its way up to the South Col. This rampart was at first judged too cheaply and just two or three days were allowed for the climbing and placing of our Camp VI, and little more for the 'easy' crawl up to the saddle. On paper it had looked simple. As it was, the Face was such a tough problem that to use any of the potential summit teams would risk exhausting them. And that's where I came in – an expendable quantity, with Mike Westmacott and George Band – to make a route up without oxygen, preparing the way for the assault parties.

But before we could get too carried away, the snow started to fall. Mike and George were both suffering with the altitude, so in the end I was left to lead the Face on my own. The Sherpa Ang Nyima came with me. The journey from Camp V was some of the steepest ice climbing I had ever experienced. It took us up ice walls and over ice bulges and by mid-afternoon to the foot of some very steep cliffs. Finally we came to a tiny ledge and pitched the tent and called it Camp VI. Three other Sherpa followed us up, dumped their loads there and went back down to Camp V.

We fixed ropes on long pitches at angles well in excess of 60 degrees. I tried to photograph and to capture some film, but often it was difficult enough just to struggle on. Moving slowly higher, bent double in toil and caked with ice, I cut steps most of the way up to 25,000 ft, without oxygen, with just Ang Nyima for company. It was heavy, soul-sapping effort. The snow

constantly obscured my route, drifting, biting, and frequently leaving me to wade back down to my tent for shelter and safety. This was the front end of the attempt on Everest and it felt like it.

After ten days or so I could do no more, and others came up to support me. I still feel that I failed in a way. I had not yet made it to the South Col and I had said I would. I think we had all underestimated how tough it would be. I was embarrassed when others said that they had admired my efforts. John Hunt was kind later to describe my performance as 'tremendous'. At that moment though, I felt hollow and weak, and I resolved to make amends higher up the mountain.

Out of this disappointment and delay John took bold action. He launched Wilf Noyce and Annullu with oxygen to strike for the South Col. They reached it on 21 May, as I descended, establishing Camp VIII. The way was finally open for the big lift of supplies and the long-awaited assault on the summit.

How events then played out, I was able to describe in one of a great bundle of letters that I sent home during the three months spent on Everest. I'm so glad these letters were saved for me, treasured by my family; they give a sense of our time on this mountain better than I could ever give now, after all these years.

…When the great lift reached the South Col on 22 May, John Hunt decided to launch the Assault Plan and accordingly the closed-circuit boys went into action. Tom Bourdillon and Charles Evans set off that afternoon with all their bedding tied around their closed-circuit apparatus, with spare soda-lime canisters and spanners poking out – in all some 50 lb. John Hunt went with them on open circuit as support and possible emergency. Two Sherpa also went (Da Namgyl and Balu, who had been specially chosen) to carry a tent and oxygen above the

RIGHT Our route to Everest's summit is shown in this Indian Air Force photograph. The three great peaks of the massif, Everest, Lhotse and Nuptse, together with their high connecting ridges, enclose a basin that Mallory named the Western Cwm. The assault was made up the Lhotse Face to the saddle of the South Col, where the route swings up to the left. Our staging camps ranged from Base at about 18,000 ft to a final tent, Camp IX, alone on the ridge at 27,900 ft.

South Col as a possible emergency ration and shelter in the case of a late descent by Tom and Charles. In the event of this tent and oxygen not being used it was to be added to by the second assault party (Ed and Tenzing), backed by Gregory and three special Sherpa, who would establish Ridge Camp – Camp IX.

It was at this stage that I came into the story. The original plan did not include me, but I was very keen to get to the South Col. Because of Ed and Tenzing's trip to the South Col with the first Sherpa lift and their consequent tiredness, they decided to wait a day longer than originally planned. Then it was discovered, mostly through my propaganda, that a little more food and oxygen would be advisable. Accordingly I was commissioned to escort five Sherpa to the South Col, along with Gregory and his three special Ridge Camp boys, to back up Ed and Tenzing. I spent all of 23 May frantically trying to fix a leak in the oxygen set I was to use. Finally, by cutting and binding one of the rubber feed pipes, I stopped the hiss. Tom, Charles and John climbed to Camp VII that day too.

On 24 May, Tom, Charles and John with their two Sherpa crept above Camp VII and worked slowly to the South Col. We watched them through glasses; they were slow, seven hours, and arrived late and very tired. We packed up and Greg and I with our Sherpa left for Camp V, where we spent the night. A cold night – our thermometer read –27°C at 5 a.m.

The following day Tom and Charles were timed to make an attempt on the South Peak – and summit if possible, using closed circuit. Due to the weather (wind) and their tired condition from the previous day they stayed on the South Col. Greg and I left for VI using oxygen (2 litres per minute). We made good time, and at VI I changed to 4 litres and we headed on up the difficult Lhotse Face for VII.

Above VII I began to falter. I started to worry and think I was failing – but it turned out to be a defect in my oxygen set which was cutting right out and the mask was stopping even the outside air getting in. The trip to VII, for me, was hell, and I collapsed on the snow there and took a couple of hours to recover. At VII I was able to trace the trouble and the set behaved beautifully the next day. Ed and Tenzing came right through to VII from IV that day and arrived fresh and fit.

Although Everest was blowing a cloud plume on these days, the weather was very settled and the weather report (from Indian radio) was: 'Warm temperatures, winds 15–20 knots and settled weather. Monsoon still only in the Andaman Sea.' Camp VII (24,000 ft approximately) was calm that night (Temp. –28°C).

26 May. We left VII at 8.45 a.m. and had wonderful conditions for our climb to South Col. I filmed much of the climb and felt really wonderful. The climb starts near the top of the Lhotse Face glacier and for perhaps a thousand feet is a steady crampon climb up crevassed slopes and then swings left to traverse above rock bands and goes diagonally and up the great snow slopes towards the Col. The South Col is not reached direct. The rock buttress of the 'Éperon des Genevois', the Geneva Spur, stops this, and our route connected with the very top of the Éperon, over which we climbed and dropped several hundred feet into the South Col (25,850 ft).

About 1 p.m. on 26 May we began traversing rock and snow on the top of the Éperon. The South Summit of Everest was in view (the South Summit is a beautiful snow peak and sweeps up looking incredibly steep) and on the final slope I saw two dots, like flies on a wall, about 200 ft below the cornice of the top. We went mad with excitement as we watched Tom and Charles go steadily up and over the South Summit (28,720 ft) and, we

thought, off for the main summit. They were now higher than anyone had ever been before and were apparently going at a very fast rate. They had climbed from the South Col that morning and reached the South Summit in five and a half hours. John too had set out from Camp VIII with Da Namgyl (both on open circuit) ahead of Tom and Charles to carry Ridge Camp, but with closed circuit they easily overtook him and far outclassed the open circuit at the highest altitudes. Balu, the other Sherpa, had not gone above the South Col.

Greg and I were so excited at seeing Tom and Charles that we ran down into the Col Camp (VIII) to shout the news to Ed and Tenzing. Ed came out of the dome tent with a great whoop, then dived back again. Ed's disappearance I thought strange, and I pushed my way in to find John lying quite exhausted, with Ed plying him with drinks and oxygen. Ed and Tenzing had arrived on the Col before us and Ed saw John returning with Da Namgyl from his ridge carry. John and Da Namgyl had carried to 27,350 ft, and were returning completely done in. John was staggering and crumpling when Ed rushed off to help him. Ed assisted him on his shoulder and slapped his oxygen mask on him for a good half hour (John's oxygen had run out at 27,350 and he came down without). Da Namgyl's hands were frostbitten and he was very tired. John certainly earned our admiration – he's got tremendous guts and this day he pushed himself to the absolute limit – but this was typical of him all through.

There were three tents on the South Col; a pyramid, a dome and a Meade. They respectively housed four, two and two. The pyramid had previously been used by Sherpa, but was in a disgraceful condition. The floor was in shreds and parting at the stitching at the seams. The windward side had a four-inch tear, which later caused great inconvenience by admitting drifting snow and cold wind. The rope guys were far too tight and in the tremendous and ceaseless buffeting on the Col they were fraying and broken when we arrived. Ed and I went out in the afternoon into a freezing, roaring wind and began to repair the tent. We found a pile of strong line left by the Swiss and began replacing all the guys and placing rocks around the worst tears in the floor to protect it from the plucking of the wind.

During this time the South Summit became enveloped in cloud and we began to worry about Tom and Charles. We knew, as they knew, that if their closed-circuit sets failed in any way (and they had many gadgets, valves, tubes and canisters susceptible to error) they would not come back. Tom was an exceedingly determined thruster and we felt his enthusiasm could overcome good sense – but Ed remarked 'Charles is pretty sensible – I think he'll balance Tom'.

About this time the three Sherpa who had been chosen to carry with Greg to establish the Ridge Camp arrived on the Col from Camp VII. They had set out with us and gone slowly and badly. This was disturbing as we had placed high hopes on them. They were Ang Temba, Pemba and Ang Nyima. Ang Temba we thought the best and were amazed to find that when he dumped his load (30 lb) outside the tent he keeled over and for ten minutes was out cold. Pemba was very tired, while Ang Nyima was quite fresh and unaffected by the altitude.

John by this time had recovered and was fretting about Tom and Charles. He kept peering up the ridge awaiting their return. The afternoon passed and we all became concerned. As we fixed the last ropes I saw some moving dots at the head of the couloir by which they had reached the South-East Ridge. I watched until in shifting mist I was certain and shouted the news. Our relief was tremendous.

Their descent of the couloir was frightening to watch. Dog tired, they started down one at a time, each anchoring the other and each falling off as they tried to kick downhill. They slid and fell, their rope lengths each just managing to hold the other. As Tom said, 'We yo-yo'd our way down – it was quite fun!'

Ed and I went out to meet them and I filmed their arrival. They were still wearing and using their closed circuit, and apart from the masks, which covered nose, mouth and chin, they were covered in icicles. Ice driblets from the mask outlet had stuck to their windproofs and they were panting and labouring just to move along the flat.

They had not gone far beyond the South Summit – a few yards only – as their soda-lime canisters did not leave them with enough time in hand to risk going on. The summit ridge seemed long (Tom judged two or three hours and Charles thought four or more), it was corniced and had a difficult vertical rock step in it. Tom took eighteen photographs and they turned back down. Just below the South Summit they jettisoned two oxygen bottles, having enough left to get back to the South Col. These bottles were a vital help in getting Ed and Tenzing to the top a few days later.

That night Ed, Tenzing, Greg and I slept in the pyramid, while Ang Temba, Pemba and Ang Nyima passed the night in the even smaller dome. That night for everyone was pure misery. The wind slammed over the Col and worried the tents, whining, roaring and snapping incessantly. It became the curse of the Col, sapping our tempers and eating indelibly into our memories. We will never forget the South Col. We all spent there the most miserable days and nights of our lives.

The temperature dropped until we were all cold even though fully dressed (we wore our high-altitude boots in the sleeping-bag to stop them freezing) with full down clothing and in our warm sleeping-bags. I have never been so miserable, with freezing feet (they were lightly frostbitten – getting better now), cold knees and back, which was rammed hard against the windward side of the tent. My pillow was a kit bag full of frozen snow – hard, cold and unsatisfactory. What a night! But it was only the first of four which grew increasingly worse.

At 4.30 a.m. on 27 May we began to prepare breakfast in the hope of an early start in carrying Ridge Camp. Our appetites were good – we had carried up some 'luxury food' and ate the lot at breakfast. I remember the menu – Vita-Wheat biscuits with honey; sardines on biscuit; two tins of pineapple (between four); slices of saucisson (salami or raw bacon sausage); biscuits and honey; and lastly a tin of Australian pears. We ate and spread honey with gloves on and you can imagine what a messy business it was.

Our hopes of starting faded when at 8 a.m. the wind velocity had increased to over 70 or 80 m.p.h. and never looked like decreasing. All day it blew and put the chances of climbing on a ridge out of the question.

Supplies on the Col were limited and Charles and Tom had to go down. Ang Temba was so sick that he too was to go down. John, too, although he felt, as leader, he should stay to see and support the main assault, decided to go down and leave me to join the Ridge Camp carry. With Ang Temba out of the carry, someone had to replace him and I was fit. So again, although not supposed in the plan to stay on the South Col, I was now in the Ridge party.

Ang Temba, Tom, Charles and John left in the howling wind. Their climb back to the top of the Éperon (300 ft) took nearly two hours. Ed and I assisted them – they were dreadfully

RIGHT Evans and Bourdillon return to the South Col exhausted after their ascent of the South Summit on 26 May 1953. This day they had been the two highest men on Earth.

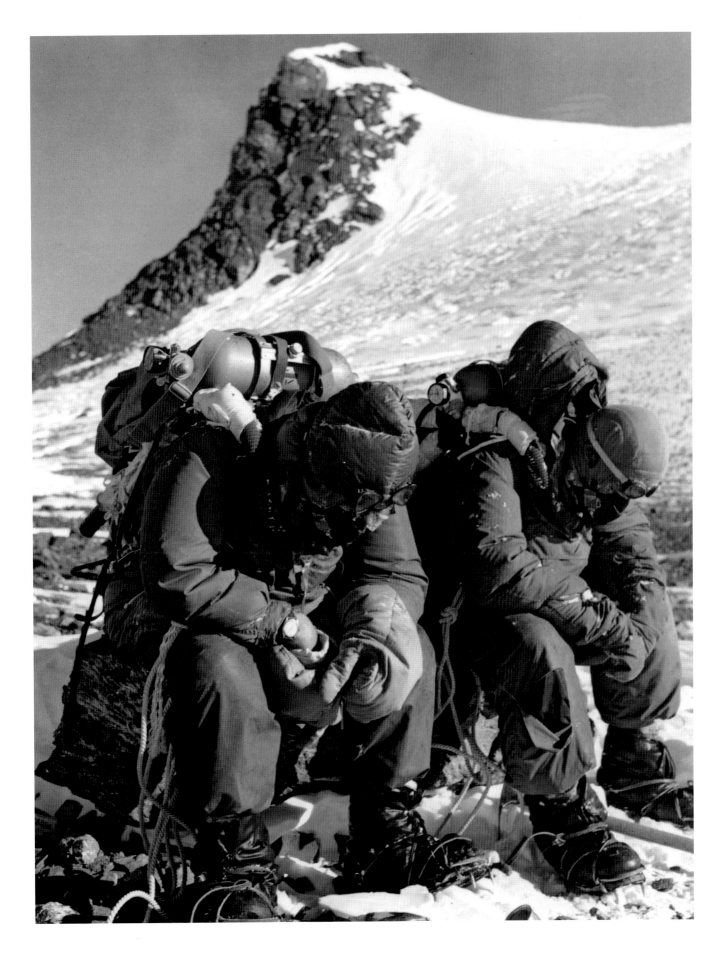

weak, but once over the Éperon they were out of the worst wind and going downhill. Their journey to Camp VII was an epic one and there they were received by Wilf Noyce and Mike Ward. On 28 May they limped to Advance Base (Camp IV), to good food, attention and much-needed rest.

For the remainder of 27 May we sat out the wind and dreaded the coming of night. The night was a repetition of the previous one and in the morning we were still bad-tempered and ill-fed, with very frayed morale. The wind mercifully eased and we stiffly prepared to go. Three hours it took to make a few simple preparations. Then an apparently crippling blow fell. Pemba suddenly spewed over the tent floor and began to groan and said he couldn't go. That left one Sherpa, Ang Nyima, and we needed three. That hour the expedition hopes recorded their lowest reading!

After a discussion we agreed to try and lift the two extra Sherpa loads between us. The weights were about 45 lb, each of which seemed Herculean when a good load at this altitude was considered to be 15 lb.

Greg, Ang Nyima and I got away at 8.45 a.m. Ed and Tenzing decided to delay at least an hour to save their strength and oxygen while we cut steps up the couloir. We were heavily clothed and with the loads we stomped along like robots. We made a very slow steady pace, which we managed to hold without stopping and began to make height. The wind dropped to a comparative breeze and we slugged up into the couloir and I began cutting steps. Cutting steps at 27,000 ft is an experience – a study in 'go slow'. It took three hours to get up to the ridge, where we saw the wreckage of the Swiss top camp (one tent), with not a vestige of the cloth on the aluminium bones.

Here we dropped our loads and enjoyed the tremendous view. Lhotse and Makalu were wonderful. Kangchenjunga

jutted out above the clouds. Below were the Kangshung and Kharta glaciers, with wonderful views of brown Tibet beyond. Oddly enough I enjoyed and remembered the couloir climb and the view as if it were at sea-level. I had read that altitude robbed both enjoyment and memory. With me it was not so. Here Ed and Tenzing caught up with us. Greg was going exceedingly well, Ang Nyima the same, and we urged him on by saying that if he went a bit higher he would have carried and gone higher than any Sherpa in the world. He was very ambitious and carried magnificently.

About a hundred and fifty feet above here we reached John's highest point and found the rolled tent, food, an RAF oxygen cylinder and other oddments, and these we had to add to our loads. Ed took the tent, Greg the RAF cylinder and I took food oddments and some of Greg's load: we left there with Ed carrying 63 lb; Greg 50 lb; self 50 lb; Ang Nyima 45 lb; Tenzing 43 lb.

From here the South-East Ridge is moderately steep – odd broken rock and towers followed by snow ridge. I led and the snow was bloody – knee deep and loose. From then on the upward progress was grim, dead-brained toil. I don't really know how we endured the weight. We pushed up to where we thought a flat spot would be and found it quite untenable. We pushed on again – and again the same thing – and so on. At about 2.30 p.m. we stopped below a snow shoulder and found a tiny ledge where we dumped our loads. Ed and Tenzing began clearing a site which was too small for the tent. Snow flurries were beginning, and although very tired we set off back down within two minutes of arrival after some cheery banter to and from Ed on the chances for the morrow. The height of Camp IX – Ridge Camp – has been estimated at 27,900 ft.

Our return was slow and tough. Greg had cracked up, Ang Nyima was very tired and I had to recut steps all the way down the couloir. From the couloir Greg was collapsing every fifty yards and gasping with exhaustion. I was tired – dreadfully tired – but quite able to keep going without pause, and funnily enough with sufficient mentality to appreciate the glorious evening colours over Kangchenjunga and Makalu. I photographed them. Near the tents I unroped and pushed on. Pemba had made a hot drink and I tossed this down, grabbed the movie camera, staggered out and, sitting against a rock, filmed the arrival of Greg and Ang Nyima, which I hope shows something of the state of really flogged men. We drank hot lemon and tea and crawled into our bags – but not to sleep. The night, the wind and the cold came and we passed another bloody night.

29 May finally dawned. On the Col it was windy – it was always windy. The sun hit the top of the tent about 5 a.m. It crept down the walls, releasing the frost of condensed breath in a shower over us – as usual. At 8 a.m. we saw Ed and Tenzing on the way up the final slopes of the South Summit – going slowly but steadily. Greg had decided to go down as he was too weak to be of use to any returning summit party. Ang Nyima and Pemba went down too and left me alone on the Col to receive Ed and Tenzing. At 9 a.m. they disappeared over the South Peak and somehow then I felt that they would reach the summit. I boiled soup and lemonade and filled the two Thermos flasks we had. I prepared oxygen bottles with all connections and masks ready for instant use and set bedding ready as if to receive casualties.

Outside I prepared the spare oxygen frame with the two emergency cylinders which I intended to carry up and meet them to assist their descent. At 1 p.m. they appeared again on the South Summit and began the descent of the steep loose snow slope. I was wildly excited and leapt into action. I packed the Thermos flasks, slung the movie camera on (4 lb) – put on crampons, gloves – greased my nose, face and lips against the wind – tied a scarf round my face for extra protection (I was severely windburnt and my skin was frost-affected from the other days – and very sore); got into the oxygen carrying frame with two bottles and set off to meet the boys. About four hundred yards from camp I began to feel groggy – I was carrying too much, had started too excited and too fast, and was climbing without inhaling oxygen. After the previous days' effort I was not as good as I thought. I looked up and saw Ed and Tenzing were coming down quite fast and steadily and were so far away that I could be of no immediate help, so I tottered back to the tent. There I watched them from the tent door. They stopped at Camp IX at 2 p.m. and didn't leave there until 3 p.m. (they had a boil up of lemonade and collected their sleeping-bags), and came down the ridge and then the couloir going absolutely steadily.

Just before 4 p.m. I set out again to meet them, and as I left the tents Wilf Noyce arrived with Pasang Phutar. They had been sent up by John as a useful support to receive and help the summit party in case they were exhausted. It was good to see them and they began to prepare hot drinks as I left.

I dragged up again and met Ed and Tenzing at the foot of the couloir – perhaps 500 ft above the Col. They were moving fairly rapidly – the only tiredness showed in their slightly stiff-legged walking as they cramponed the last bit of the couloir. I crouched, back against the wind, and poured out the Thermos contents as they came up. Ed unclipped his mask and grinned a tired greeting, sat on the ice and said in his matter-of-fact way – 'Well, George, we knocked the bastard off!'

PORTFOLIO

CAMERAMAN ON EVEREST

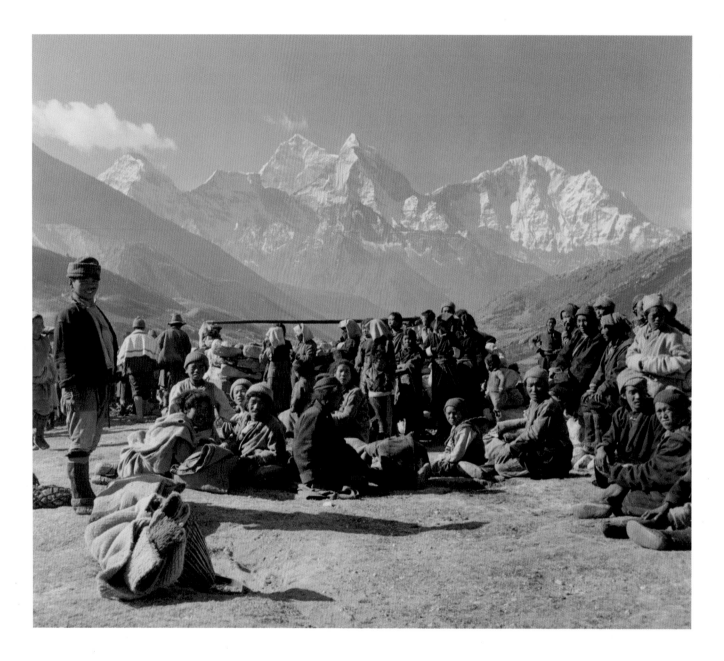

ABOVE The Sherpa took over from the lowland porters, and at Pheriche a group gathers in the grazing grounds before moving off at the start of the day. In the background are the impressive Kangtega and Thamserku.

RIGHT John Hunt was a meticulous planner with an eye for challenging logistics, and it was a good job too. The baggage of the expedition first arrived at Tankot, 5 miles from Kathmandu, having journeyed by ship, train, lorry and finally an overhead ropeway. It was a massive undertaking to sort it all. Most of our equipment had been packed in England – some 473 packages.

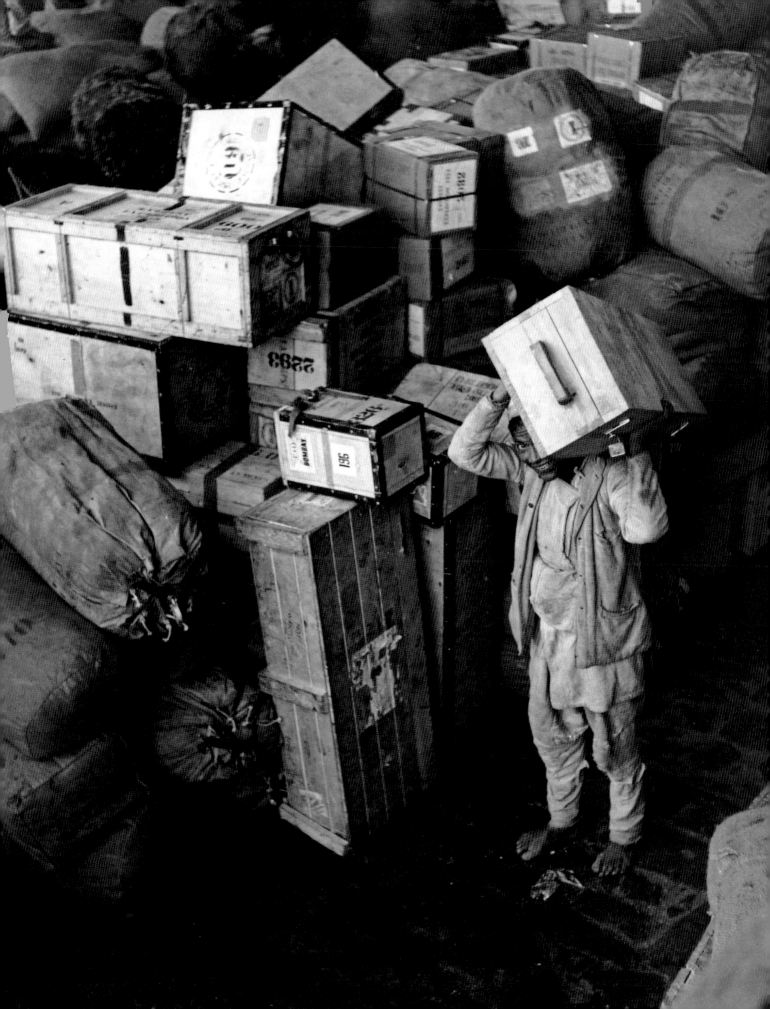

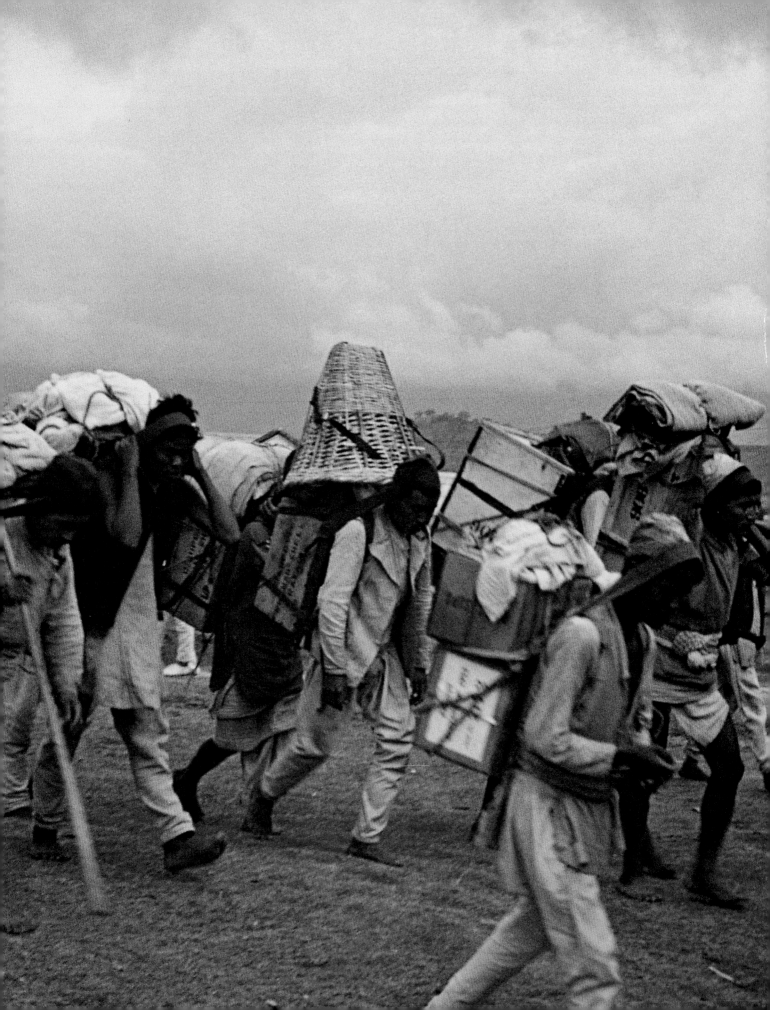

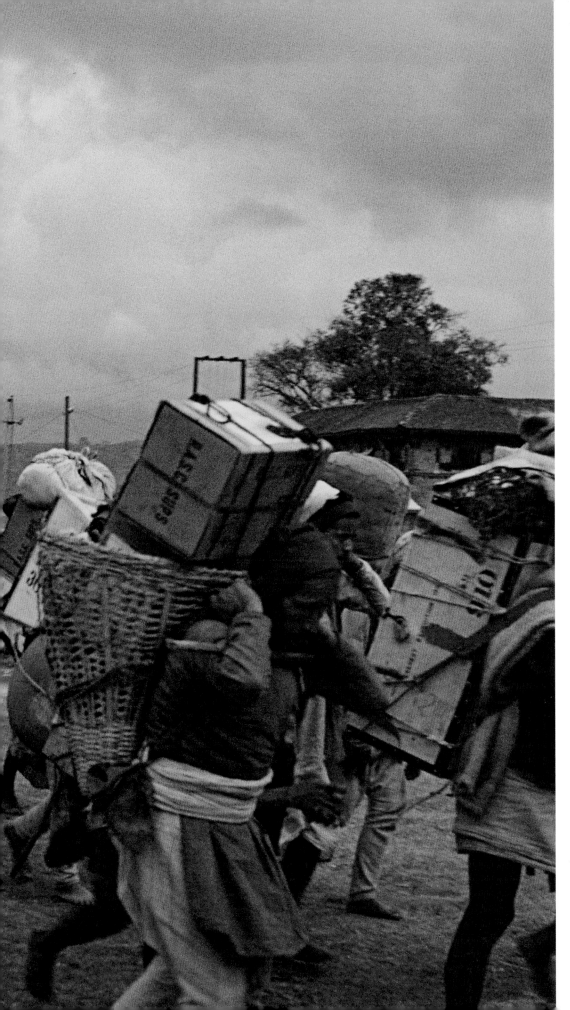

LEFT From Bhadgaon, just outside Kathmandu, it was a seventeen-day journey on foot to Thyangboche, our main camp, from which we would carry out our training and acclimatization. The track led us eastwards, cutting across the grain of the land, down into deep valleys, across foaming torrents of water, and up the far hillsides.

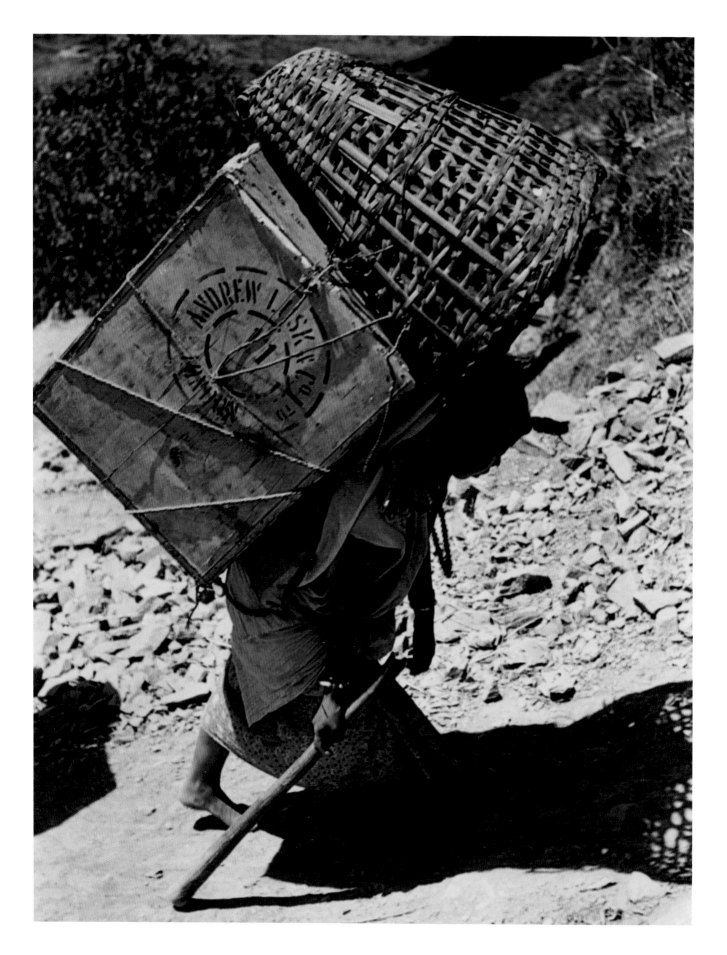

LEFT One of our Sherpani porters carries a highly prized packing-case full of our luxury food boxes. We had all chosen our favourite things. There were mint cakes and chocolate, soups and Nescafé coffee, tinned pineapple and pears, pots of chutney, Cheddar cheese, sardines, mustard, and eight jars of Marmite.

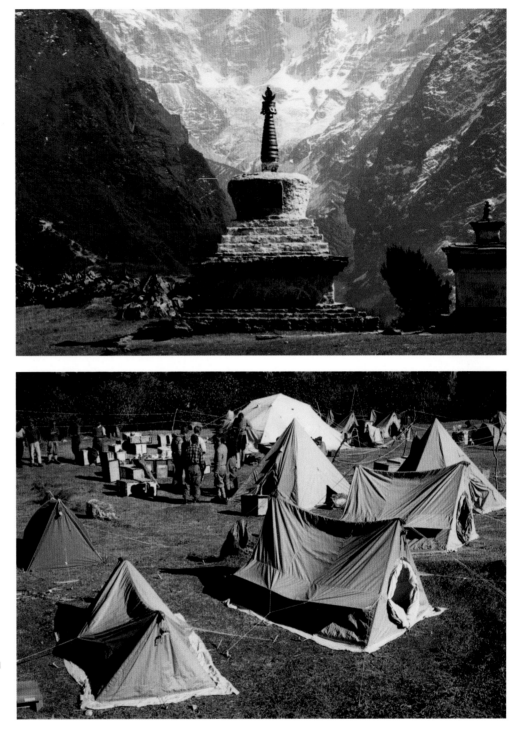

RIGHT, ABOVE AND BELOW We camped near the Thyangboche Monastery for a few weeks, pitching our tents in a grassy meadow where yaks were grazing peacefully. The top photograph shows the Buddhist stupa there. Our encampment was ringed with silver birch, azaleas, tree juniper and fir, and beyond in almost every direction towered ice-fluted peaks of an unrivalled majesty. Some mornings we woke to find a light covering of snow on the tents, but it soon melted in the warm sunshine.

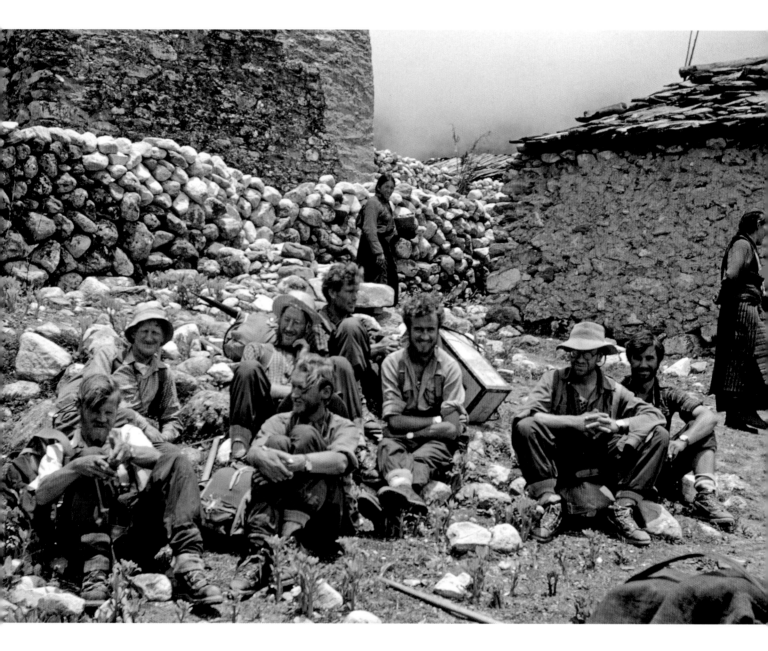

ABOVE We rest on the march near the village of Pangboche, looking more like a band of brigands than a team of British climbers. In front on the left is Noyce, then Stobart, a smiling Wylie and Westmacott with the rather extravagant head gear, and to the right black-bearded Ward, our cheerful doctor. Hunt is behind Noyce, next to Band, who is sporting the straw panama, and behind him is Bourdillon.

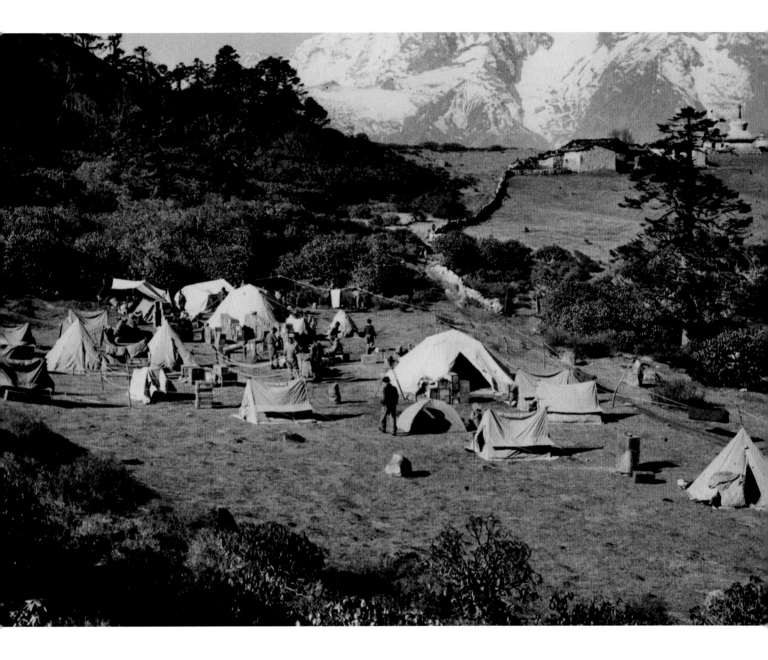

ABOVE Thyangboche Monastery is certainly the most beautiful place in all the Himalaya. We reached here on 27 March and pitched camp in a grassy paddock set aside for us by the lamas. All around were mountains, and straight ahead of us was Everest, clear on one side and streaming with a plume of snow and cloud on the other. It looked immensely high and formidable from here.

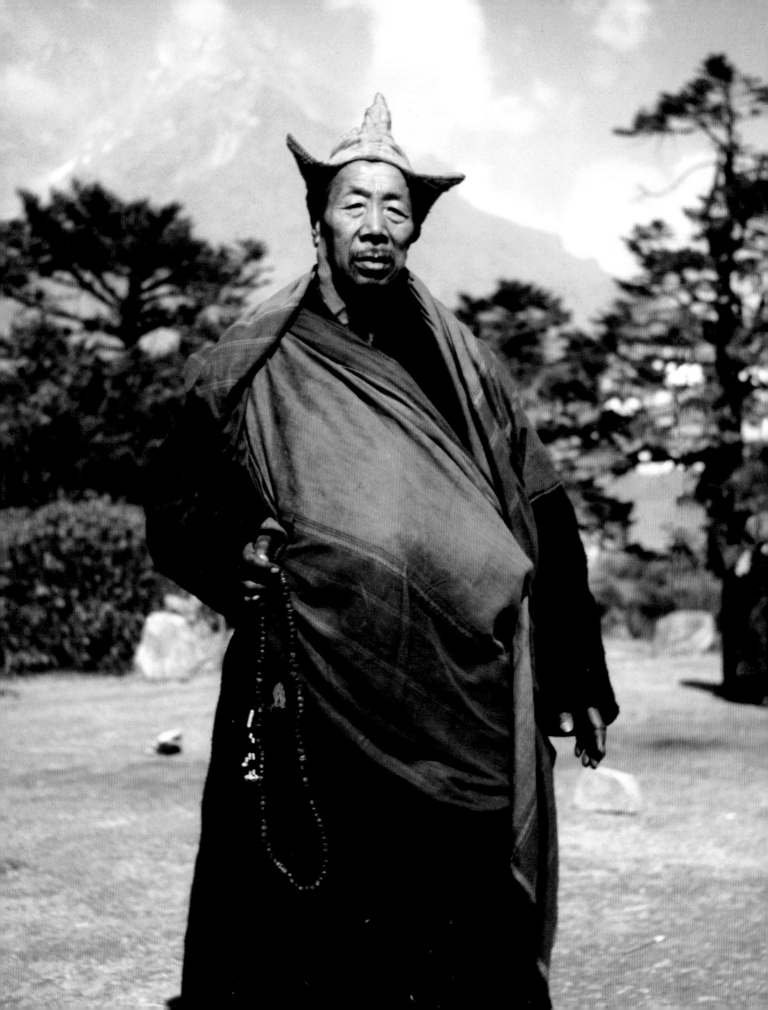

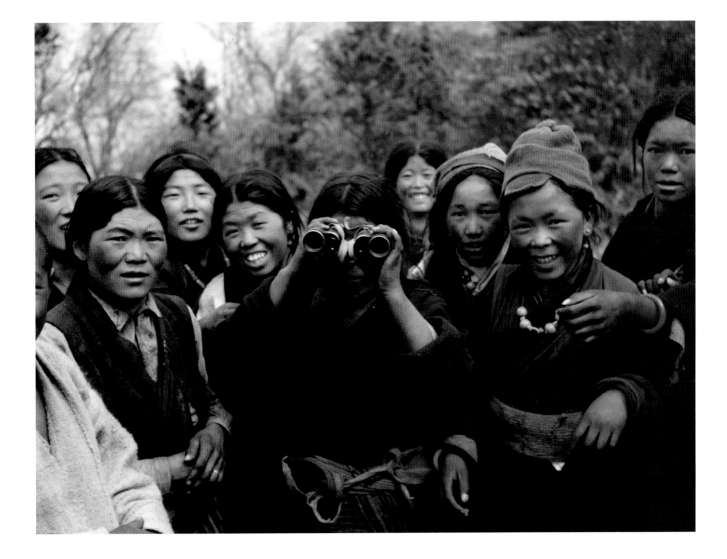

LEFT AND ABOVE At Thyangboche one of
the principal Buddhist lamas came out
to give us his blessings. Our arrival, as
much as our binoculars, was the cause
of some curiosity among this group of
young Sherpanis.

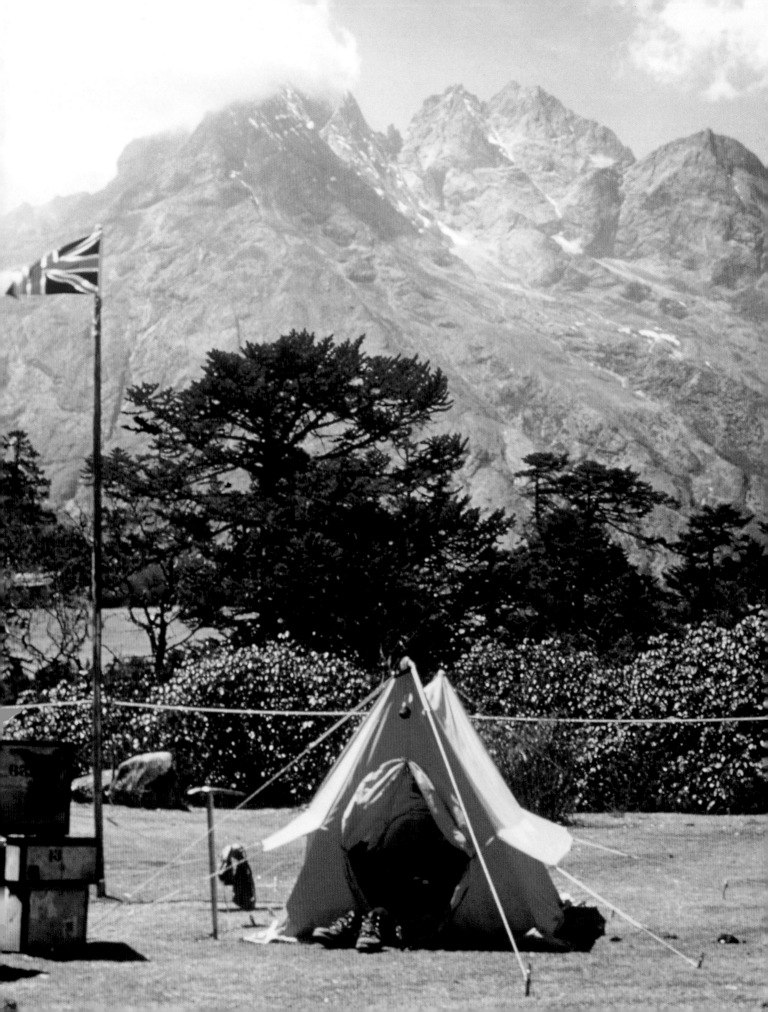

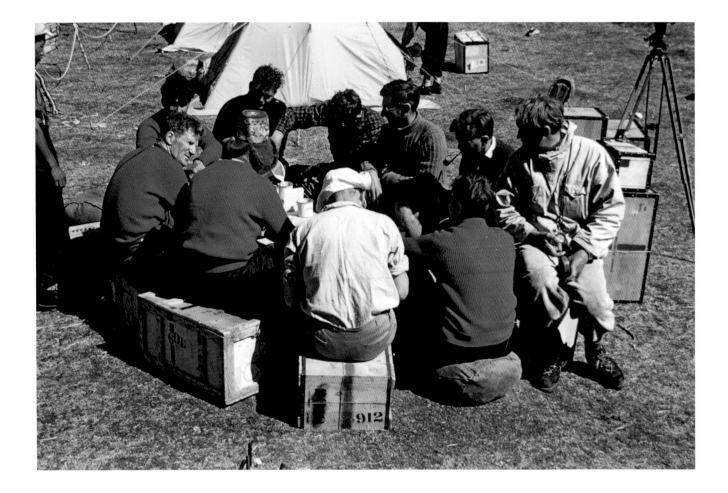

LEFT At Thyangboche we pitched all our tents for the first time, about twenty of them of various shapes, sizes and colours: three miniature ones intended for a final camp; orange ones for Advance Base (Camp IV) and above; yellow ones to be used as far as the entrance to the Western Cwm; a distinctive Swiss tent as Tenzing's temporary home; and two bigger dome-shaped tents, one used by the Sherpa and the other by ourselves. In one corner of the compound Thondup set up his cookhouse, and in the other our Union Jack was hung on a pole – inadvertently upside down!

ABOVE A leisurely breakfast at Thyangboche, seated on packing-cases around a table of oxygen boxes. On the left is Hunt, behind him is Ward, Bourdillon, Hillary pouring milk, Band, Noyce and Stobart. On Hunt's right, I'm wearing the Tibetan hat, then Evans and Westmacott.

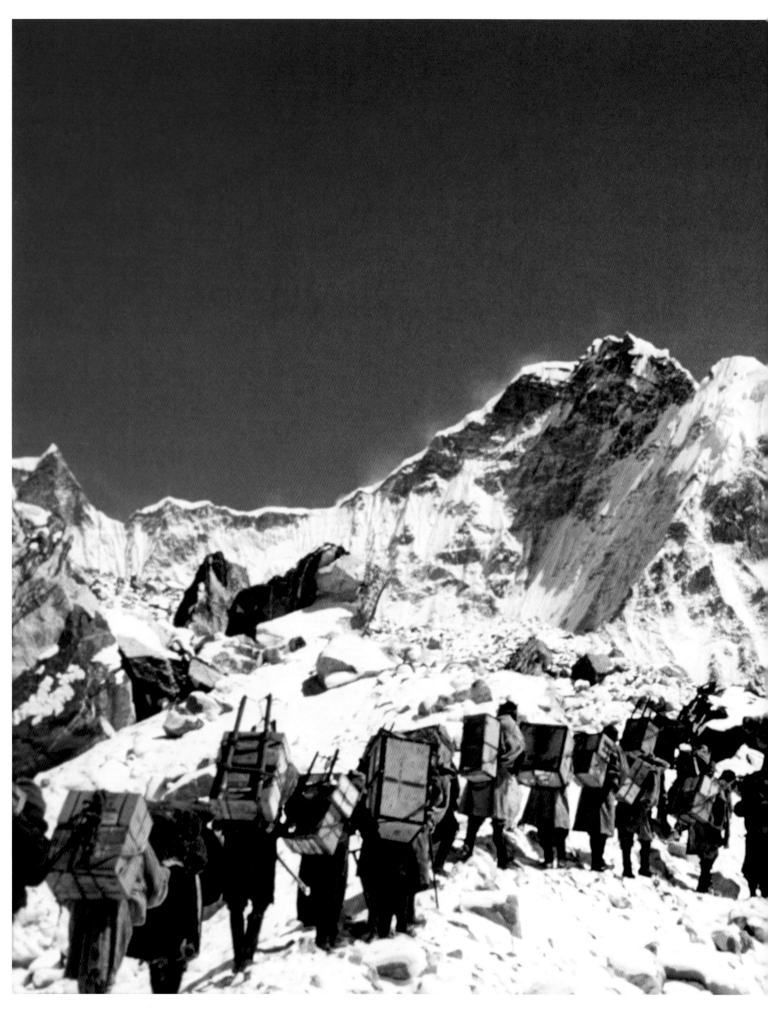

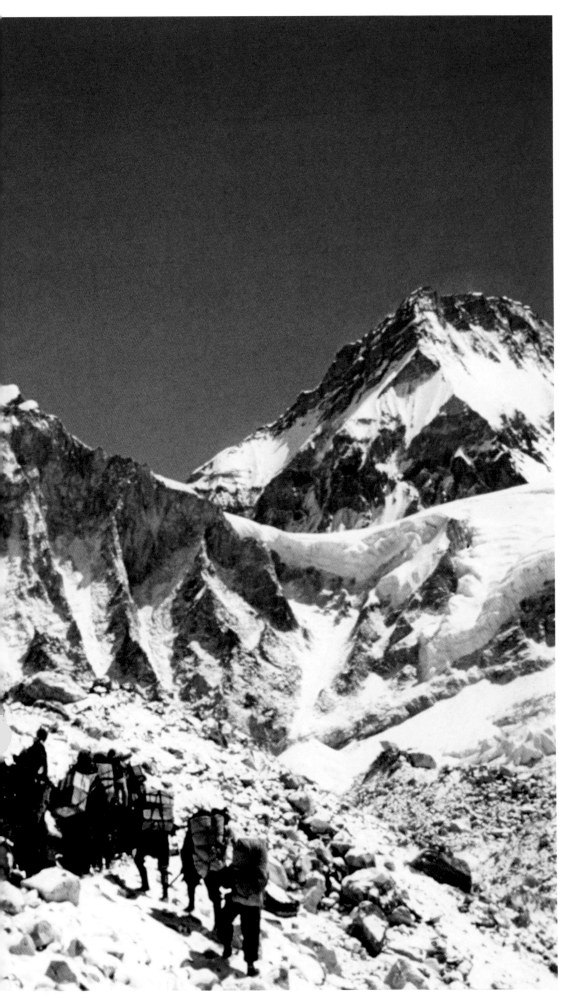

LEFT Our Sherpa party, loaded with supplies, weaves its way along the moraines of the Khumbu Glacier, on our way to Base Camp on 12 April 1953.

FOLLOWING Though there was much work to do, Base Camp was also a place to rest and recover – to sleep, write letters or listen to Radio Ceylon. One afternoon Evans kindly gave my hair a good seeing to. Ed meanwhile, waiting his turn, reads a New Zealand newspaper that was sent to me in a bundle of gifts from home.

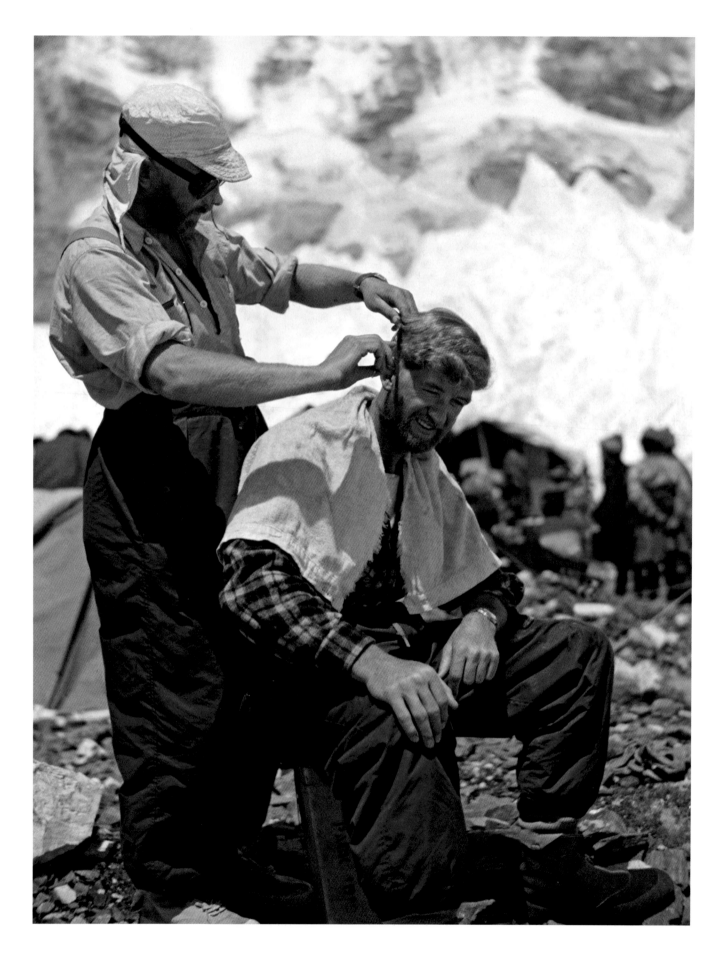

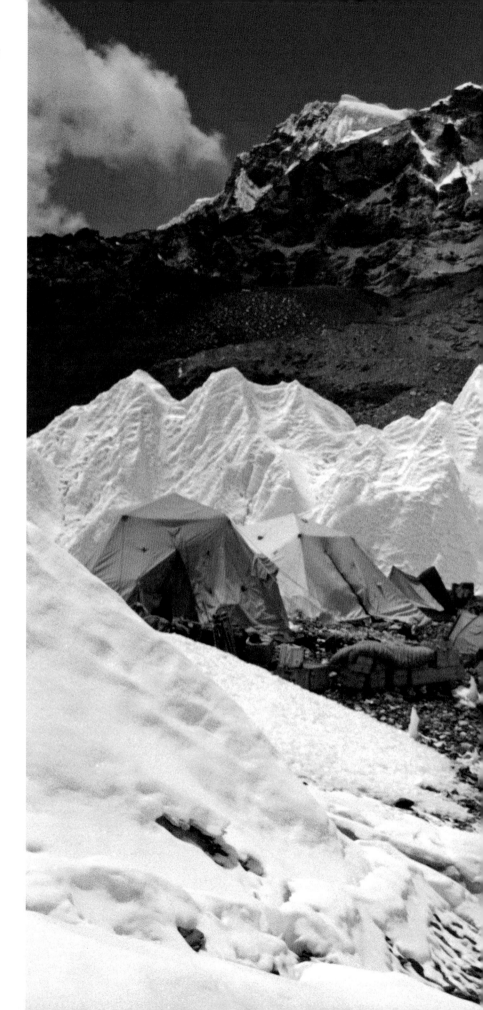

RIGHT All around Base Camp were enormous pinnacles of ice, making it quite difficult to find the camp unless you knew exactly where it was. This was our base from where all the climbing started and, although not a comfortable place, it was a welcome sight to parties returning from high on the mountain.

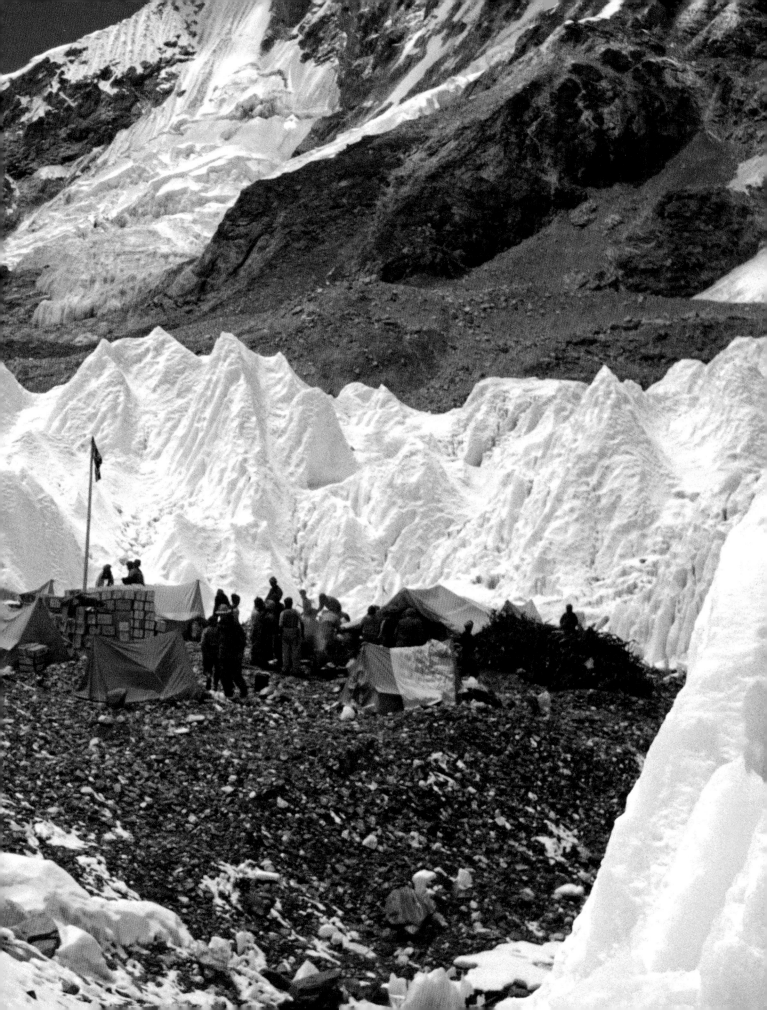

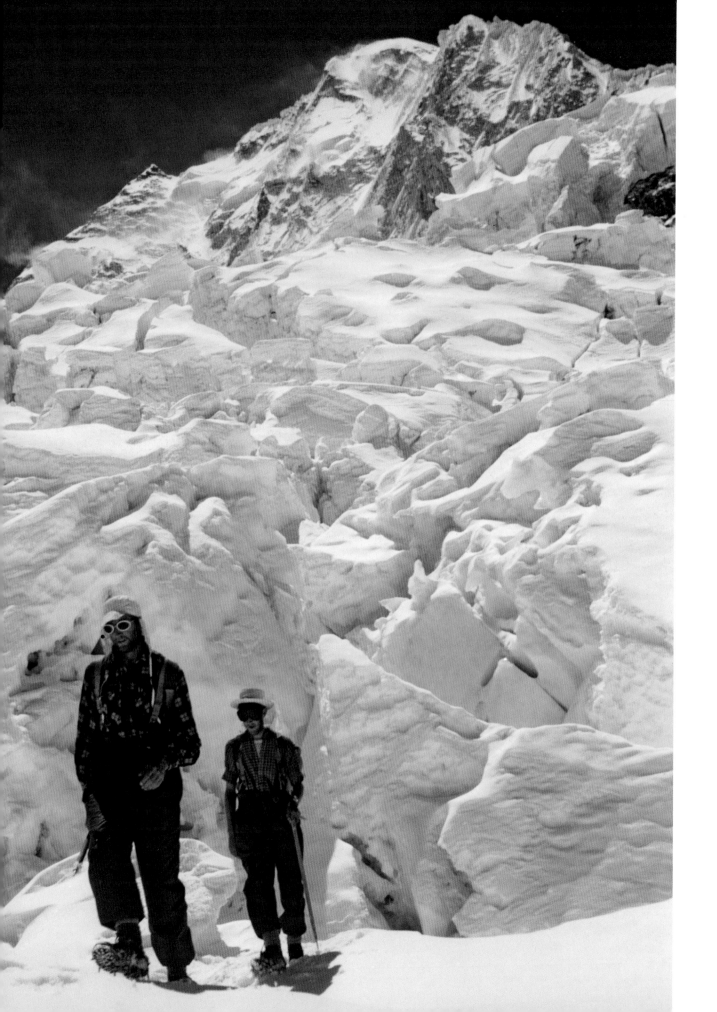

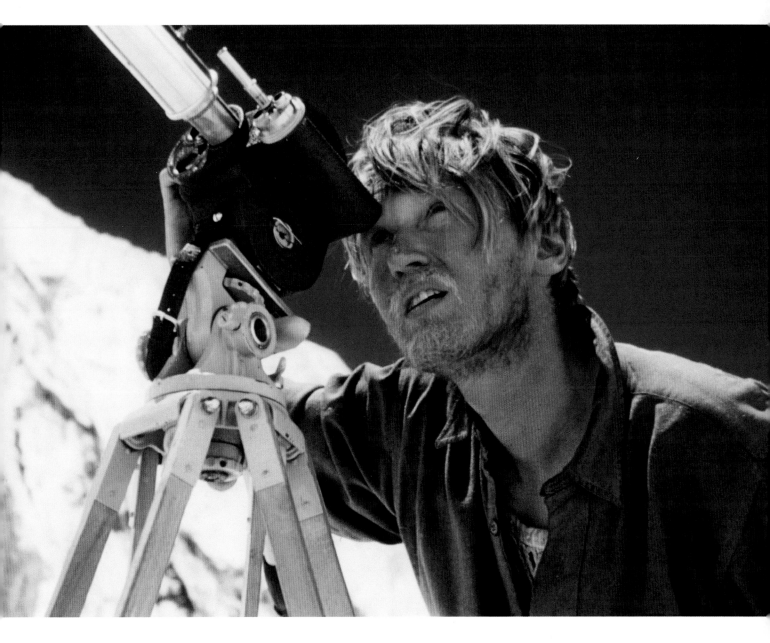

LEFT Hillary, Band and myself were sent ahead to begin work on the Khumbu Icefall, while the others finished their acclimatization and moved our stores. Here I am in front, with George behind. Ahead of us were vast ice cliffs. To begin with it looked absolutely hopeless.

ABOVE Tom Stobart came to join us and was soon at work with his Bell-Howell ciné camera. He gave me good advice and in the later stages of our climb I undertook the high-altitude filming.

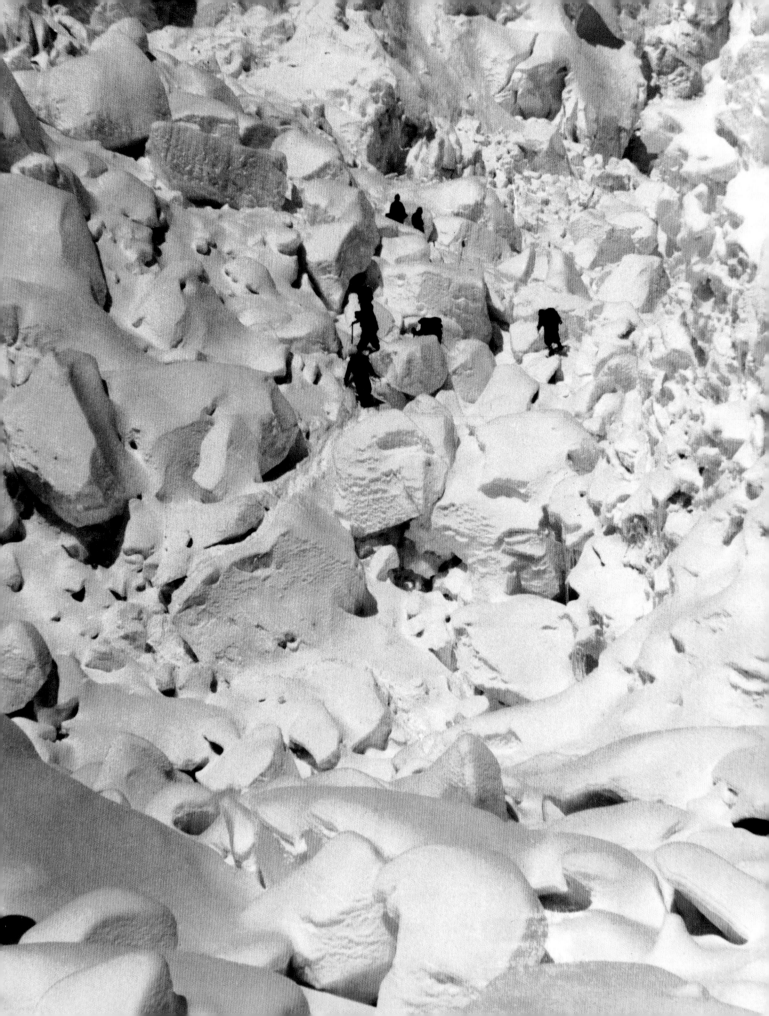

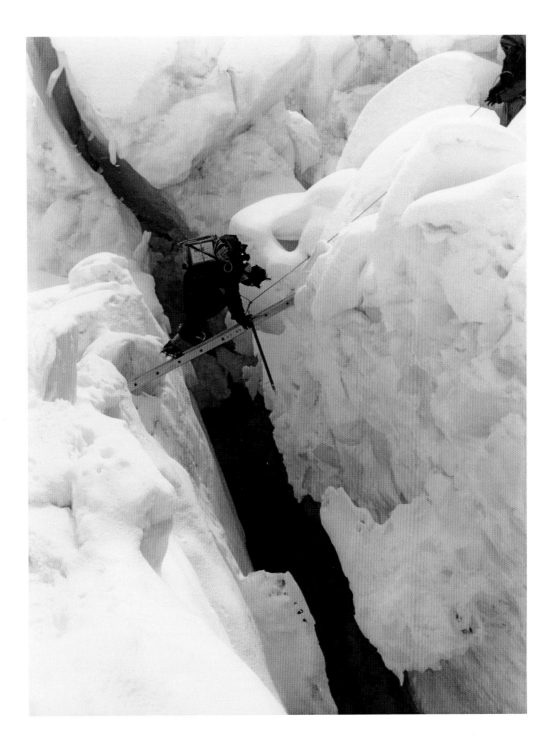

LEFT The Khumbu Icefall was a nasty spot indeed. The lower reaches, rising 1,400 ft up to the site of Camp II, were a shattered chaos of shifting ice – a very dangerous place to be.

ABOVE A Sherpa team moves through the Icefall ferrying stores up the mountain. They are crossing our ladder bridge at 'Nasty Crevasse', just above Camp II.

LEFT Our Sherpa porters putting on their crampons before a hard day's work ferrying loads with us through the Icefall.

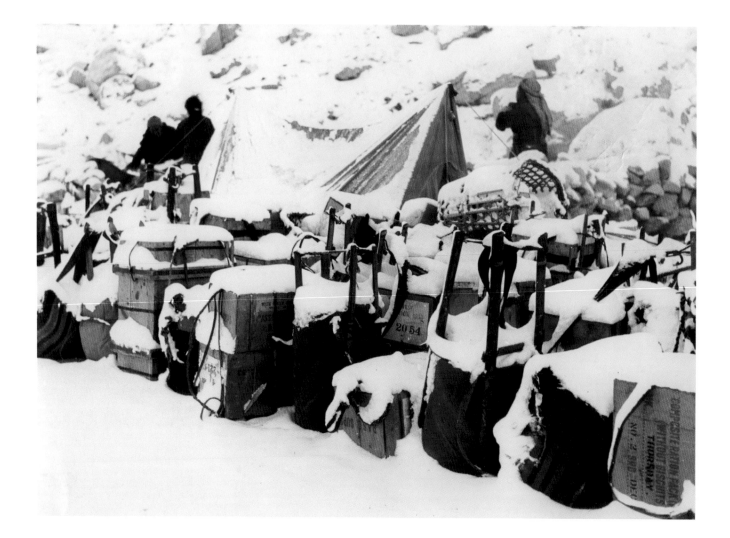

ABOVE Our boxes of army rations were marked for when they were supposed to be eaten – a different menu for each day of the week. We soon discovered that we all liked Thursdays the best: stewed steak and tinned peas, finished off with a rich fruitcake. So much so, we ate through all of them first!

RIGHT George Band is calling up Camps II and III on the walkie-talkie. It seems like an old bit of kit now, but it worked very well. We also had an ordinary receiving set to get BBC weather broadcasts. At Base Camp we'd often listen to Radio Ceylon – one night it was opera followed by Hawaiian music for good measure.

FOLLOWING To carry about three tons of stores up the Icefall we employed thirty-four Sherpa porters, all now equipped for high altitudes. A member of the climbing team escorted each group upwards through the labyrinth of ice, and we fixed ropes and ladders to ease the passage up the difficult parts.

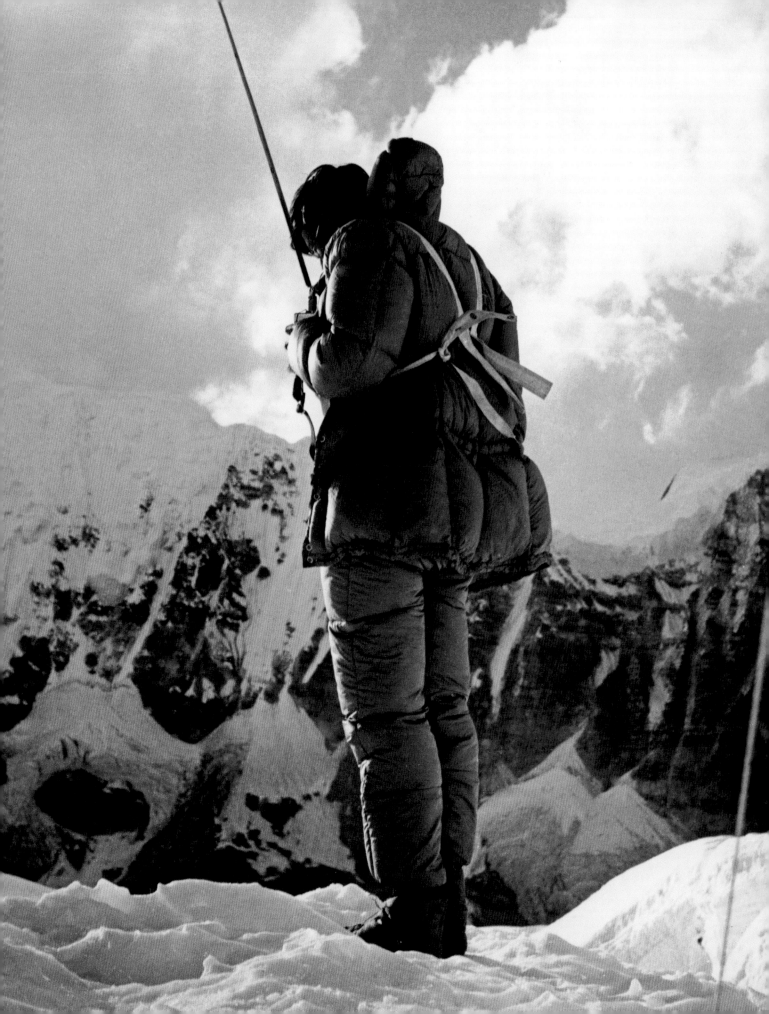

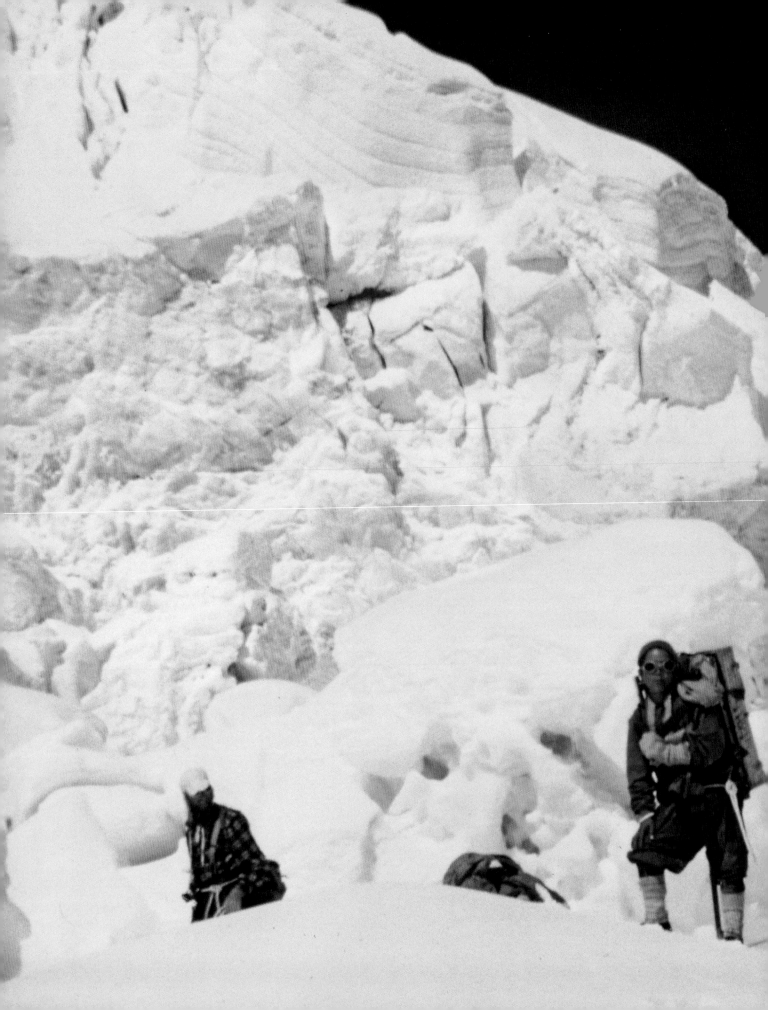

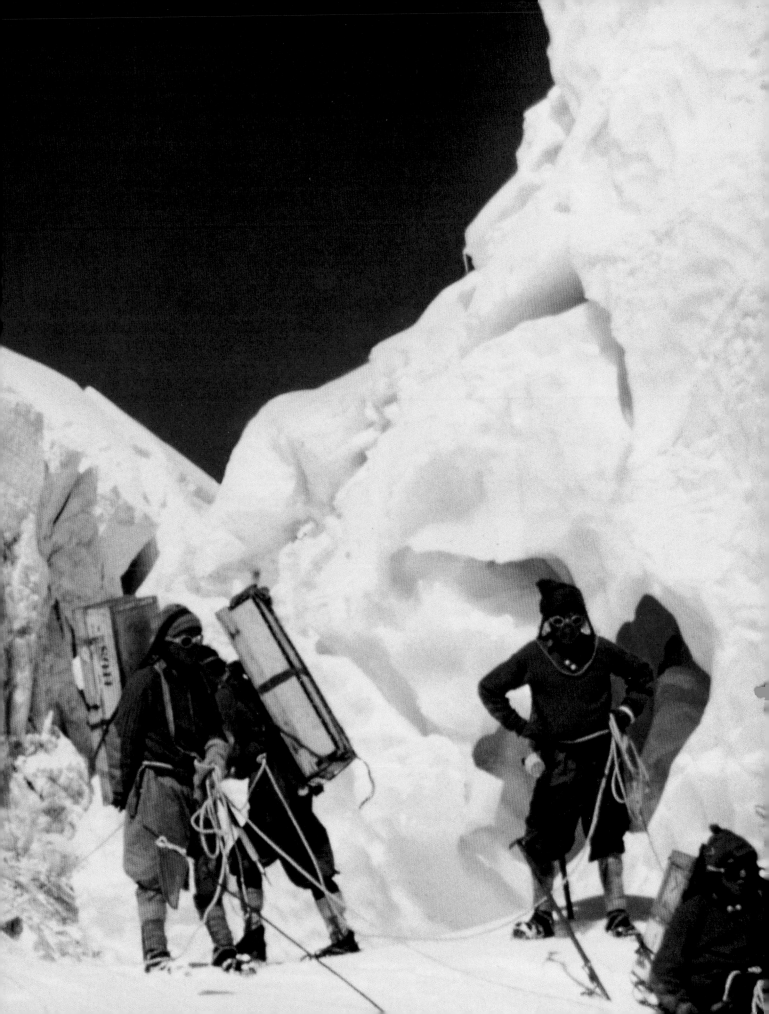

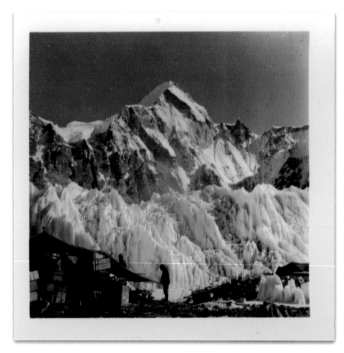

LEFT After each ferrying trip through the Icefall, the safety of Base Camp provided a welcome rest.

BELOW LEFT I knew Alfred Gregory well, as we'd both been to Cho Oyu in 1952. On Everest our photography overlapped. We'd often repeat each other's shots when we both saw something we liked or felt was important to the record of the climb – in case either of us lost a camera or the film went astray on its way to London.

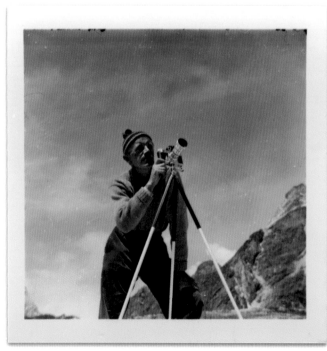

RIGHT The Khumbu Icefall was a frozen cascade of giant ice blocks, constantly moving and changing, pouring in waves towards our little Base Camp. To journey through it was a precarious business. In this photograph, we are nearing the top of the shattered section of steepest ice known as 'Hellfire Alley'.

FOLLOWING Our Sherpa were undaunted in their work ferrying supplies up to our high-altitude camps. We used a couple of logs to bridge one particularly tricky crevasse.

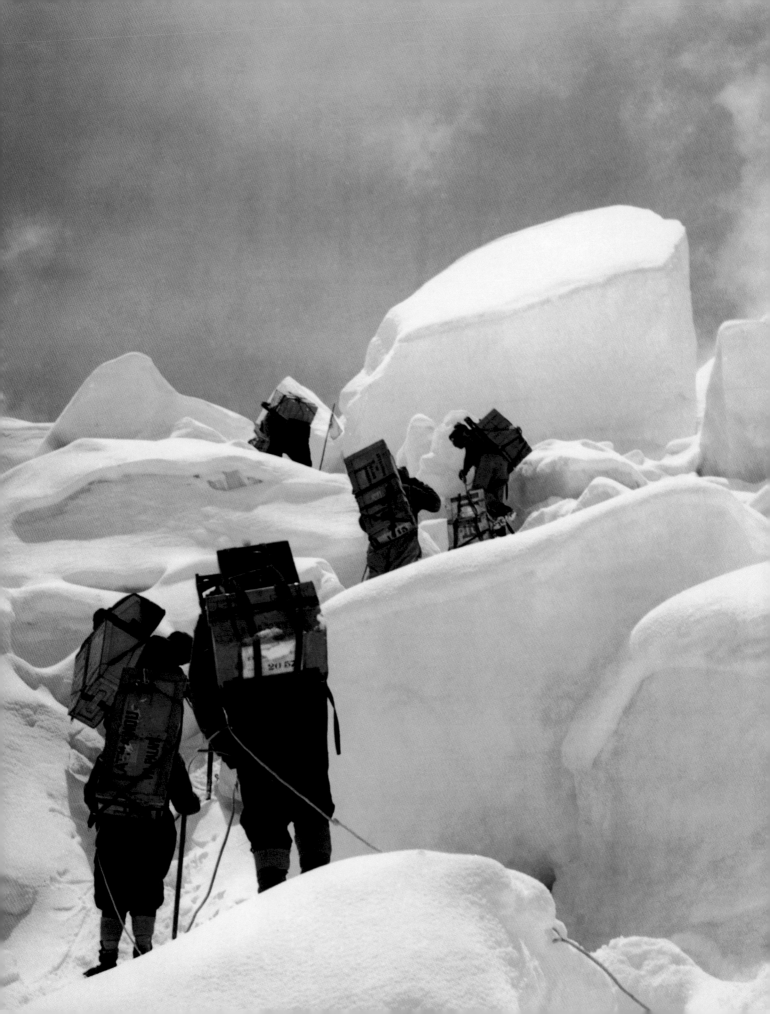

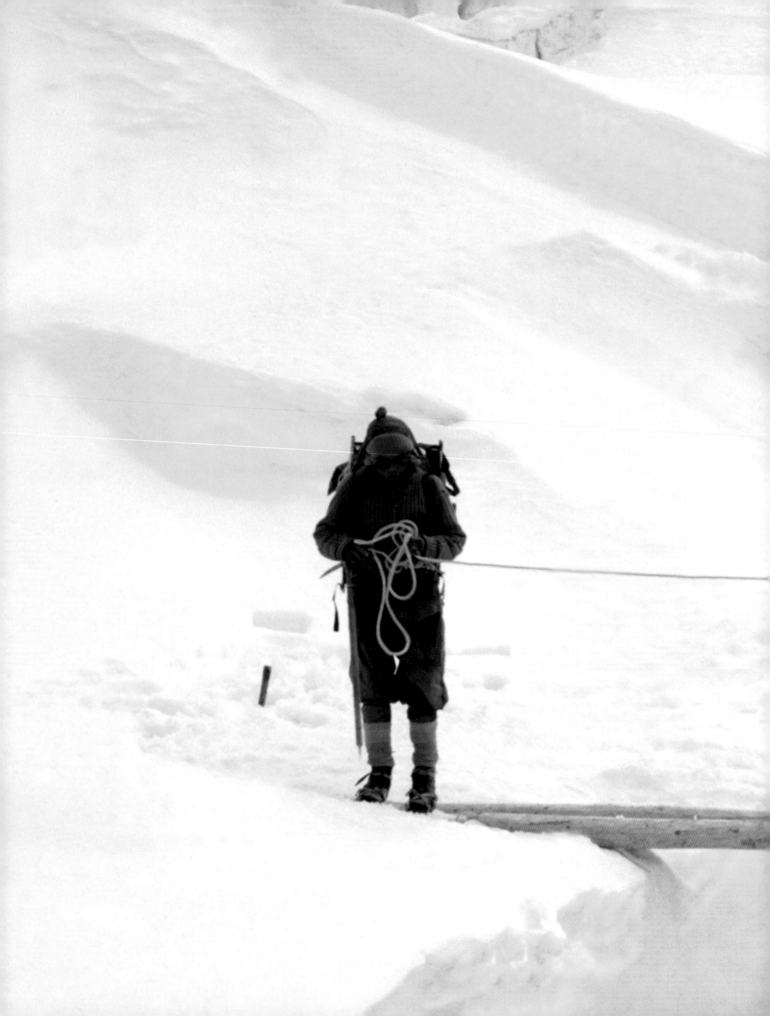

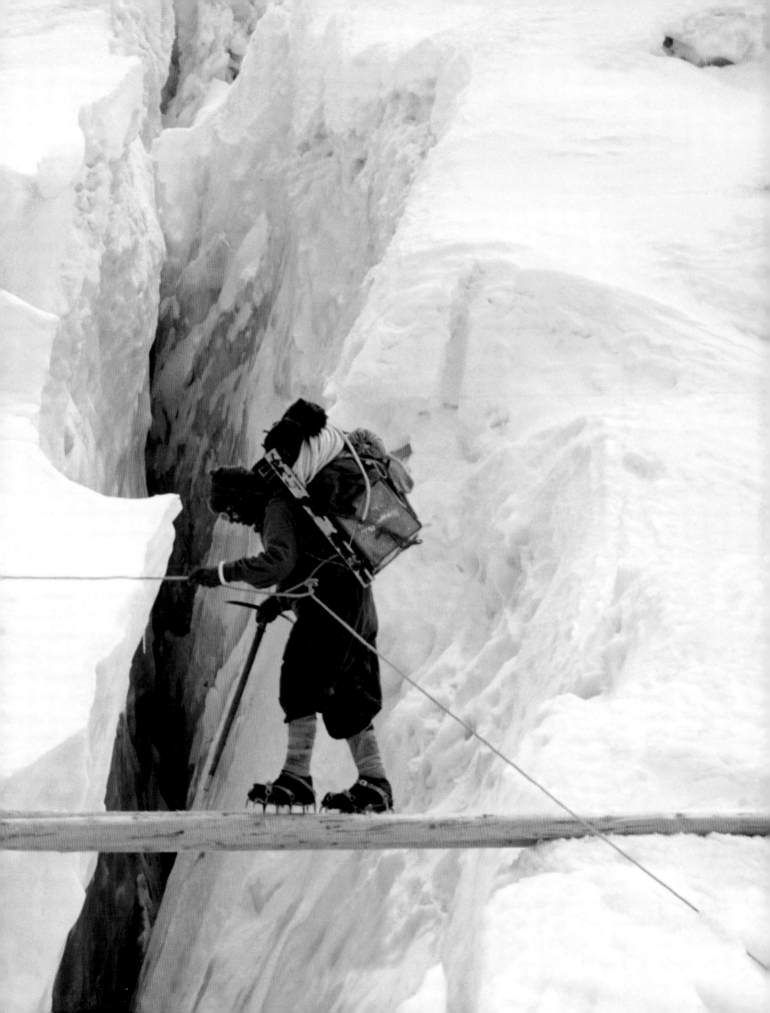

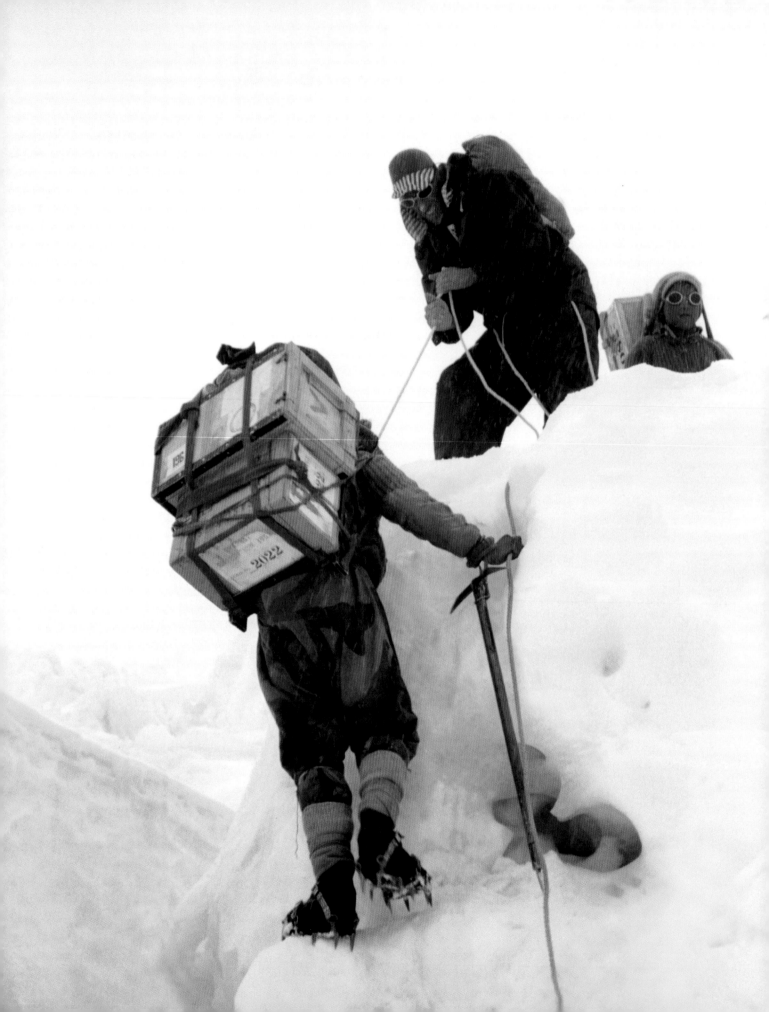

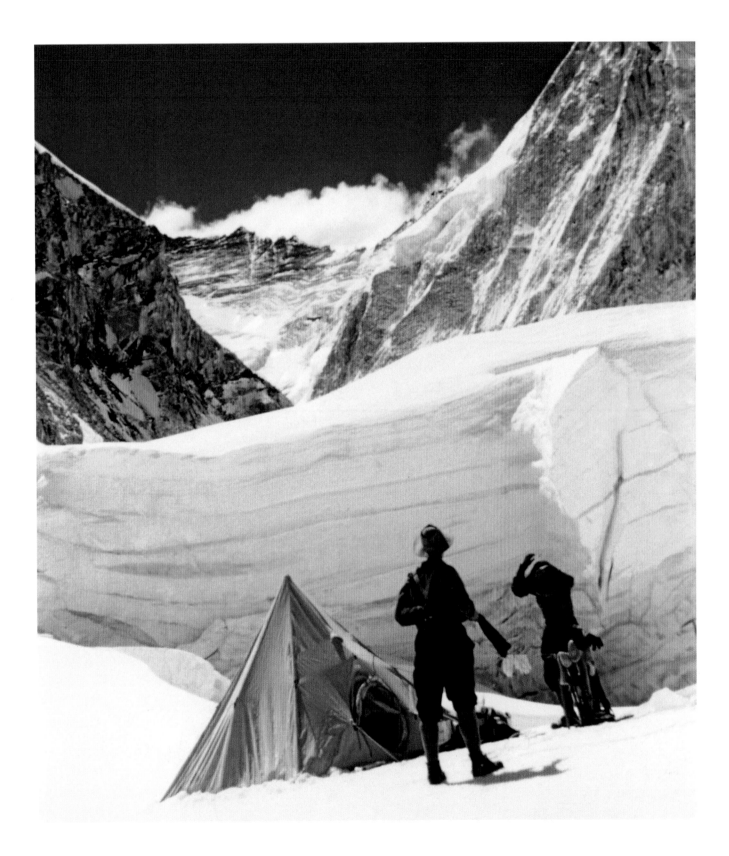

LEFT Hillary assists a team with its loads. We pitched Camp II half-way up the Icefall, but later abandoned it as it was so unsafe. Sleeping here was frightening – the ice shook underneath the tent and great cracks broke the silence, as the glacier moved relentlessly downhill. The Sherpa were soon lifting loads all the way up to Camp III, preferring this effort to spending a night at Camp II.

ABOVE The first tent at Camp III was established on 22 April at the entrance to the Western Cwm – a small outpost of life in the wilderness of ice. Westmacott looks up towards the formidable Lhotse Face, in the centre, some three miles away. Tackling it would prove crucial to our progress to higher altitudes.

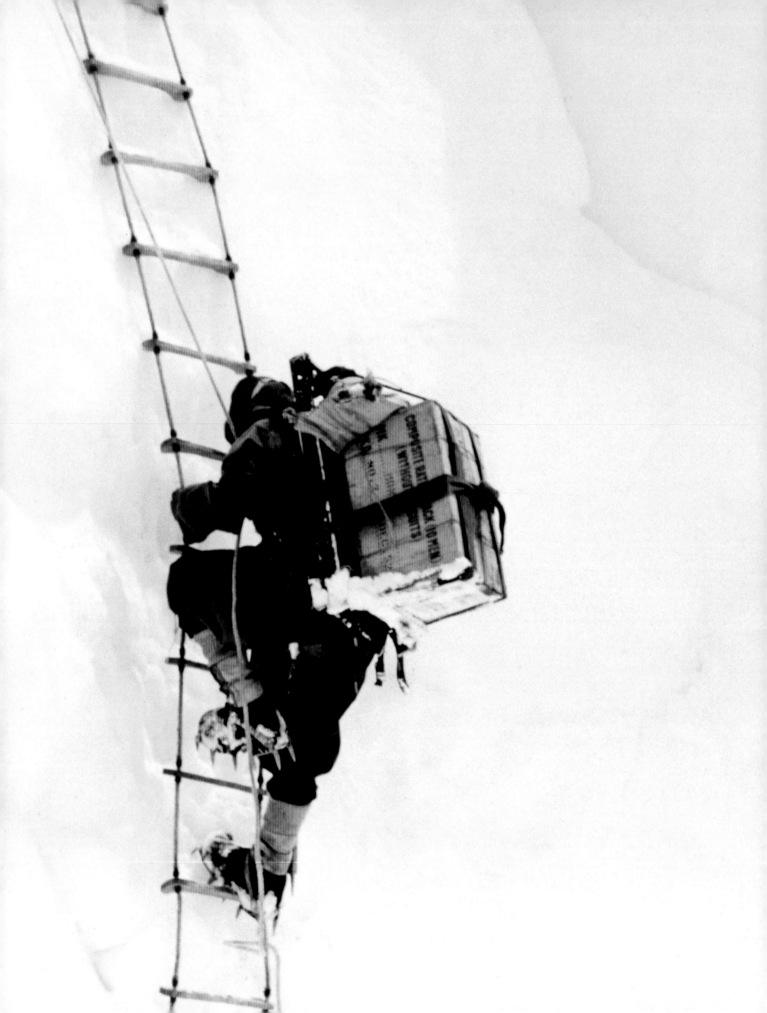

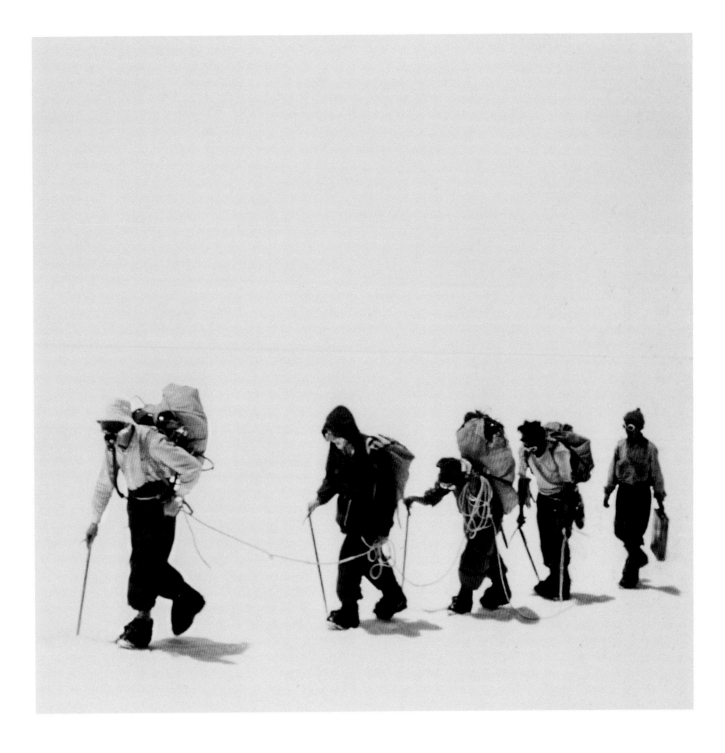

LEFT After overcoming such hazards as 'The Nutcracker', 'Hellfire Alley' and 'The Atom Bomb', we arrived at the head of the Icefall to find the last and steepest ice wall. We anchored a rope ladder to enable the others to climb up and join us.

ABOVE Wearing his oxygen gear, on 30 April John Hunt leads a group between Camp III and the site for Camp IV.

FOLLOWING Beyond the Icefall, a team of Sherpa are ferrying stores up the Western Cwm to Camp IV. The Swiss in 1952 called this beautiful place the 'Valley of Silence'. Looking west, Lingtren and Khumbutse are in the distance, on the frontier with Tibet.

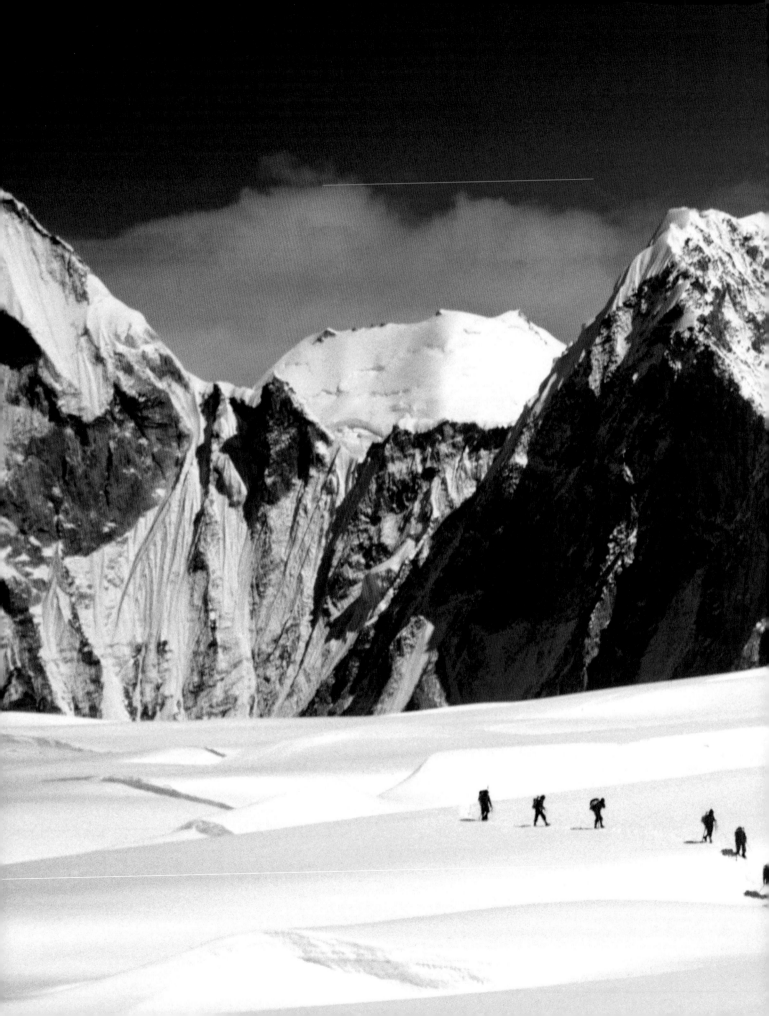

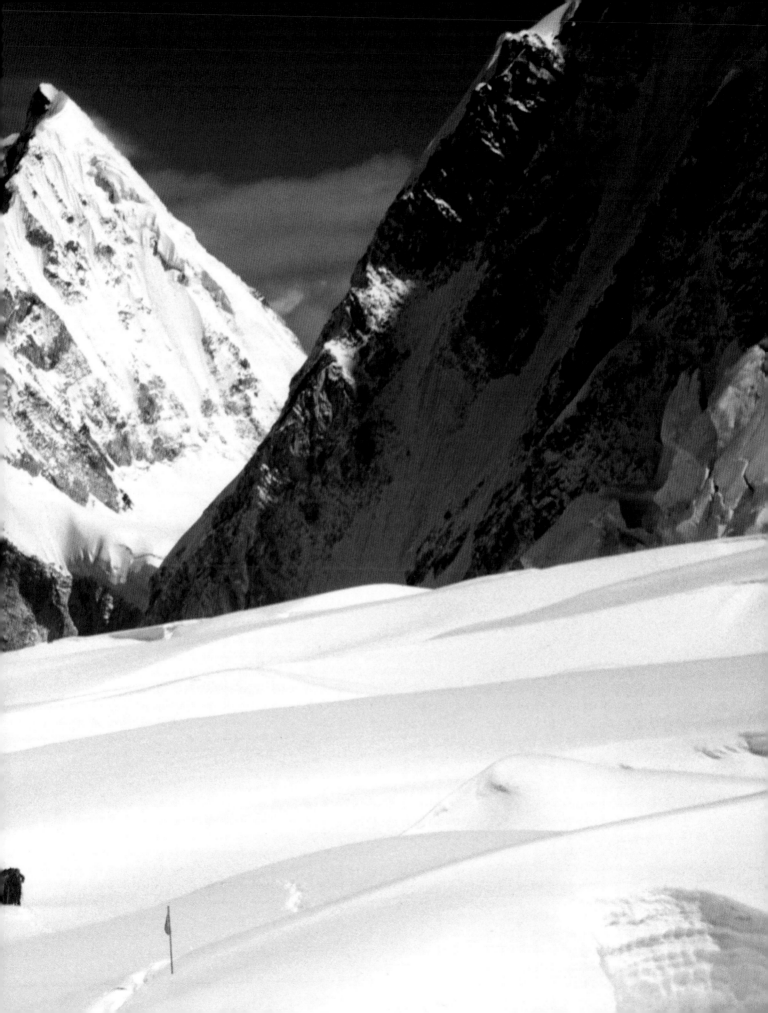

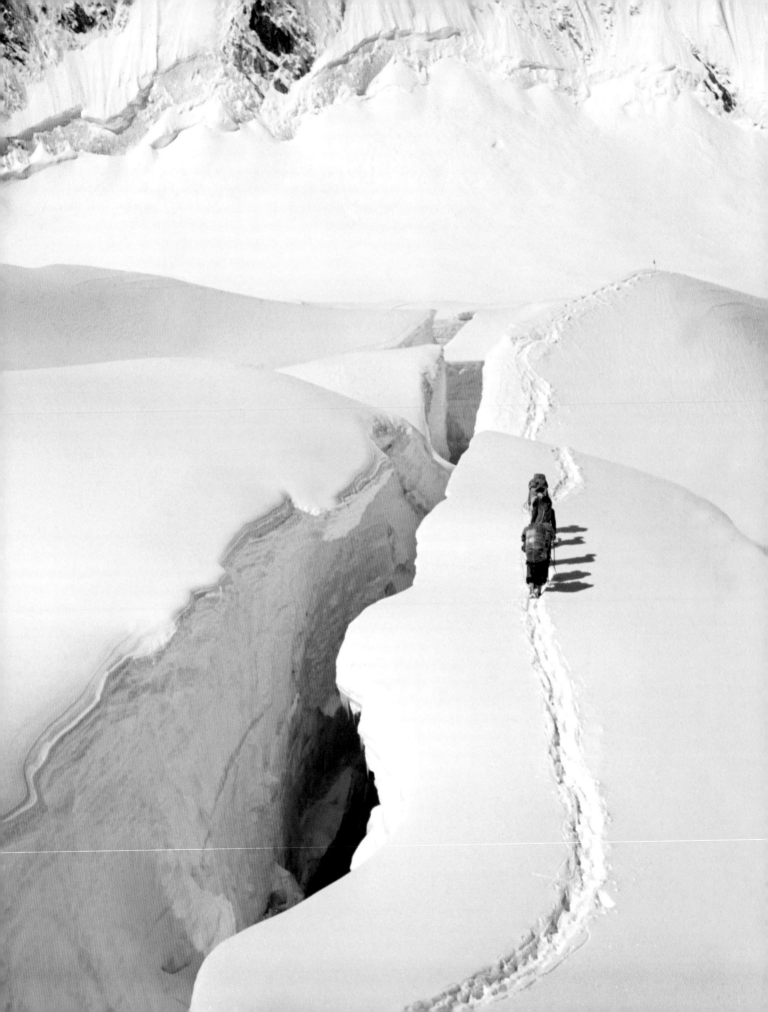

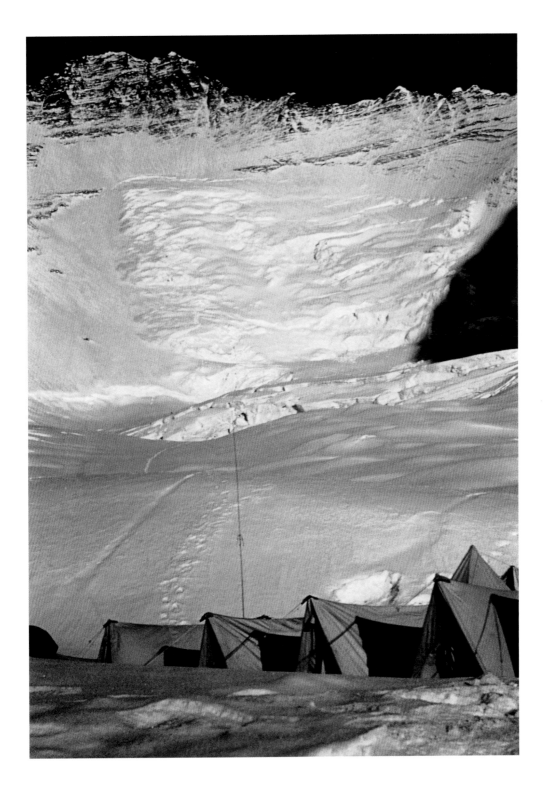

LEFT Noyce leads a party along the marked route in the Western Cwm. The afternoon snowfalls would make our footprints vanish, and each morning we had the hot work of beating a new trail through the snow. We followed the jagged edge of this crevasse until, under the wall of Nuptse, we could cross by a natural snow bridge and take a direct line up the Cwm again.

ABOVE By 1 May we had established Camp IV, our Advance Base, at about 21,000 ft, a mile from the foot of the Lhotse Face, which loomed large before us. It was a situation of great beauty. Behind our camp, Everest rose in a mass of black rock, shattered ice and hanging glaciers.

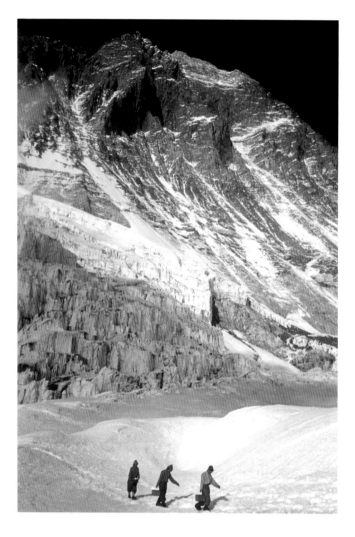

ABOVE We are fetching fresh melt-water in the Western Cwm from an unexpected pool near Camp IV.

RIGHT Sherpa preparing equipment at our Camp VII, high on the Lhotse Face. The picture shows our Meade tents, assault oxygen bottles and stores for the South Col nearby on the snow. By 18 May a safe route had been made up to this camp and some way beyond, but there still remained the long traverse across the upper part of the Face to the South Col.

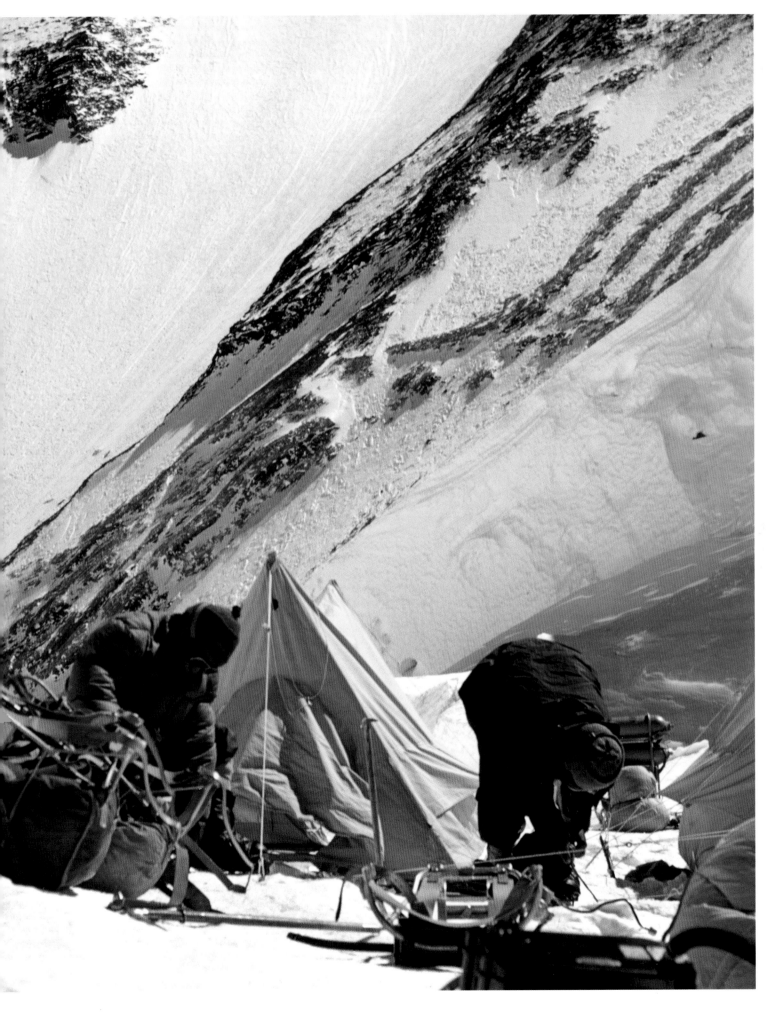

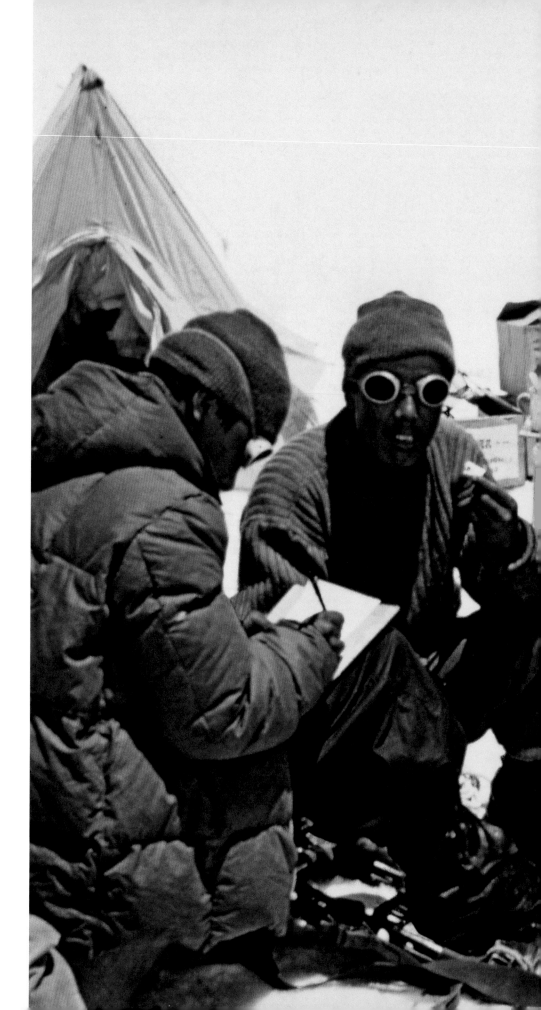

RIGHT Our Sherpa team take a well-earned break before carrying supplies up the Lhotse Face. We all had specially made high-altitude boots in what was then a revolutionary design, with an inner boot and an outer shell.

FOLLOWING Looking to the west down into the Western Cwm from Camp VI on the Lhotse Face – fold after fold of whiteness, dropping downwards in a pure wilderness of snow, until the view disappears over the edge of the Icefall.

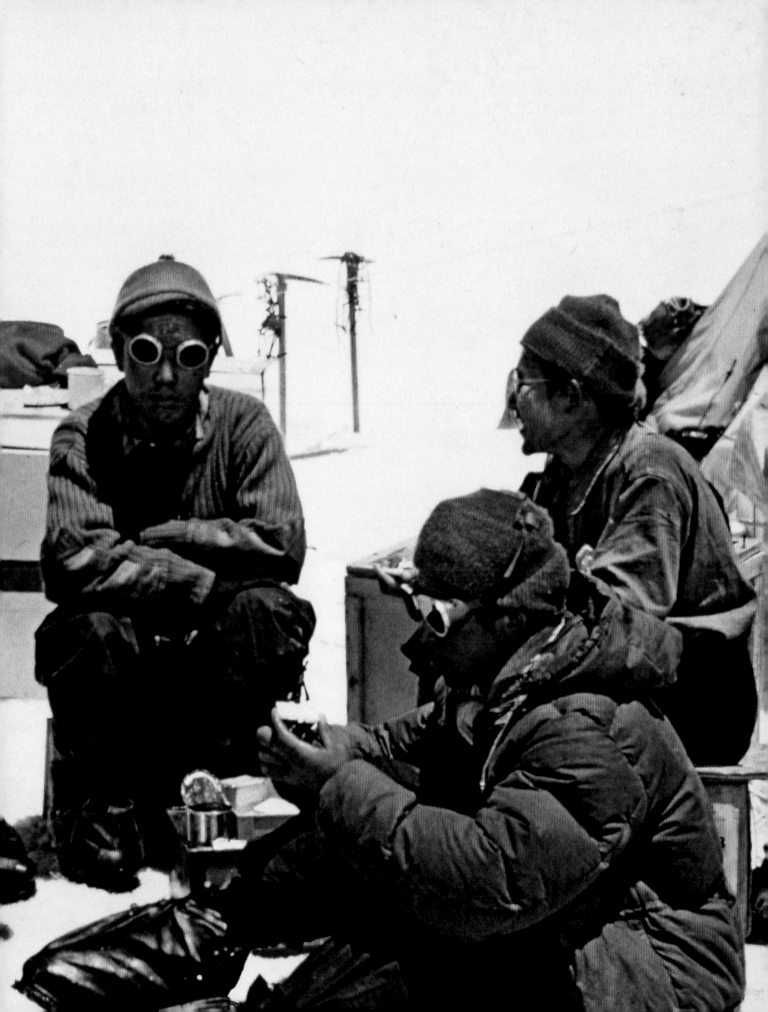

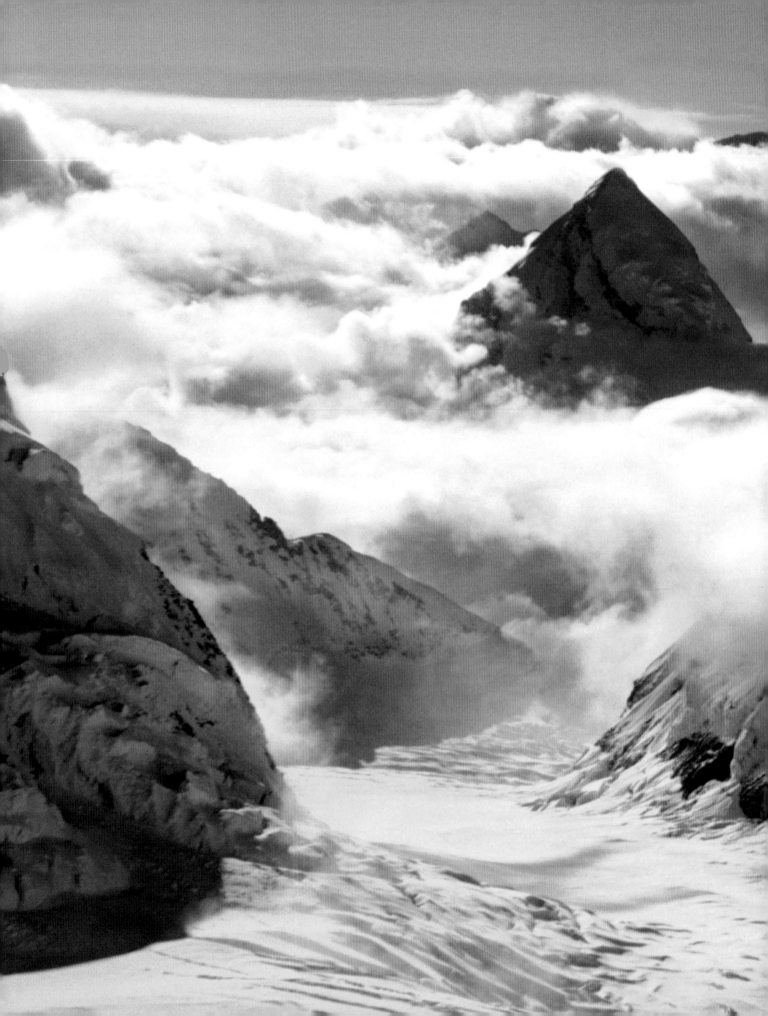

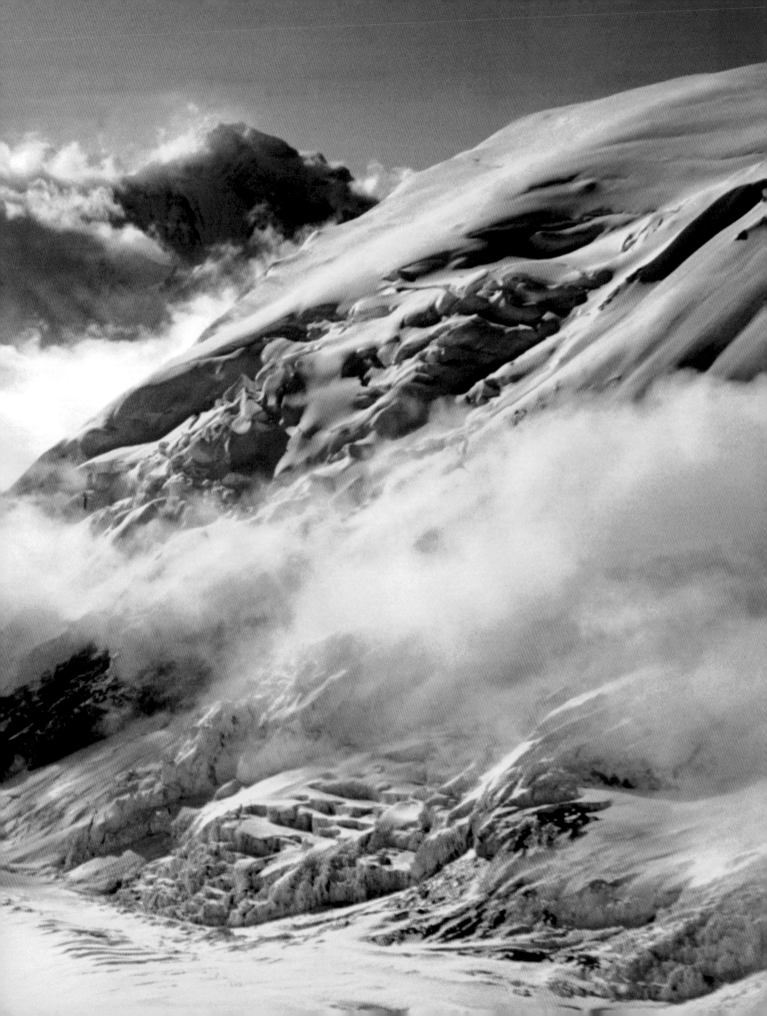

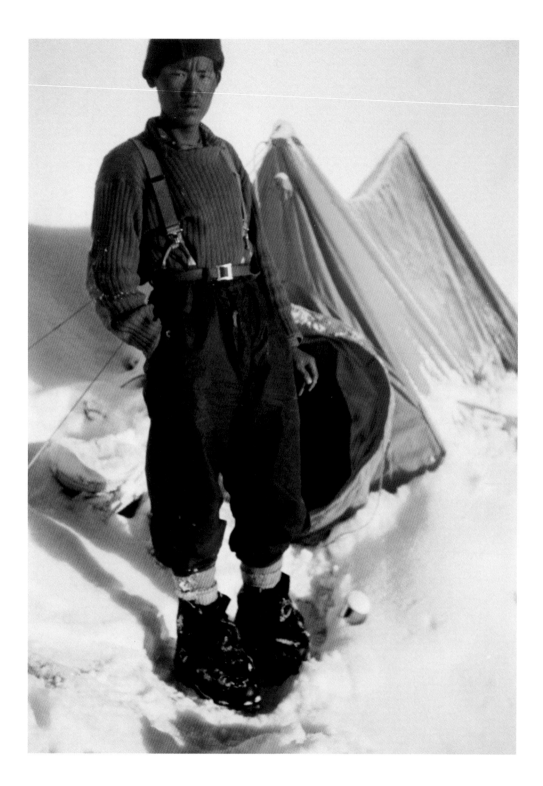

ABOVE AND RIGHT From Camp VI, Ang Nyima and I began our work
to cut a route up the Lhotse Face. It was a lonely, exhausting task,
but we pulled through. I took this shot of him (right) securing the
hand lines, which would enable the rest of our companions to
follow in our steps. The last portion of the route up to the South
Col was finally secured by Noyce and Sherpa Annullu on 21 May.

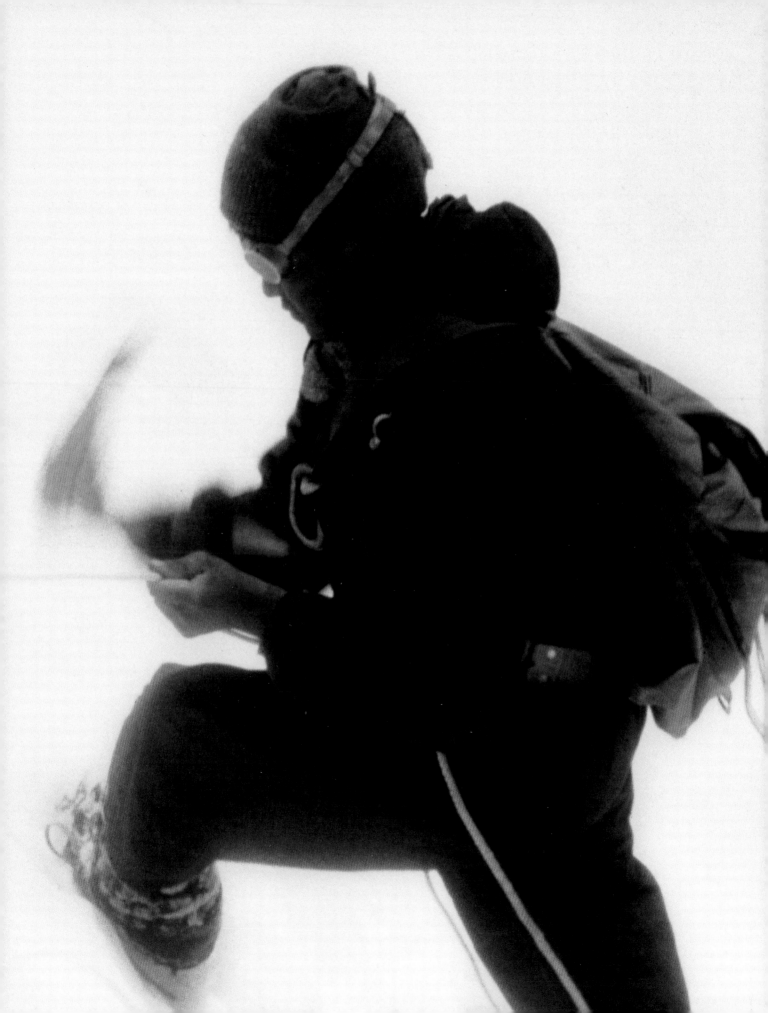

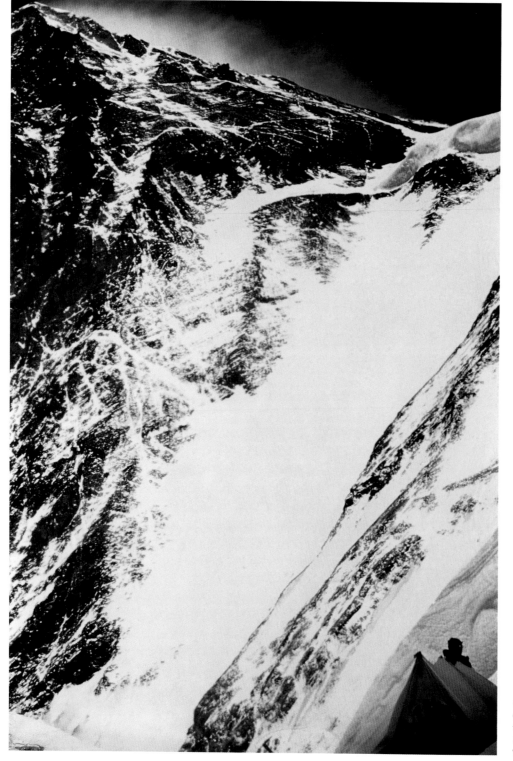

LEFT Camp VII, high on the Lhotse Face, was a dangerous place, with little room to rest on your laurels. The Geneva Spur cuts our path to the South Col, and high above, the summit ridge of Everest sweeps up to the sky.

RIGHT Our steps were continually covered in fresh snow. Ed Hillary helps to keep the Lhotse Face secure, as he leads a team of Sherpa up to our Camp VIII on the South Col.

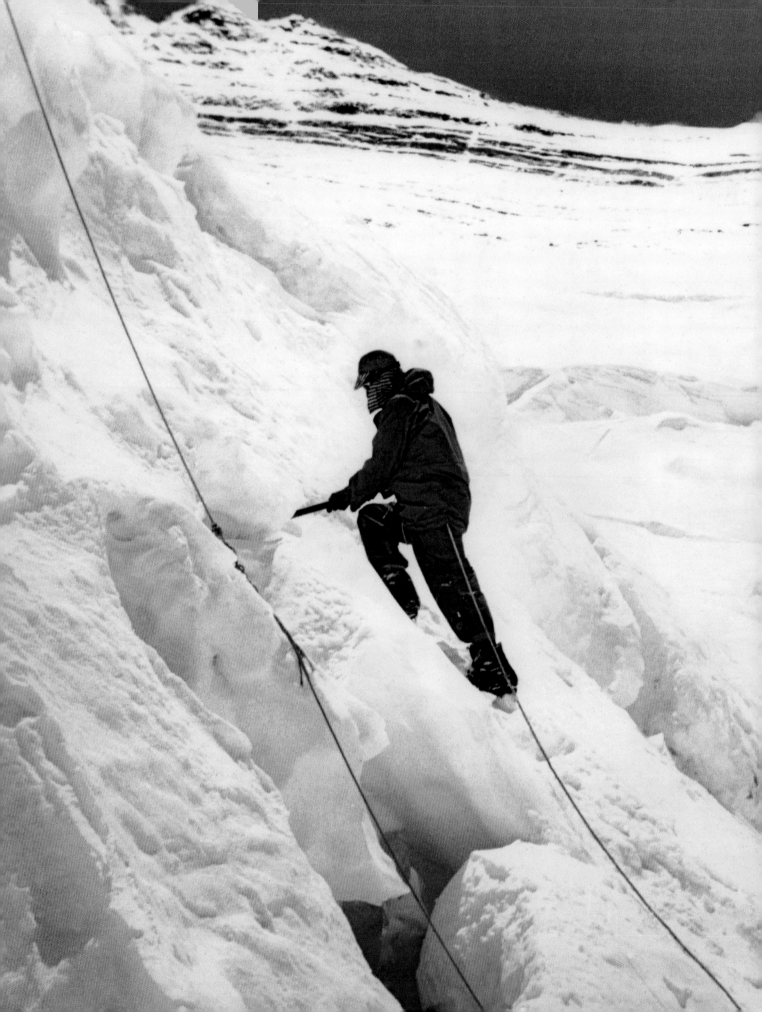

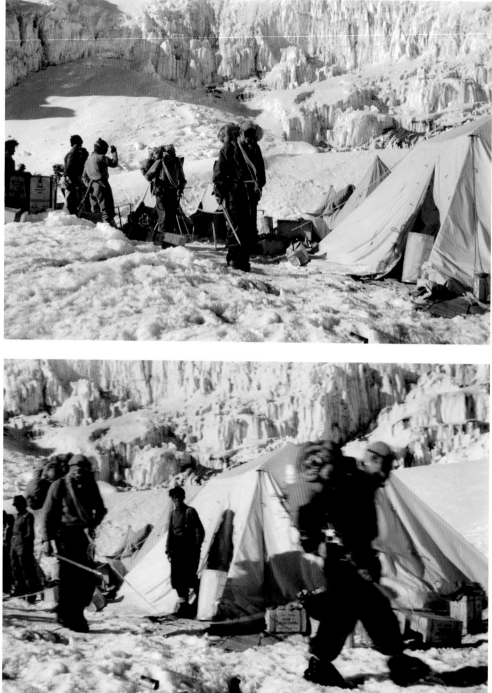

ABOVE On 22 May the first assault pair, Bourdillon and Evans, left Camp IV on their way up to the South Col. They were using the closed-circuit oxygen system. Bourdillon, the first on the rope, is wearing his blue wind-proof suit and rubber-soled high-altitude climbing boots. His rucksack, eiderdown, sleeping-bag and crampons are all strapped to his oxygen set.

RIGHT On 25 May the second assault party, Ed and Tenzing, left Camp IV. Ed makes a quick check of their oxygen equipment, which they used all the way to conserve their energies. Tenzing's ice-axe is prepared for the top, with flags wrapped round its shaft. I had already left as part of the support group, along with five Sherpa to carry more stores to the South Col.

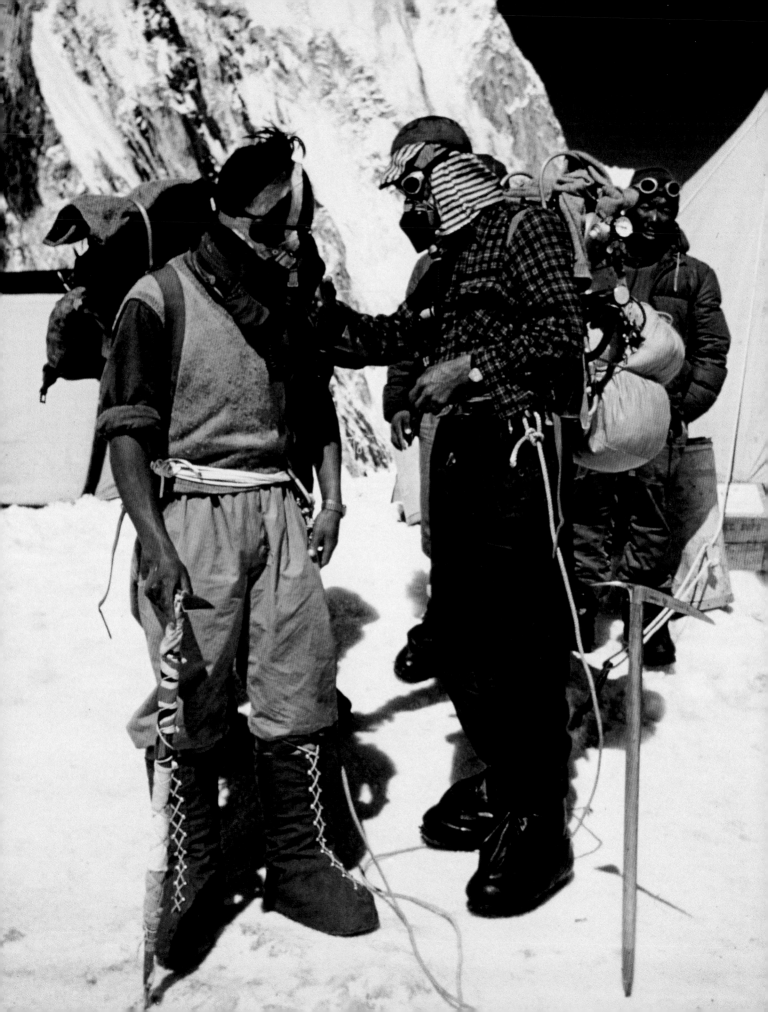

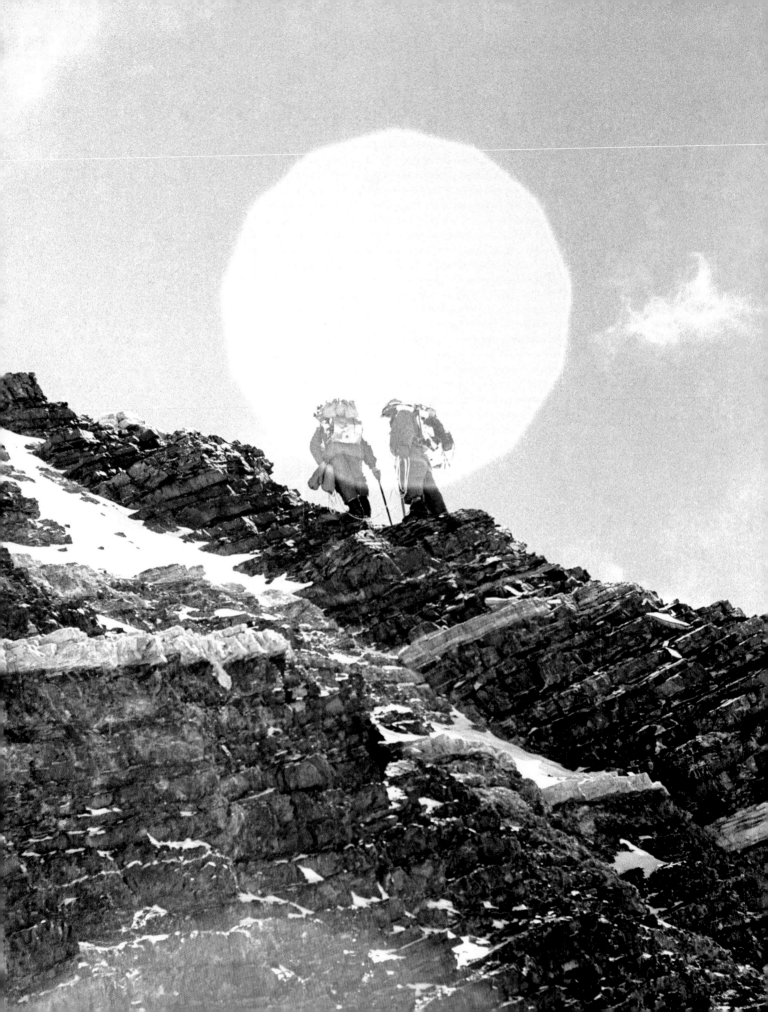

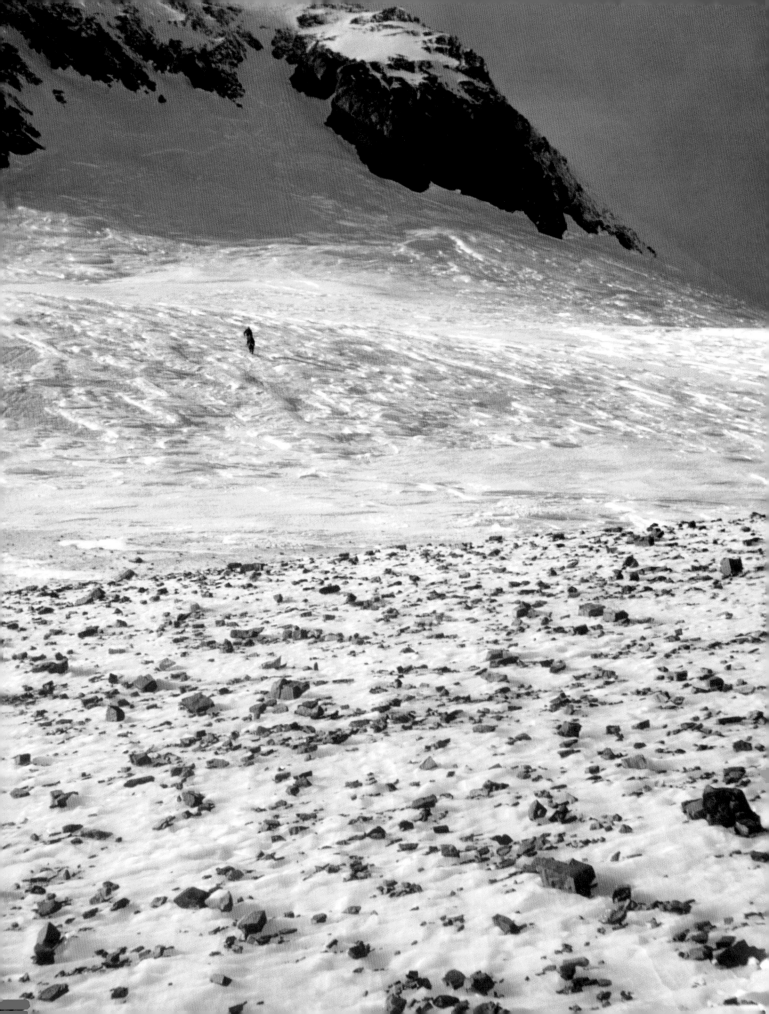

PREVIOUS LEFT On the first assault of the South Summit on 26 May, Evans and Bourdillon are photographed by Hunt on the rocks approaching the ridge at 27,200 ft.

PREVIOUS RIGHT Camp VIII was on the dreary waste that is the South Col. It must be one of the most unpleasant spots in the world. Here the altitude, the wind and the cold combine to make life pretty unbearable. The stones and glistening blue ice are swept continually by an Everest gale.

LEFT Two tiny black dots emerge from the shadows at the foot of the couloir – Evans and Bourdillon are returning from their summit attempt, making their way wearily across the windswept ice of the South Col. Had they got to the top? We had no way of knowing until they staggered towards us.

ABOVE Hunt welcomes an exhausted Evans and Bourdillon back to our Camp VIII. I have never seen men more tired. They had given their absolute all, climbing over 3,000 ft in one day to reach the South Summit. Just 300 ft above them, the final summit would seem tantalizingly close, but they could go no further. Had they done so, they would have surely died in the process.

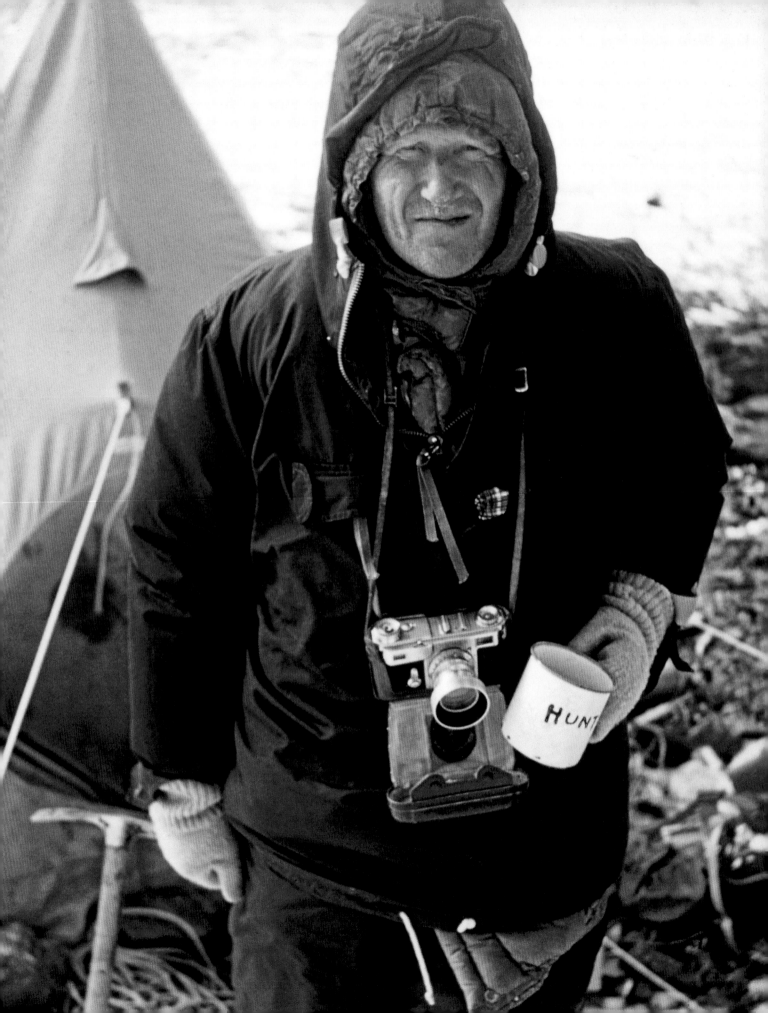

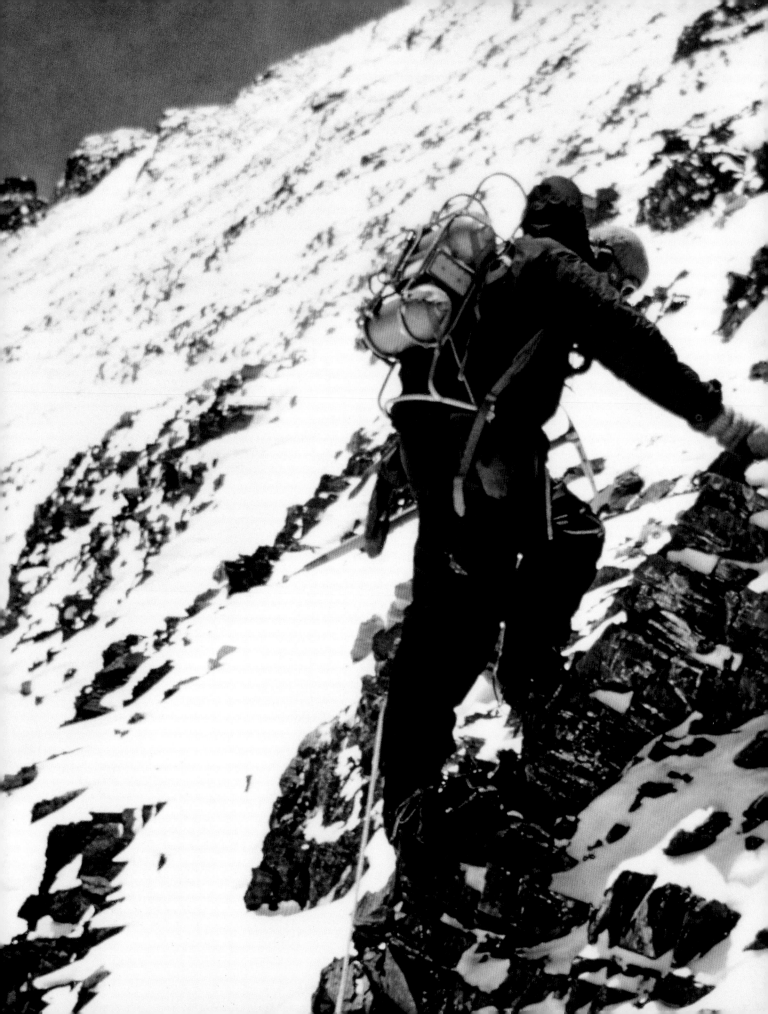

PREVIOUS LEFT Wilfrid Noyce climbed excellently to secure our route up to the South Col.

PREVIOUS RIGHT John Hunt returns exhausted to the South Col on 26 May, after his support carry on the South-East Ridge. A mug of tea was his first request. We were crowded that evening at Camp VIII. The second assault party of Hillary and Tenzing, with Gregory and myself, were in the pyramid tent, while Hunt, Evans and Bourdillon crammed into the two-man Meade. It was a terrible night. Continually buffeted by the gale, there was no question of sleep.

LEFT After waiting out the storm, our push from the South Col began on 28 May. In this photograph I am beginning to climb the rocks of the steep couloir that leads up to the South-East Ridge.

FOLLOWING Alf Gregory took this nice shot of me changing film in my Kodak Retina II at about 27,300 ft. Soon we had to start looking for somewhere to place Ed and Tenzing's tent – Camp IX. The ridge continued upwards in one unbroken, remorseless sweep and yet we plugged slowly on, hoping for a ledge, which we finally found beneath a rock bluff just below 28,000 ft. Gregory, Ang Nyima and I dropped our loads, and after I had taken a few photographs of Ed and Tenzing moving up to join us, we began our weary descent back down to the South Col.

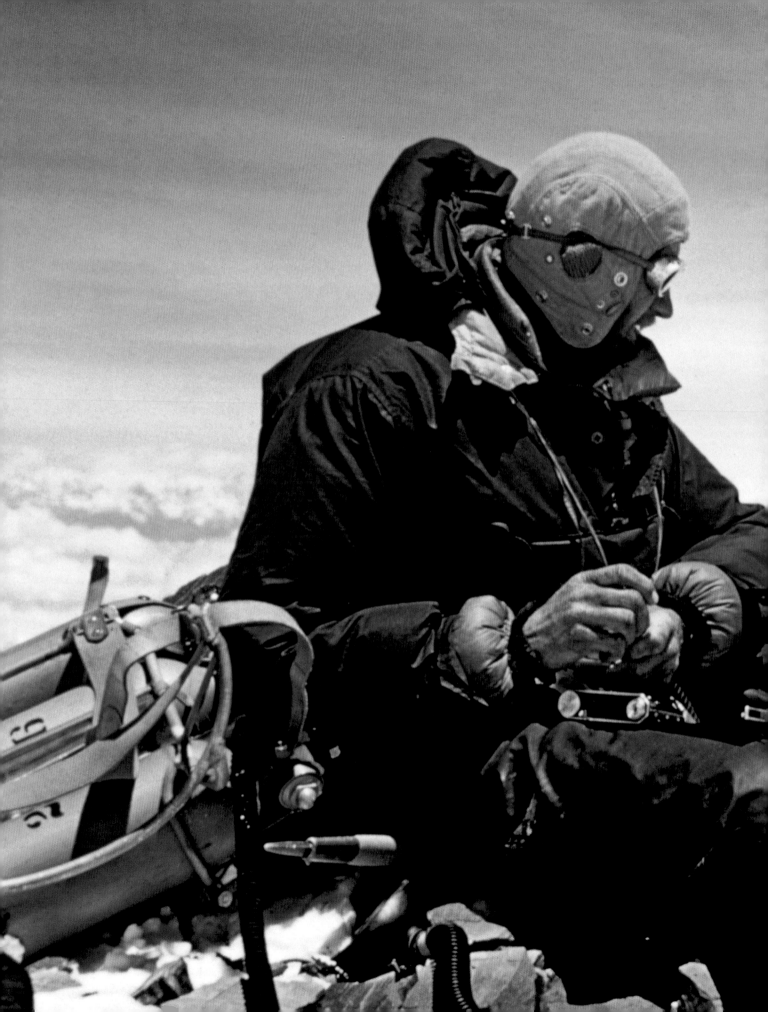

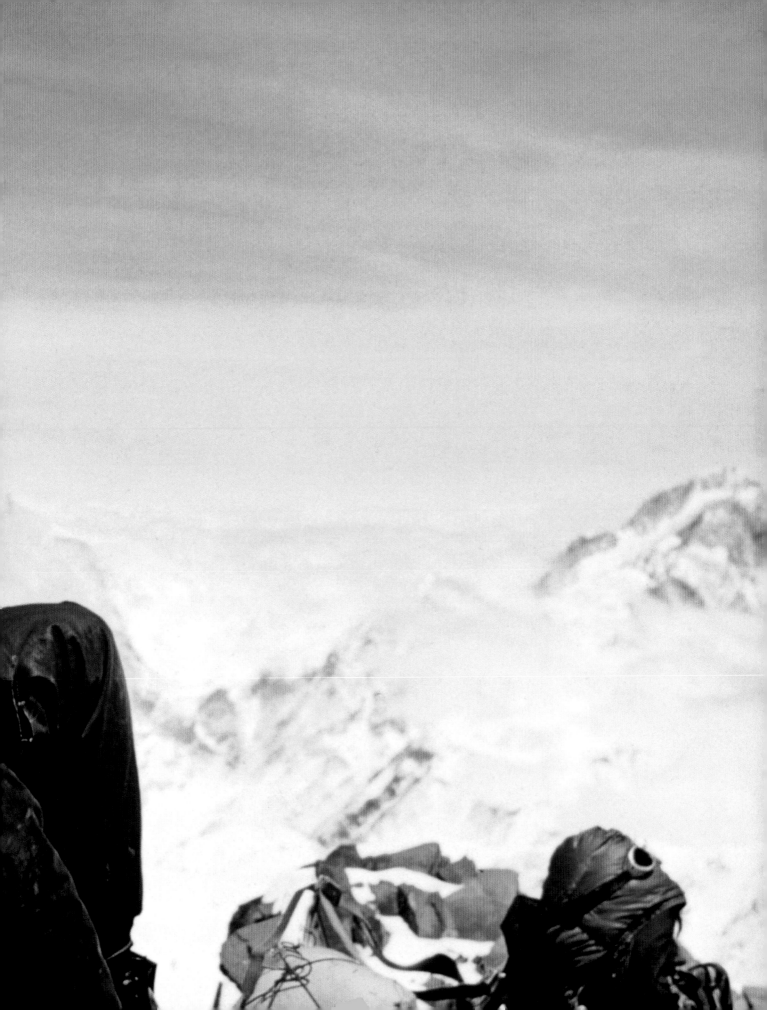

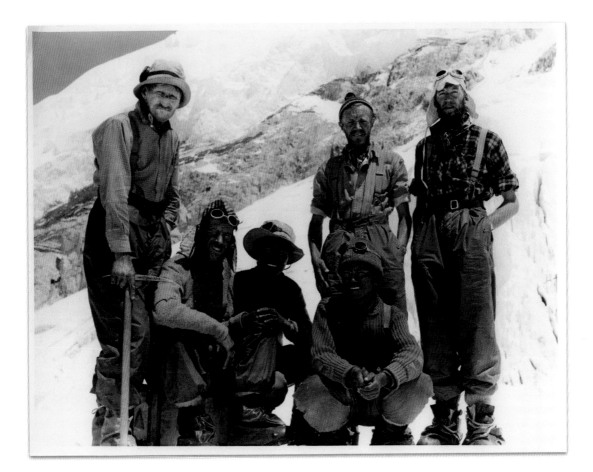

3 | BEYOND THE SUMMIT

Meantime let us count our blessings – I mean those thousands of peaks,
climbed and unclimbed, of every size, shape and order of difficulty,
where each of us may find our own unattainable Mount Everest.

Bill Tilman, 1948

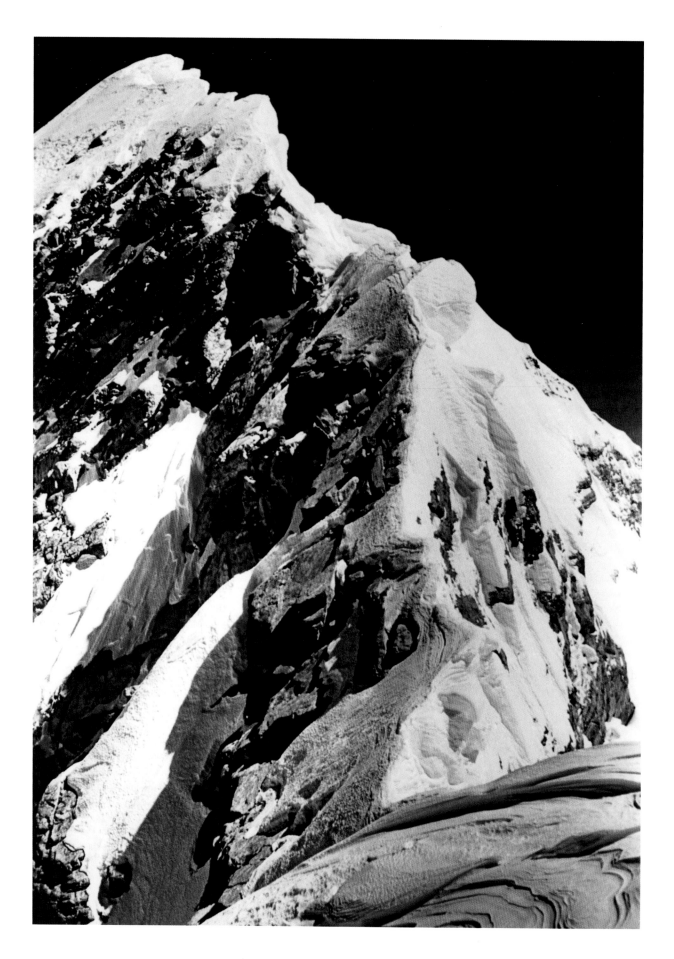

After Everest came the wining, the dining, the lecture tours. It began within minutes of our return to England and lasted a month until we flew home to New Zealand – there to be given a further exhausting spell of the same treatment. The film of our climb, *The Conquest of Everest*, also proved a real success. Though I still feel the mountain is unconquerable in its way, the film was well received and the public enthusiasm for it all amazed us. Even my colour footage turned out rather well and in the end I had a hand in directing the whole thing. Lucky again, I suppose.

But before all that, we had to get safely off the mountain. Everyone now knows what Ed and Tenzing achieved that day up high, so I won't dwell too long on the detail. Needless to say, it all went pretty much according to plan. They sat the night out in Camp IX – the platform was too small to lie on – they dozed and brewed drinks and left at about 6.30 a.m. on 3 litres of oxygen per minute. By 9 a.m. they had reached the South Summit, the last part a very steep climb up bad snow. The summit ridge was corniced and steep and Ed led for almost three hours, cutting steps all the way. He said he felt good and was able to cut and move steadily without pause.

A rock step – vertical 40 ft – was climbed by a chimney in which he worked back and knee, and the last part was tantalizing because of crest after crest without the summit. Finally, at around 11.30 a.m., they approached a sharp snow cone from which they would be able to look down on everything. A few more whacks of the ice-axe, a few very weary steps, and they were there!

'Tenzing was so excited that he embraced me,' Ed told me later that night, 'we thumped each other on the backs and enjoyed the moment, but there really was no time to waste. It's the perfect summit, every main ridge comes up to it and you can look down each one. I took a photograph looking down every ridge and one of Tenzing on top waving the flags that he had carried up. I think they were the United Nations, Union Jack, and others, I'm not sure. I didn't worry about getting Tenzing to take a picture of me. He'd never taken a photograph before and the top of Everest was hardly the place to show him how.' I chuckled at this – pure Ed. As it was, that photograph he took on top was a brilliant one, perhaps the most memorable from the whole expedition. It really can't be bettered.

They took off their oxygen sets and walked around, Ed photographing and Tenzing pointing out Thyangboche Monastery in Nepal and Shekar Dzong away in Tibet. There was a steady breeze, but otherwise it was a perfect and clear day. Ed collected a handful of stones from the top and brought them down – he gave me the first and it's quite a treasure. Tenzing left an offering of food – a bar of chocolate, a packet of biscuits, a few lollies – small things, but a gift to the gods who make their home on the summit. Ed also left a small crucifix, which John Hunt had asked him to take to the top. Whatever the religion, both men were united in respect for this mountain, and both keen to get down as quickly as they could. After only about fifteen minutes they turned to go.

After I'd met them on the way down, the fourth night on the South Col was another bloody windy, cold night. On 30 May we gingerly descended the entire Lhotse Face aiming for Camp IV in the Cwm to share word of our success. At Camp VII on the Face, Charles Wylie was there to receive us with tea and whoops of joy. We went straight on, past VI and V, and in the afternoon met Tom Stobart on the way as he was filming. As I approached him, I gave the 'thumbs-up' sign and he went

LEFT When Hillary took this photograph on the morning of 29 May, just four men had seen this final ridge to the summit of Everest – and none had set foot there.

PREVIOUS Back down safely at Camp IV on 30 May, our South Col and summit team pose for a photo: Hunt, Hillary, Tenzing, Ang Nyima, Gregory and myself.

mad. He told us John and everyone were waiting at Camp IV, and were nearly out of their minds with anxiety and conjecture. Here we entered a conspiracy and decided to make no sign, walk up to Camp IV and surprise them with the news. Tom was keen because he wanted to film the ensuing scene.

We pushed on towards IV, and when a quarter of a mile away and in view of the tents John and nearly everybody began to come up to meet us to see what the news was. We plodded towards them, excited as hell, but not making any sign. John, we could see, had decided we had failed. His shoulders were slumped and he walked wearily and slowly, thinking dismal thoughts. The others were hesitant as to whether to make the effort to meet us and hear the worst. Tom was with us saying, 'Not yet! Wait a bit, get closer.' Then, when John was perhaps a hundred yards away I shoved up my ice-axe and waved the marvellous victory news.

John stopped and gaped, Mike Westmacott began to run and the others did varying things from cheering to crying. John cried. He ran forward, hugged Ed and Tenzing with tears running down his face. He had put so much work and worry into his efforts that the tension broke him. Tom filmed some rather un-English scenes of emotion, but it was just such a supreme moment for everyone. James Morris, *The Times* correspondent, was there to witness our return, then raced off down the Icefall to speed the news to London. Even later, John was so overcome that he retired to his tent, so stirred that he couldn't talk. Mike Ward, the doctor, gave him sedatives and put him on to oxygen.

The expedition, after all the trials and work and hope, was now a success. The top was reached and, most important of all, everyone was safe and well. We were so glad that a British party had reached the 'third pole' after over thirty years of trying. That night we toasted the old Everesters, John, the Sherpa, Eric Shipton, and talked far into the night.

The rest of our descent is a blur to me, even now. The Icefall was especially dangerous, as it was nearly dark when we reached Base Camp. For two days we never left our sleeping bags. As I wrote at the time:

… At present, don't imagine our band of thirteen rolling and rollicking in an ecstasy brought on by victory. If you were at Base Camp now you would see nine sahibs and about fifteen Sherpa lying listlessly around the tents with bloodshot and glazed eyes, thin, dirty and bewildered. Ed now is sleeping as he has done for hours and hours, Charles is just smoking and tired; the talk is desultory and dull; everyone is quite played out. Five of the other lads will be descending tomorrow from Camp III and they too will come in stiff-legged and flogged after the last two weeks.

Two days ago we were on the South Col urging ourselves to the limit – and now like pricked balloons all our reserves have gone. Yesterday we came down to Base Camp. Ed, Charles Evans and I were together on one rope and it took hours. I have never been so tired, nor had Ed. Now, if you could see us, you would see the most beaten, played out, lustreless team of climbers that it is possible to imagine.

There, with bloodshot eyes and wasted bodies, we heard the broadcasts for the Queen's Coronation on a small radio. And then the BBC announcer broke in, and said that they had to announce that Mount Everest had been climbed – and I thought, 'My god, we've really done it!'

Miraculously, Morris's dispatch had got through perfectly, sent via the Indian Army radio station in Namche to the Indian Embassy in Kathmandu, who passed it to the British Embassy, who then cabled it to *The Times* in London. It really was a marvel of reporting and logistics to achieve this back then. The secret message read: 'SNOW CONDITIONS BAD STOP ADVANCED BASE ABANDONED YESTERDAY STOP AWAITING IMPROVEMENT STOP ALL WELL', which, de-coded, meant: 'Summit of Everest reached on 29 May by Hillary and Tenzing.'

That Coronation night we toasted the Queen and the Duke with a noggin of rum. The quantity was hardly an egg-cup full each, but such was our depleted state that nearly everyone became quite drunk and garrulous and we passed the evening in singing and merriment – too exhausted really to sing well but also too excited to sleep.

The acclaim given to the first ascent was due, I suppose, not only to the achievement, but also to the way it was announced. John Hunt once called it 'fortuitous timing', and he was right in saying that the story of our success would prove as important as the facts of our climb, perhaps even more so. We've all gone on to have equally satisfying, and dangerous, times in the mountains. There are moments, when alone, that the experience is even more enjoyable – to be still and allow the hills to soothe the soul and clear the mind. But, of course, these experiences are not the stuff of newspaper headlines, certainly not of the sort to release a global frenzy of reporting as our time on Everest did.

Our expedition success caught the imaginations of many people and, in its own way, met the expectant public mood, weary after five years of war not long before and hopeful of a bright future. As the crowds gathered in London for the Coronation on 2 June 1953 the news of our success was announced on the radio and over speaker systems lining the streets. We shared the front pages with the young Sovereign. 'THE CROWNING GLORY – EVEREST CONQUERED!' We were delighted, of course, but also more than a little embarrassed to be held up so high.

The news was greeted by some climbers with a sigh of relief. Our friend and mentor Shipton voiced the opinions of many when he remarked: 'Thank Goodness, now we can get on with some real climbing.' He could be forgiven for some of his cynicism and there was some truth in it for us too. Everest had become the focus of so much attention, and the pursuit of the ultimate in altitude had burned so strongly in the hearts of climbers from many nations, that it had tended to distort the mind a little away from those aspects that had drawn us all to the hills in the first place – the pure enjoyment of it, the personal experience, free from the glare of publicity.

As we left the Khumbu, John Hunt had gone ahead to make arrangements for the welcoming of the team, and Hillary and I were left to bring the main party south. We started getting mail runners – carrying bags of letters, newspapers and telegrams – and every day it was becoming clear that the climb of Everest had attracted worldwide attention. Late one afternoon Ed and I were walking along a narrow path when we met still another mail runner – the second that day. I sorted out the post. 'A letter for you', I said. The envelope, addressed in John Hunt's handwriting and with the last three letters heavily underlined, was to Sir Edmund Hillary, K.B.E. I suppose I started to laugh a little. Ed looked up at me in astonishment and said, 'What's so funny?' I told him he'd been given a knighthood, and he said 'Ha, ha, big joke'. He simply didn't believe me, but sure enough,

THE ILLUSTRATED LONDON NEWS.

The World Copyright of all the Editorial Matter, both Illustrations and Letterpress, is Strictly Reserved in Great Britain, the British Dominions and Colonies, Europe, and the United States of America.

SATURDAY, JUNE 27, 1953.

THE CONQUERORS OF EVEREST: E. P. HILLARY (LEFT) AND TENSING BHUTIA, THE FIRST MEN TO SET FOOT ON THE SUMMIT OF THE WORLD'S HIGHEST MOUNTAIN.

On the night of June 1-2, the eve of the Coronation, *The Times* received from the British Mount Everest Expedition, 1953, the message that E. P. Hillary and the Sherpa Tensing Bhutia, had reached the summit of the mountain, 29,002 ft. high, on May 29. It was later announced that the time of their triumph was 11.30 a.m. and that they stayed on the summit for about fifteen minutes. The news was taken directly to H.M. the Queen and published on the morning of her Coronation—a "crowning homage" for the great day. The Queen sent an immediate message of congratulation; and on June 8 it was announced that she had approved the conferring of a K.B.E. on Mr. E. P. Hillary and a Knighthood on Colonel John Hunt, the leader of the expedition. At the same time it was stated that she desired also to honour Tensing Bhutia, but that, since he is not a British subject, the form of the award would require consultation. He is claimed as a citizen by both Nepal and India. A George Medal was offered and it is understood that Nepal has agreed to this.

(Photograph and excerpts by arrangement with "The Times.")

c

158

in the letter it indicated that the Queen had made him Sir Ed. So, that was when we both really realized there just might be a real hullabaloo about our success. 'You go and have a good time on a mountain and then this happens to you,' Ed said, adding, 'I used to wear normal clothes for beekeeping. *Goddammit,* I'll have to get a new pair of overalls!'

As the years passed, the Everest achievement travelled in many directions, both to the good, and the slightly bizarre. John described this well:

Our ascent became a symbol of national status, a subject for sermons and for The Goodies, an incentive for export drives, a target for charitable appeals, a trade name for an Italian wine and for double-glazing against the rigours of the British climate. The names of some members of the expedition have been given to schools and school houses, to streets, youth clubs, Scout troops, exploration groups, and even to three tigers in the Edinburgh Zoo …

Fortunately, I was able to step out of the limelight fairly soon and, as far as I can remember, never had an animal named in my honour. I did get a mountain in the Antarctic though, some time after my expedition there, and was more than happy with that.

The story of our time on this, the largest of the world's mountains, went on a journey all of its own and it was used in ways that we had no control over. Often we could only observe it all from a distance. Publicity, with all that involves, was bound to get our motives wrong, or at least simplify the objectives into something clichéd and newsworthy – 'dare-devil', 'record-breaking', 'all-conquering', or 'intrepid heroes slashing a path to victory up hazardous ridges', as some newspapers had it.

But that was not the way we saw our experience. I've always liked the way Bill Tilman, an Everest pioneer, viewed this publicity machine:

Every genuine mountaineer must shudder involuntarily when he sees anything about mountains in newspapers … Mountaineering is altogether a private affair between man and his mountain; the lack of privacy is disagreeable and particularly so if, as usually happens, the newspaper gets hold of the wrong mountain wrongly spelt, adds or deducts several thousands of feet to or from its height, and describes what the wrong man with his name wrongly spelt did not do on it.

At least they did manage to spell Everest right most of the time! But, more often than not, the precise details didn't always win out. As it was, the climb had become public property and it grew to become an achievement far bigger than all of us. At best, we were each left with our own experience as we tried to continue on with the rest of our lives.

And life was moving a good deal faster than on any mountain. Ed carried out the proverbial whirlwind courtship, and on 3 September 1953 married a girl we both knew: Louise Rose, whose father was president of the New Zealand Alpine Club. At the wedding I was his Best Man. Just twenty-four hours later we were boarding an aircraft for another trip to Europe, followed by a still more heady round of lectures that seemed to span every major or minor city between Reykjavik and Rome. In England, France, Scandinavia, Finland, Belgium, Holland, Italy, we were telling the Everest tale at the rate of twelve to fifteen lectures a week. It was the only time in my life I had ever earnt fairly big money.

LEFT Back from the summit, Tenzing and Ed pose for the first of very many portraits. My photograph of these 'Conquerors of Everest' made the front page of *The Illustrated London News* on 27 June, as the excitement of their achievement spread across the world.

By now our film, *The Conquest of Everest*, was showing in theatres around the world. I can't recall exactly how many times we watched it, or had to, but it was a huge amount, although it was often a pleasant chance to catch a moment's relative quiet – before having to summon the courage and energy to give yet another lecture. Even *The New York Times* gave us a useful review:

> No need to give an explanation of what this nerve-tingling picture is about. It is the official film record of the ascent of Mount Everest last spring. But more than a slapdash compilation of incidentally-taken photographs, picked up by the climbers at odd moments – as such records often are – this is a skillful visualization of drama of the most tremendous sort, filmed in magnificent color and edited, scored and presented in brilliant style … Thanks to brave men and fine technicians, the experience of climbing Everest may be had for the price of a theatre ticket. This is certainly the bargain of the year!

By the end of January 1954, three of us from the Everest party – Hillary, Charles Evans, the deputy leader, and I – were embarking on two more expeditions. The first, and in a sense the most gruelling, was a two-month, coast-to-coast, how-we-climbed-it, why-we-did-it lecture tour of the United States. The second, still in its birth pangs, was a New Zealand Alpine Club expedition to be carried out in the Himalayan region of the 27,790-ft Makalu, the fourth highest mountain. It was unclimbed, unexplored, and every bit as testing as Everest.

The grand American tour, talking our way up Everest, with Steak Diane for rations, Cadillacs for Sherpa, nightly climbs over glassy peaks of Scotch or Bourbon on the rocks – the alcoholic Western Cwm, the dipsomaniac Icefall – was the worst kind of training programme for our assault on Makalu. And the junketing did not end in the United States. Ed and I worked our way lecturing down through Honolulu, then across the Pacific to Fiji, finally home again to New Zealand. Four days later we flew to Calcutta, took the train to the Nepalese border (where we again met Charles Evans who had come round the world from the other side), and on 1 April 1954 we walked wearily into the Himalaya – three fat and flabby climbers suffering from what Dylan Thomas once called 'the ulcerous rigours of the lecturer's spring'. Getting ourselves back into condition was a process almost as exhausting as the good living which lay behind and inside us.

From America we had brought at least one astringent experience that gave us deep satisfaction. It was an article written by the leader writer of the National Geographic Society, who was assigned to obtain a story from the great Sir Ed Hillary while we were visiting New York. By that time we were all fed up to the teeth with newspaper reporters and endless interviews, with their unceasing demand for a fresh 'anecdote'. Now, even a journalist from such dignified circles as the National Geographic was no longer being given much of a welcome. The writer was an extremely amiable as well as a persistent young man, however, and as Hillary expressed it later: 'Only a chap with a fine sense of humour could have withstood the cold war of George Lowe, Charles Evans and myself.'

In the end the man produced a neatly designed piece. His final paragraphs gave us untold joy:

> Installed in a drawing-room with Hillary, I encouraged him to stretch out his long, lanky frame, take his boots off, and retell the account of his ascent, foot by sweating foot. For

four hours we worked our way back up the mountain. I found, to my delight, that I was now quite well acclimatized: even in the worst sections, where the narrative had been packed down hard and tight by previous parties, I managed to keep my footing, and the drowsiness which afflicts many writers at this stage scarcely bothered me.

Hillary, however, was obviously having a rougher time. His phrases were becoming more and more laboured; his invention seemed to be flagging; at times I found him almost about to yawn, until he caught himself with an effort and moved on. He even complained of a headache – a common enough affliction on this ascent, but one which he has trained himself usually to suppress.

The last ten pages were the critical part. Our notes were coming more and more slowly. At one point I wondered whether we had not better give up altogether and admit failure. After all, the mountain had beaten better teams in its day; there would be no disgrace in turning back. But just then, in a final magnificent burst of New Zealand slang, Hillary lurched forward and achieved the crest. We had made it!

Later, I asked Hillary where he was going to camp in Boston. 'At the Statler', he replied. 'But why?' And this was his answer – one which I shall always remember. Quite simply, but with a deep undercurrent of emotion, he said: 'Because it is there.'

❧

For many months now I had been spending most of my time in the stimulating company of Ed Hillary, and I too began to realize what fantastic strides the man had made from mountaineer to potential leader. Until Everest our climbing careers – along with the progress of that basic driving initiative that good climbing demands – were running more or less in step. But Ed strode mightily forwards on Everest, in every sense; and a year later he was the natural leader among us for exploration into this other delectable corner of the Himalaya near Everest.

While our attempt on the great Makalu in 1954 was in the end frustrated – though it turned into a successful climb of the nearby ice spire, Baruntse – it was notable for two major incidents. One was a terrifying combination of frostbite and crevasse accident, the other a predicament of Hillary's which had the effect of putting even *The Times* into a dither when it learnt they possessed no obituary of Sir Edmund.

He had gone, in almost total darkness, down into a crevasse on the end of a rope in an effort to extricate one of our teammates. With the wind howling madly and our Sherpa pulling on the rope, Ed was dragged back up and thumped like a rag-doll on the ice-edge of the crevasse, in the process breaking three ribs. To boot, after a few days he was also showing signs of pneumonia and all the symptoms of malaria as well – a recurrence of the illness he had contracted in the Pacific during the War. Before long a message went out to civilization saying Ed was in trouble, and within twenty-four hours the story had ripped through the world's headlines. HILLARY IS SICK. In London (we learnt much later) there was consternation. Hillary was dying. The man who had stood on Everest's summit was reaching his end in the middle of the mountains, not far from the scene of such a triumph the year before. Would Sir John Hunt be good enough to write Sir Edmund's obituary?

John was truly cast down by the news. But he was adamant about one thing. He flatly refused to write a line unless it was

Our film, *The Conquest of Everest*, had a Royal Premiere in London and was later shown in theatres around the world. I watched it at an ice-rink in Canada and also once in an Egyptian hotel by the Nile. I was proud of the part I had played in making it.

irrefutably demonstrated that Hillary was dead. 'You don't know what that man's powers of resistance are like – but I do', he told reporters. When it was all over, having stretchered Ed off the mountain to recover at lower altitudes and continuing on with the expedition, we were able to joke with John about the incident. 'I had such confidence in Ed's resilience', he told me afterwards, 'that my heart just wouldn't have been in the writing of that obituary.' But even as he spoke I could see the real distress that he had experienced. We were more than just fellow climbers after Everest, you see. We were a brotherhood, a family.

I'm often asked to reflect on our Everest experience – why it was so special. It made history, of course, but we were not really aware of that at the time. We were all just doing something that we loved. To be in the hills is one of the purest and most unalloyed blessings that is on offer to us. John's leadership was just so crucial to the end result of placing two men on the summit. He won the warmth of your heart as few commanding officers could hope to do, captivating and inspiring his party with his own dreams. After the success of Everest he publicly pushed the well-worn platitude that it was the 'teamwork' and 'team effort' on the mountain that had made the Everest dream come true. This was not only a fact: it was the essential basis for reaching the summit.

And yet, endlessly put forward to the world by a lesser spirit, the simple fact could have sounded not merely trite but tawdry. Not for an instant was it seen thus, for John Hunt had made Everest into a message, a goal for all human beings. Every man and woman could have their own little Everest, and it was undoubtedly Hunt who fostered the ideal. True, the nature of our expedition was on his side in this matter, the climb to a dramatic summit having been achieved by group effort at a most

dramatic moment in time, the coronation of England's young queen. All the same, Hunt's ideal, born out of the physical fact that only two men stood on the top of a mountain, could easily have faded away. But it was something we all believed in too.

And that's the real point, and the real reason why 1953 was so special for us. We were a group of people that had gathered together from all corners of the world, yet we quickly became a team of friends – it was an expedition that became a lifelong meeting of friends. It has rewarded me in ways that are impossible to sum up. I will forever be grateful for Everest and for my other journeys in the Himalaya. To me the mountains are not a place for competition. The mountains are just where you want to be.

It could be said that the obsession with Everest has turned into something like a procession in recent years, with so many men and women crowding to the summit. Yet there are still significant challenges to be found there. Techniques, equipment and skills change rapidly over the years, but nothing can replace courage, judgment and a good helping of luck. And of course, there are many ranges full of challenges still out there, far beyond this one majestic mountain.

Before we arrived, Everest was still a dream. It was open to doubt and uncertainty. It remained that way after we left. As Wilf Noyce so beautifully wrote, 'Men we descend, Conquerors never'. Within days the drifting snows covered our footprints, the mountain's flanks a blank canvas once more. And yet, in achieving the summit our expedition had answered that major question, was it possible? John Hunt summed this up well:

Our biggest difficulty was to overcome, not so much the physical and physiological, great as these were, as the psychological problems, both in general and particular to each man. Like Bannister's four-minute mile, there was that uncertainty about man's ability to do it: in our case there was that question mark over the last 1,000 feet or so … When once a man has made a breakthrough, be it on the surface or the bed of the ocean, over land or in the air, or in outer space itself – that barrier of doubt is down; others can be sure that what has been achieved can be repeated, over and over again.

And people have been flocking to Everest ever since. Ed once said that he and Tenzing had thought that after they'd knocked it off, nobody else would want to bother. But our climb did not put a full stop on the mountain, quite the reverse. John Hunt hoped that 'ultimately, the justification for climbing Everest, if any justification is needed, will lie in the seeking of their "Everests" by others'. And that's a lovely notion. It's just that there is only one true Everest, and it's the mountain that everyone still seems to covet most above any other.

I got to within 1,000 ft of the summit, helping Ed and Tenzing set up their final camp to push for the top. I felt no anguish or envy at not being in the summit party; we did it together and I was happy to play my part. I watched as my friend's life was overwhelmed by the world's reaction to the feat, but I didn't for a moment wish to have swapped places and be hit by that avalanche of international fame. I've been able to have a private life, so I'm glad I did not go all the way to the top. Ed Hillary was the right one. I wouldn't have had the diplomacy that he had.

Ed naturally stood tall among his fellows. The big-hearted, big-chested, raw-boned giant with energy and humour in plenty, to whom fame came as a shattering blow. The ebullient, restless Ed, who hated the 'walking part' of a mountain expedition, who

made such gigantic strides after Everest, retained basically the same spirit of adventure and (there is no other word for it) 'fun'. Ed had always the same attack whether the location was a glacier or a gondola. So, I've one last story to share.

Before the Everest expedition of 1953, when life was less complicated, Ed and I were in the party led by the doyen of Himalayan explorers, Eric Shipton, to Cho Oyu. At the end of this long expedition we forced our way down through the jungles of Nepal and made our way to the Indian border along the banks of a great river. We had been walking steadily for six months and had covered hundreds of miles, and though the scenery was beautiful, we longed for rest and the comforts of home. We dreamed and talked of great roast dinners, although Shipton always said he'd like, above all else, a nicely done kipper. As we walked over a winding path that we found near the river-bank, we talked of sailing along on the smooth untroubled waters. We had no raft with us, but the idea caught our imaginations, and we saw mirages of comfort and coolness as we sweated away beside the rolling waters.

With Ed dreams had always to be translated quickly into reality, and during our evening bathe in the flooding waters we blew up our inflatable air-mattresses and paddled on the water. Separate we were unsafe and easily capsized, but by joining the mattresses side by side with two poles tied across the front and back with our climbing rope we found we had a stable, though still flimsy craft. There was a gap in the middle of the two mattresses of 2 ft, so that we could lie side by side and each use a paddle. After testing our crazy craft our minds were made up – we wouldn't walk one more step, we'd raft down the river.

It was a hot steamy night. We woke at four in the morning – it was our habit to travel in the cool of day – and we set off at half-past four as the black night turned to the grey of morning. The oily, swift-flowing river looked decidedly dangerous in the half-light, but having bragged to Shipton and our Sherpa of our intention, there was nothing for it – we had to go. We pushed off into the current sitting astride our flimsy craft with the water up around our waists. For half an hour we were carried along on the flood and we whooped with excitement as we swept round each new great bend, laughing and shouting.

The hills around began to close in, and I pricked up my ears when Ed said, 'Can you hear something?' A dull, ominous roar came across the water. We knew immediately that it was the river growling, and we paddled madly for the shore. The current increased, and in its grip we swept round a headland on which we could see Shipton waving frantically. The continuous roar grew louder and we saw the river ahead crashing into a great bluff and boiling its way out of sight down a narrow cataract. Ed, casting his paddle aside, shouted, 'Hang on to the raft whatever happens. It's our only chance.'

Bucking on the crest of a wave we rushed at the smooth rock wall. In an effort to soften the blow we stuck our legs out in front, but as the wave crashed against the wall our buoyant mattresses, caught by the back wave, slid off the cliffs into the racing water of a whirlpool. We paddled for the bluffs, but the current sucked us back. Again we slid off – six times we went round that bloody whirlpool. Although frightened, we both laughed, and I remember Ed shouting, 'What a helluva way to die!'

Then an extraordinary thing happened, the whirlpool tilted and the water, having built up against the cliff, began to surge out into the cataract beside the cliff and we were hurled with it. We were now on the outer edge against the dripping cliff and before we began another series of circuits Ed grabbed the rock and held

on. Miraculously, I saw a rope dangling down within my reach. I grasped it and looked up. Shipton, our saviour, seeing our plight, had lowered himself on to a ledge above us and, although we did not hear him, had been shouting and flinging his lifeline for over ten minutes. In no time at all he hauled us up from the pool, wet, shaken and rather lucky to be alive.

I think, on looking back, I enjoyed the years in the Himalaya more than the silences of the Antarctic continent. I think, too, that this was due to our riotously amusing friends, the Sherpa, in many ways an unspoiled people of great humanity and charm. It was their immense skill and effort that got us up Mount Everest. I should like to pass on one comment on our way of life as it was seen by one of them. Two Sherpa, Changjup and Dawa Tenzing, came to England, and after passing through London they were asked what they thought of this great, proud city. And Dawa said: 'In that village nobody stops to talk with anybody else.'

It was Ed Hillary, more than anyone else, who became their champion. He devoted his life to his projects improving their lives in Nepal. Among a lifetime of letters, he once wrote this and it sums up so well his approach and the kind of man he was:

I have had much good fortune, a fair amount of success and a share of sorrow, too. Ever since I reached the summit of Mount Everest the media have classified me as a hero, but I have always recognized myself as being a person of modest abilities. My achievements have resulted from a goodly share of imagination and plenty of energy.

I have had the world lie beneath my clumsy boots and saw the red sun slip over the horizon after the dark Antarctic winter. I have been given more than my share of excitement, beauty, laughter and friendship. But for me the most rewarding moments have not always been the great moments – for what can surpass a tear on your departure, joy on your return, or a trusting hand in yours?

It was an honour to know Ed – one of those people who you feel lucky to have been close to and to have been a part of their life. As the years have gone by, our Everest companions have left us. The mountains have been cruel. Strong Tom Bourdillon was killed just three years later while climbing in the Alps. I was in the Pamirs in 1962 when Wilf Noyce also fell to his death. A life tragically cut short, but it was a price I know he was willing to pay for the pleasure that the mountains gave him. Ed left us peacefully in 2008. And since then, my partners on the Icefall, young George Band and Mike Westmacott, have also gone on their final journeys. I am the last man standing. Though my health is fast failing me too, I find great comfort in recollection.

Everest of course stands firm. Its flanks and ridges are often cluttered with climbers, and it may ever be this way. Perhaps we are somehow to blame for this – we opened the door, we showed the way. We made men and women believe the impossible. We experienced the elation that comes through overcoming anxieties, and then mastering our fears in some genuinely tough and life-threatening situations.

But we chose to be there and that is the thing. We all chose to take a risk when others, just as able, might have turned back, doubting themselves, hampered by weather, or stopped by their own failing strength. We rode our luck and we were blessed in return. Our achievement, I hope, will last as long as there are adventurous hearts out there; as long as people still raise their eyes to the summits, and take on a challenge in the simple way that we did – slow and sure, head up, just one step at a time.

PORTFOLIO

BEYOND THE SUMMIT

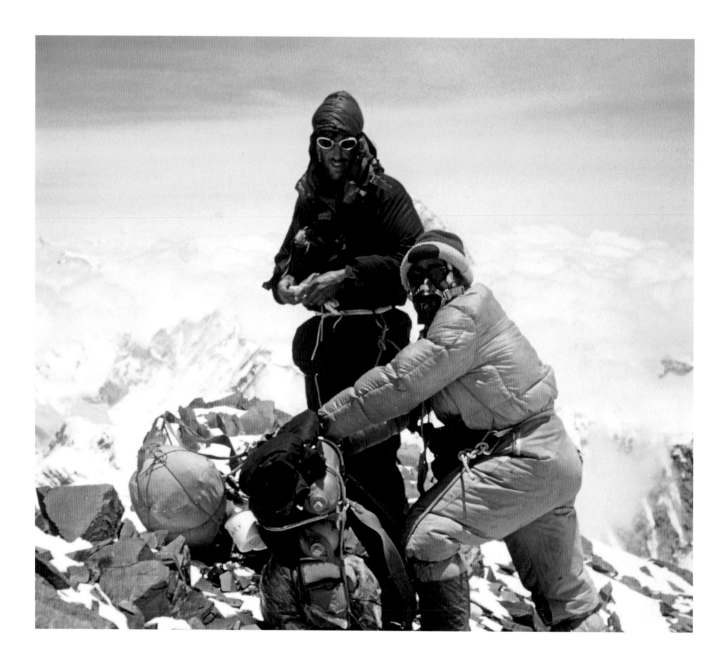

ABOVE AND FOLLOWING On the ascent we waited at 27,300 ft for Ed and Tenzing to reach us, and captured these shots as they made their way to our position high on the South-East Ridge. Moving steadily upwards, I then chipped steps at the front until we were able to find a place for their tent. Here we left them. For another two hours Ed and Tenzing levelled the ice and rocks as best they could, erected the tent and crawled into Camp IX, the highest ever, at about 28,000 ft. Tenzing cooked chicken noodle soup. They also ate sardines with honey and dates, all washed down with hot lemonade, and tried to snatch some sleep. At 6.30 the following morning they set off for the summit.

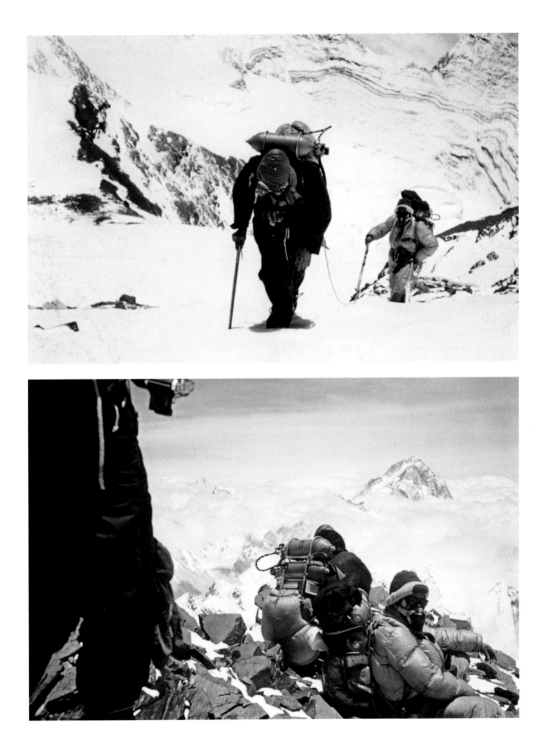

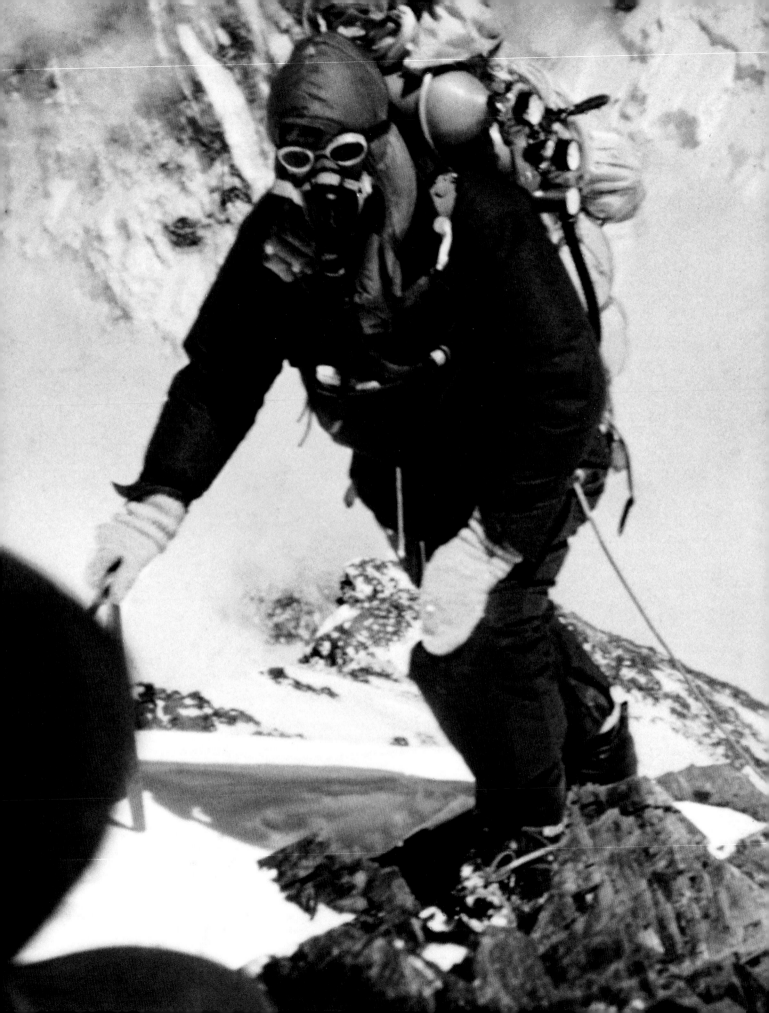

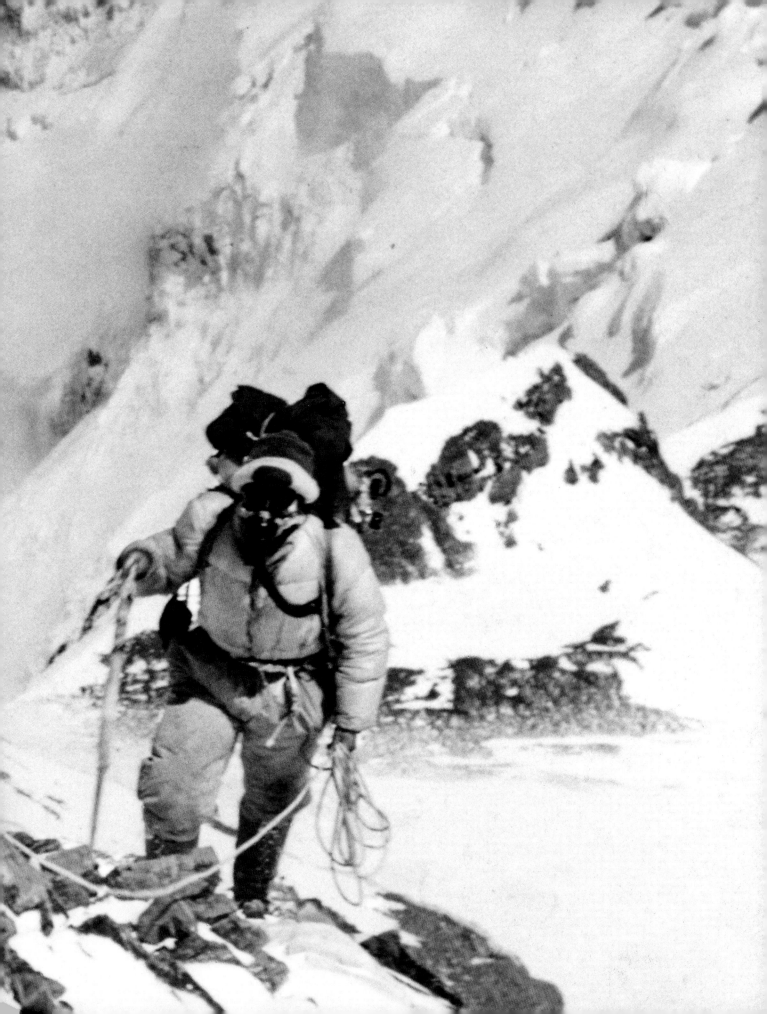

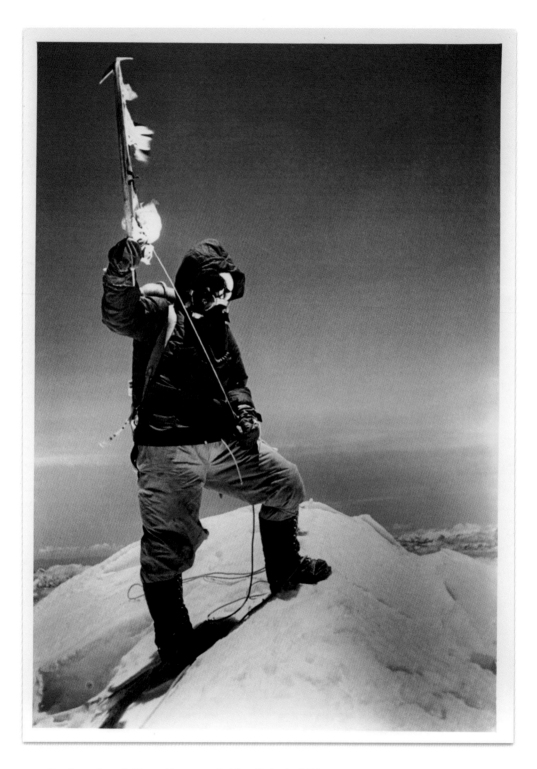

ABOVE Standing on the roof of the world on 29 May, Tenzing unfurls the flags from the shaft of his ice-axe – the United Nations, Nepal, India, and Great Britain. The team had actually only brought the small UN flag to Nepal – no one had thought about a British one – and the flag on Tenzing's axe was taken off the ambassador's car at the embassy in Kathmandu. Hillary got out his camera, stepped back a little, and took these pictures.

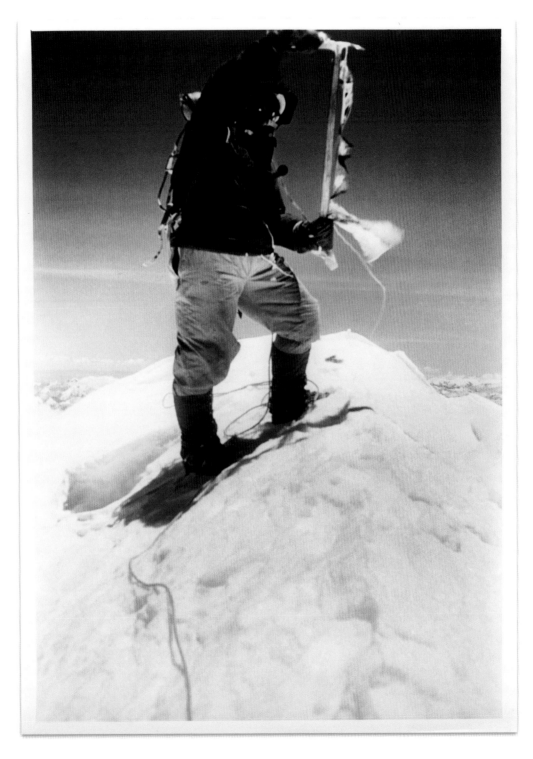

ABOVE Tenzing said a silent prayer. 'Thuji Chhey, Chomolungma' – 'we are grateful'. Ed said his first sensation was one of relief, mixed with a vague sense of astonishment that he should have been the lucky one to get there. Having just paid their respects to the highest mountain in the world, and having drunk so much lemonade, Ed later told me he had no choice but to urinate on it. Relief indeed! They were on the summit for fifteen minutes. Tenzing left the string of flags in the snow and they headed down.

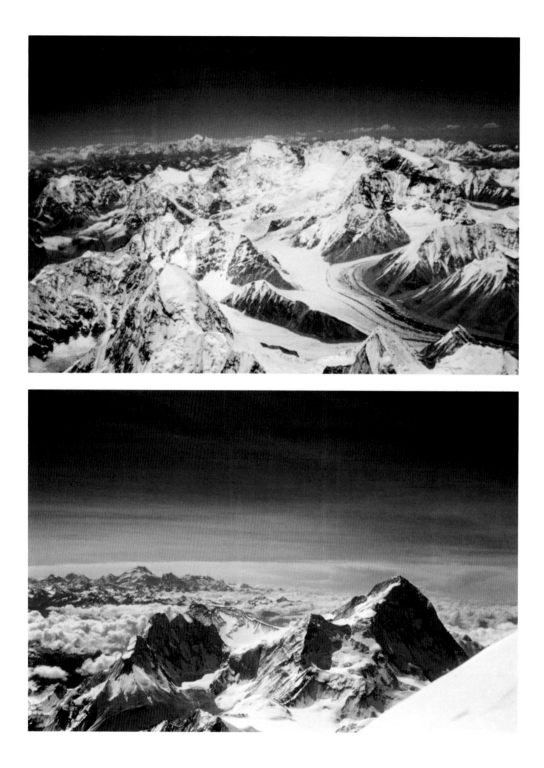

ABOVE Ed took photographs down all the leading ridges to have proof they had reached the top. Here are views north from the summit, showing the sweep of the Rongbuk Glaciers in Tibet, and the eastern panorama, with Makalu and Kangchenjunga in the far distance.

RIGHT The day after the successful summiting, I photographed Tenzing as we made our way down the Lhotse Face to greet our friends back at Advance Base Camp.

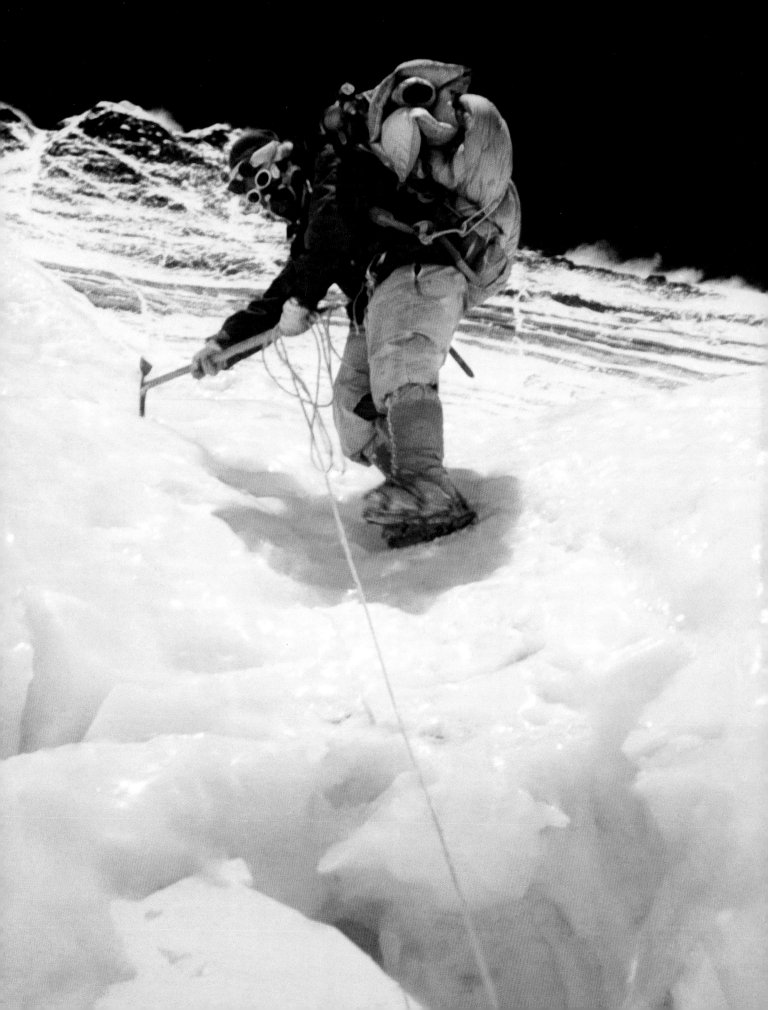

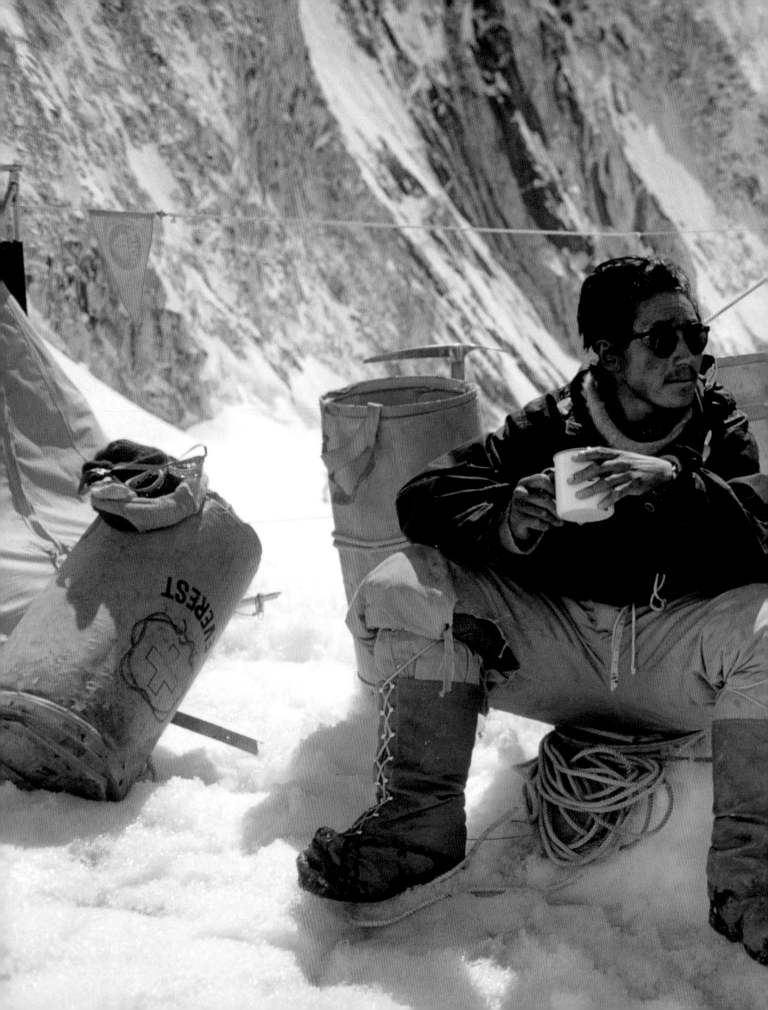

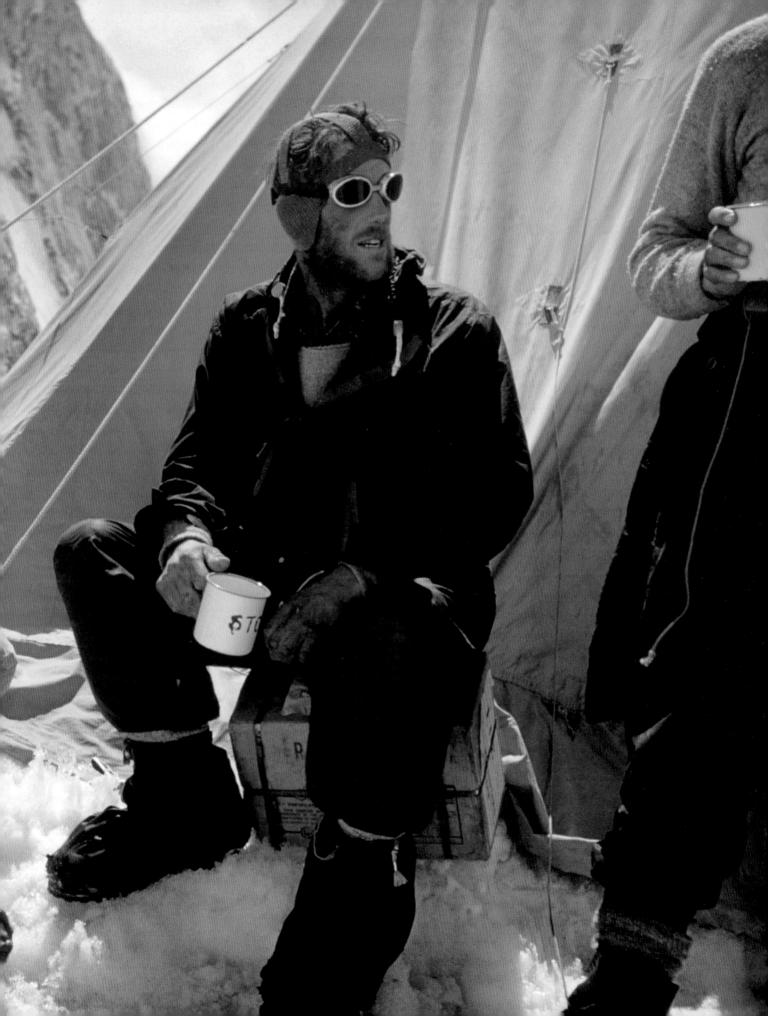

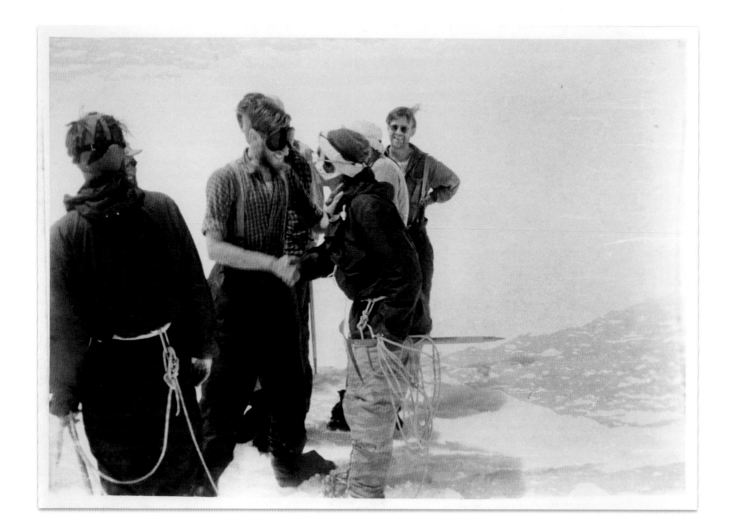

PREVIOUS Tenzing drinks a celebratory cup of tea at Camp IV the day after the successful ascent, while Ed slugs warm lemonade from Tom Stobart's mug. Our names were painted on our mugs, but since no Sherpa could read English we always ended up with someone else's.

ABOVE AND RIGHT George Band shakes Tenzing's hand as he is warmly congratulated by everyone waiting and watching at Camp IV. Ed is accompanied by Gregory, in his trade-mark bobble hat, with Bourdillon following behind.

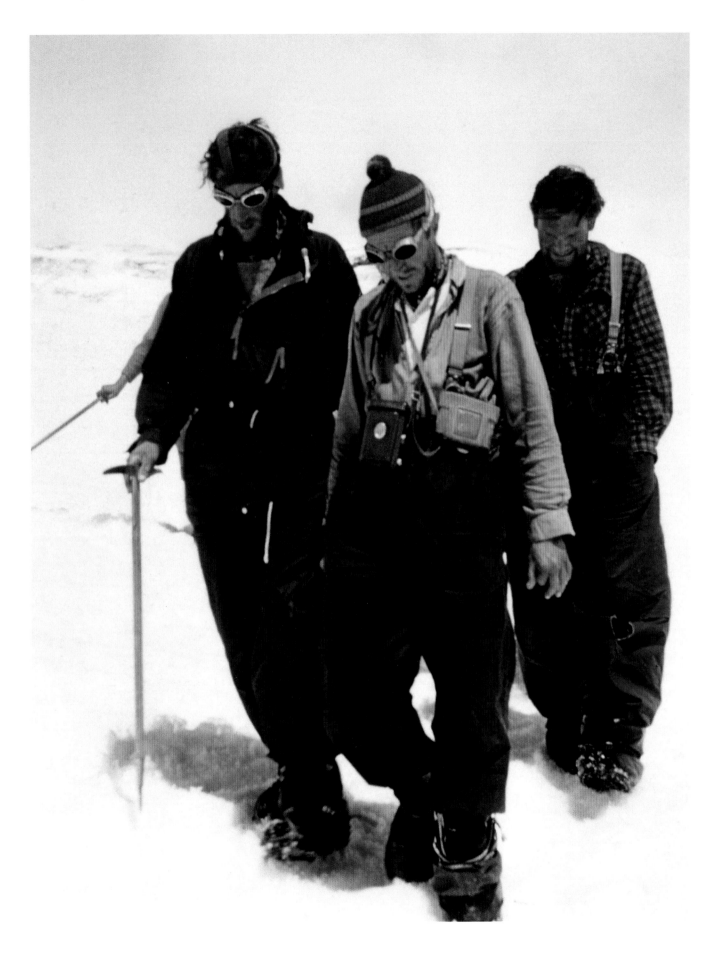

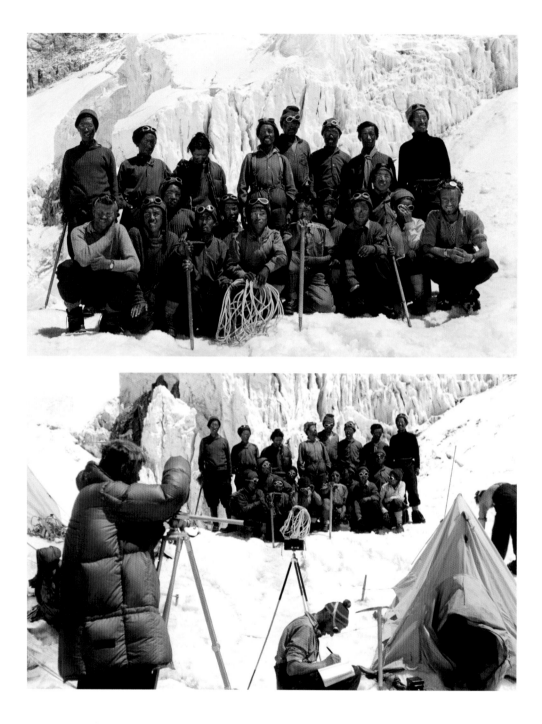

ABOVE At Camp IV Stobart and Gregory photograph the 'Tigers', the incredible Sherpa porters who reached the South Col with Noyce and Wylie. In the resulting photo (top), front row (left to right): Noyce, Phu Dorji, Ang Dawa, Dawa Thondup, Ang Namgyal, Ang Temba, Gompu, Pasang Dawa, Topkie, Ang Dawa II, Ang Tsering, Wylie; back row (left to right): Ang Dorji, Pemba, Pasang Phutar, Da Tenzing, Ang Tenzing, Ang Norbu, Gyalzen and Annullu.

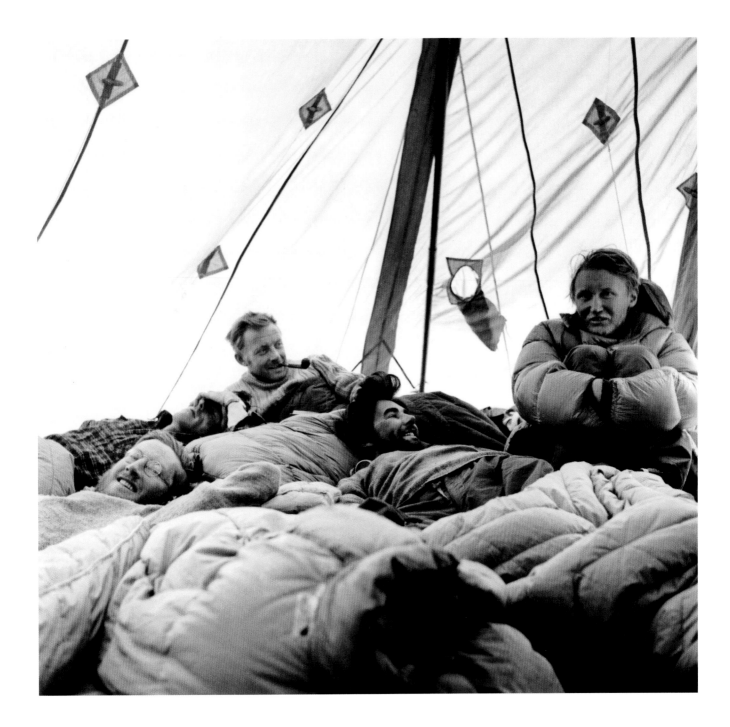

ABOVE On 2 June, after supper in the mess tent at Base Camp, we turned on the wireless to listen to news about the Coronation and were dumbfounded to hear of our Everest success. Band, Hillary, Evans, Ward and Stobart are pictured here – happy on rum and more exhausted than you can imagine.

LEFT On our return to Kathmandu in June 1953, the city was like a mad house. Tens of thousands of people came out to meet Tenzing in a frenzy of hero worship. Over a number of streets, triumphal arches displayed pictures of him on Everest holding the Nepalese flag, or pulling Ed up to the top. Banners read 'Welcome Tenzing, First Man to Conquer Everest', 'Hail Tenzing, Star of the World'. The crowds swelled and the shouting became deafening.

We were dragged straight off the dusty trail to a reception at the King's Palace, with Tenzing paraded in a horse-drawn royal coach. We followed in a jeep, while I sat on the roof taking photos, bearded, dirty, in a torn shirt and tennis shoes. Luckily, we soon managed to escape for a bath and something to eat.

ABOVE On 1 July we flew from India to London and were embraced by a whirl of social functions. We had dinner with the Duke of Edinburgh, the Expedition's Patron, here standing between Ed and Tenzing, at a British Government party held in our honour at Lancaster House.

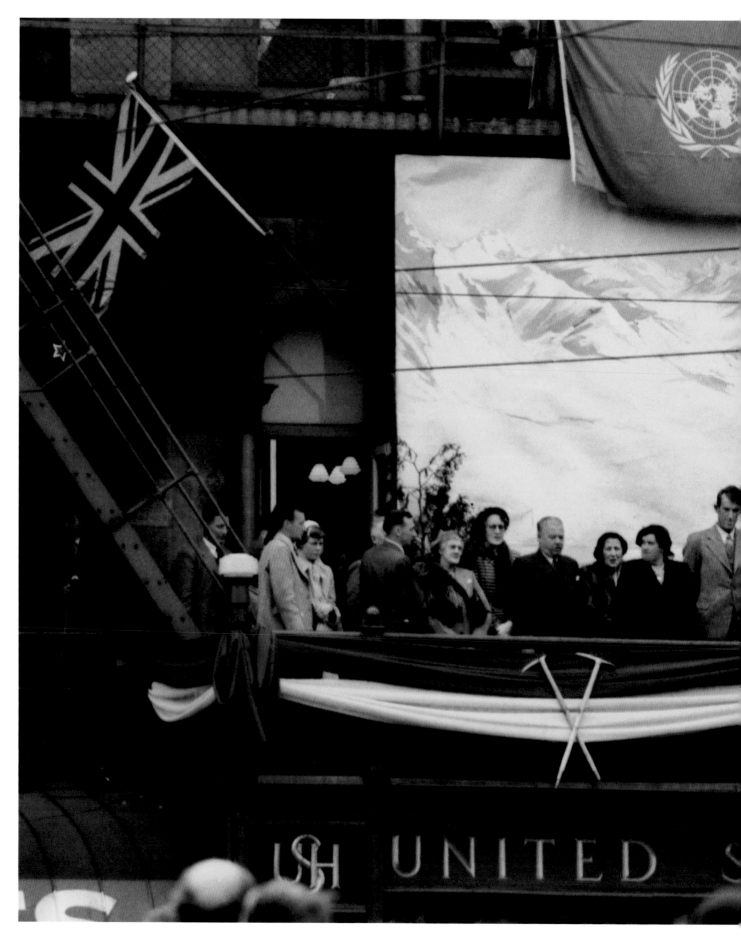

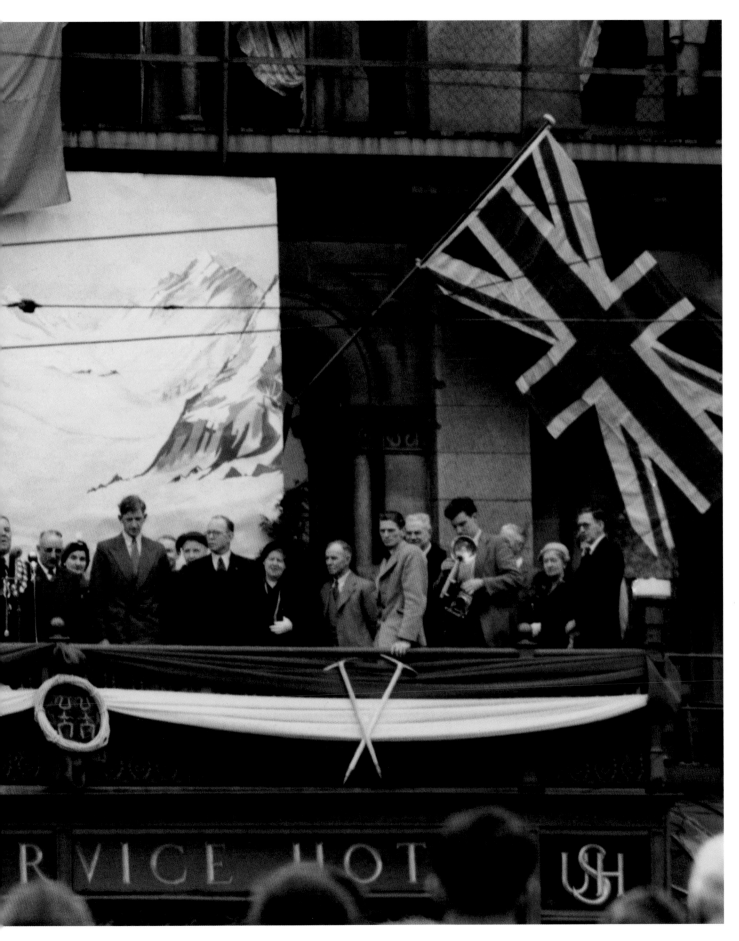

LEFT On the flying-boat back to New Zealand, the airline gave us a huge cake. We cut up this sponge and icing Everest and shared slices among the passengers. Ed had a real sweet tooth and I remember his pleasure in taking a large bite from the summit.

PREVIOUS After yet another lunch, this time a civic reception in Christchurch in New Zealand in August 1953, Ed and I nervously took to the balcony at the United Service Hotel. Below us was a sea of cheering people, like the crowds at a rugby match.

RIGHT We were met by huge crowds when we returned home to Auckland in August 1953, and Ed patiently signed autographs for hundreds of school children. He signed this photograph for me some time later, and did it twice as I was teasing him. We never felt like heroes, but were overwhelmed with the warm support we got. It was great to be back.

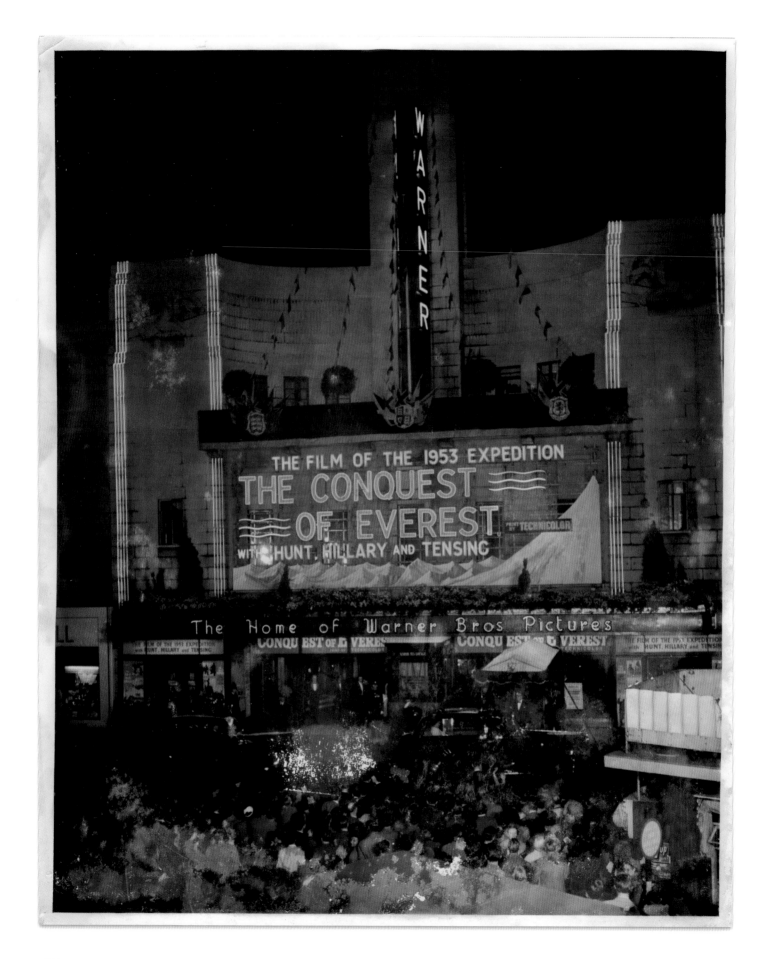

LEFT Queen Elizabeth, just visible in the back of her black Rolls-Royce, arrives at the Royal premiere of our film, *The Conquest of Everest*, on 21 October 1953. The mass of cheering people outside the Warner Theatre in London's Leicester Square that night was staggering.

ABOVE Returning to Thyangboche Monastery in 1954 we were able to see some of our Sherpa friends again. We brought with us the Coronation Medal, specially awarded by Queen Elizabeth to the Sherpa who had carried to the South Col. Pasang Phutar was away on another expedition; his eldest child was brought and received the medal. This pleased everybody.

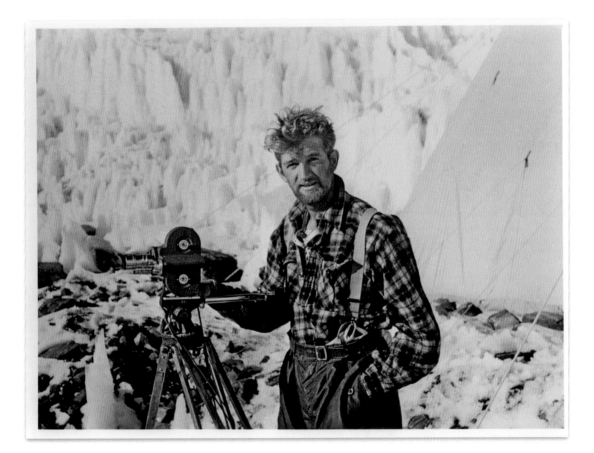

4 | REFLECTIONS

Was it all worthwhile? For us who took part in the venture, it was so beyond doubt.
We have shared a high endeavour; we have built up a lasting comradeship among
ourselves and we have seen the fruits of that comradeship ripen into achievement.
We shall not forget those moments of great living upon that mountain.

John Hunt, 1953

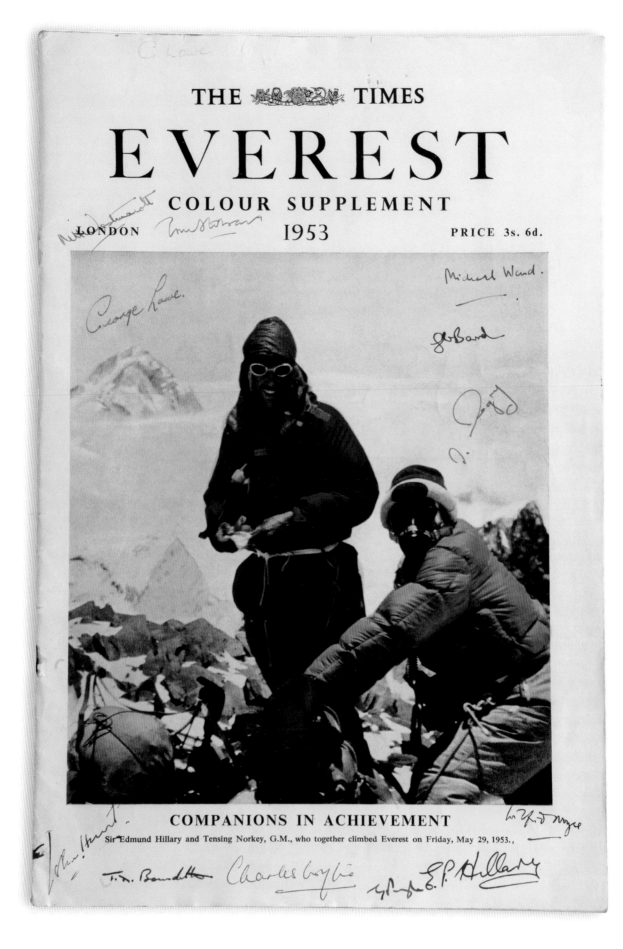

THE ☒ TIMES
EVEREST
COLOUR SUPPLEMENT
LONDON 1953 PRICE 3s. 6d.

COMPANIONS IN ACHIEVEMENT

Sir Edmund Hillary and Tensing Norkey, G.M., who together climbed Everest on Friday, May 29, 1953.

TO RISK THE UNKNOWN

REINHOLD MESSNER

George Lowe – what a lucky man. He was active in the best Himalayan years and grew up in a wild country. As a New Zealander, he experienced the tough mountains at home before journeying to the great and very wild Himalaya. Twenty years later we could go to the high mountains often, but they no longer had the same dimensions of George and Ed Hillary's time. So much had been achieved, but some of the adventure had been lost for those of us who had to follow.

They had achieved the impossible, or at least what was then thought to have been impossible. A barrier had been broken – they had reached the top of the world. From that magic moment in the summer of 1953 onwards, we were all left to follow in their footsteps, along a beaten path. Unless, of course, we were bold enough to choose a new way, a new route on a big wall, a new hope for a new summit. Making Everests for ourselves across a whole mountain range.

My respect for the young New Zealanders of that generation was growing with my own activities on Everest, Cho Oyu and Makalu. I soon found my own style on very small and cheap expeditions. I looked for good partners. And from that moment onwards I was able to finance my own expeditions. My attitude was: let's see, let's go. If we fail we will still learn something. Then we will go back. Since my expeditions were very cheap I could also afford to fail.

But in 1953, to climb Everest was a huge and expensive undertaking. John Hunt, the leader, gave George Lowe the task of preparing a route up the Lhotse Face. He later wrote that 'Lowe had put up a performance during those eleven days which will go down in the annals of mountaineering as an epic achievement of tenacity and skill'. But for chance, it might also have been Lowe who was chosen for the summit assault. Though some people just couldn't operate at the high altitudes, George was in his element. He was also one of the strongest in the three-man party who toiled hard, cutting ice steps to ease the way for Hillary and Tenzing up the South-East Ridge. Lowe set up the pair's final camp, just 300 m below the summit.

He was, essentially, the third man on that summit attempt. It would have been exhausting labour in thigh-deep snow, too; soul-sapping effort in an area that is now known to some climbers as 'the death zone', but which then was simply an unknown place – further than anyone had ever gone before. One newspaper at the time in London called Lowe 'the first hero' of the expedition, such were his efforts on that day alone.

On the sixtieth anniversary of their pioneering climb in 1953, it is right to remember and honour these men. Knowing how they approached their mountains, they will stay forever as firm points of orientation for all future climbers. They went with good hearts and up into the unknown! Traditional mountain climbing will never end if we follow the spirit and enthusiasm of men like George Lowe.

༄

I am of an age now when I can look back on my own climbs, too, and reflect a little on how mountaineering has changed. By climbing all the 8,000-m peaks in the world I became well known. Fame brought wonderful opportunities, but, as Hillary no doubt found, it also brought new difficulties and temptations. The challenge was to stick to what you knew to be right, and to believe strongly in the things you wanted to live for.

People talk of my solo climb of Everest's North-East Ridge in 1980 as being revolutionary in its way. It was the first time

LEFT The main sponsor for Everest, *The Times*, created a supplement of the expedition photographs in September 1953. This copy was signed for George Lowe by members of the expedition.

PREVIOUS Photographing and filming on Everest was an unexpected delight and a real honour for George. Just a few years later he also travelled as a cameraman on the Commonwealth Trans-Antarctic Expedition, reaching the South Pole.

that the world's highest peak had been climbed alone and without oxygen. It had taken me a lifetime of effort. For me it was all about the style of what might be possible. I wanted to try something new – to transcend what I feared to be a limit, into an unknown territory of effort. I climbed because it meant life to me, and in doing so I was able to affirm my own climbing values. Yet, all the while, there was still so much on Everest that was too difficult for me to dare. It helps us respect the mountains if we are able to see that there is always something there *beyond* our abilities.

We go to the mountains to challenge ourselves. Mountains are dangerous. If we go to the mountains and forget that there is risk, we make mistakes. But they are only dangerous if people are involved. A mountain is a mountain, existing, eternal. It is a piece of rock and ice, and is only dangerous if we venture there. A mountain without danger is no longer a mountain but something else – a climbing wall, a sports arena maybe. Outside, in the wild places, mountaineering must be dangerous so we can learn, so we can manage our own fear, make our own decisions and take responsibility for our actions. Someone who is stronger can climb the high peaks; someone with less ability can choose a smaller peak. But the most important thing is that we take complete responsibility for ourselves.

To climb Everest now I think we should rely only on ourselves. The prestige of Everest in the past was born through risk, passion, and months and years of work, training and suffering. Today, many people think they can just buy this prestige without the other investments. It is not a problem for me that so many people want to climb Everest with fixed ropes and paid guides, though I do think it is regressive for the sport as a whole. Everest has become a brand-name mountain, a trophy to be won on an expensive holiday, without gaining the necessary experience to survive or taking personal responsibility. Is this wrong? No, it is only foolish.

Everest's real value – as a symbol for our dreams and aspirations – depends on the spirit in which it is approached. Danger is a vital part of the mountain; it stops people going where, perhaps, they should not go. Dragged up and borrowing the footsteps of others, they seek records, not experience. How high, how fast or how difficult a climb was is actually not that significant. Style is much more important than distance or difficulty.

In 1970, after twenty years of climbing in Europe, I first went to Nanga Parbat in Pakistan. I dreamed about climbing the Rupal Face. My brother Günther and I reached the summit, but were forced to descend the unknown Diamir Face, where he tragically died in an avalanche. What I learnt above all on this first expedition was about death, but I also forgot about flags. On the summit of Nanga Parbat I used only my handkerchief, and I'm still very proud of it – I used my handkerchief as a flag to salute my personal achievement. The motivation to climb should come only from the passion to pursue our own limits. Each of us has different limits, and in searching for them, we discover human nature.

We climbers are dreamers. When our dreams are strong, and we are brave enough to let them live, they grow into action. To be out there in dangerous places and then try to return was everything to me. It is not the reaching of the summit but the coming back that is the great reward. What is success in the mountains? To return! I attempted to climb 8,000-m peaks on thirty occasions, and I failed twelve times. Without failing, not only would I have become complacent and self-important, I would also have died.

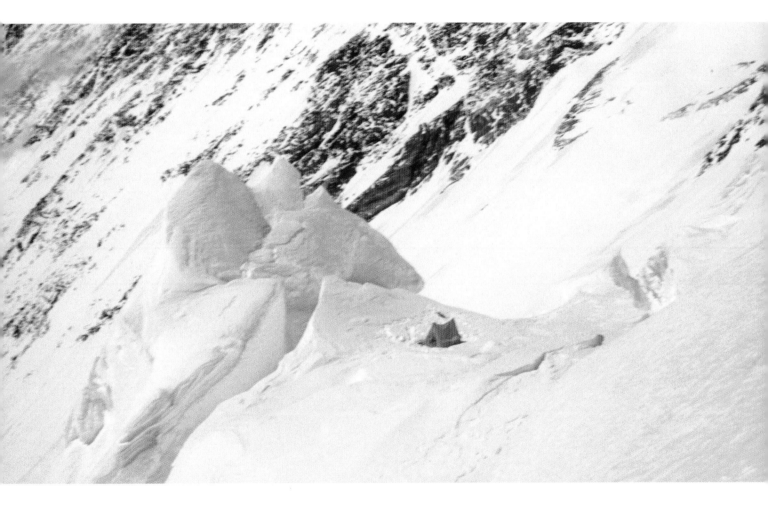

Now, growing older, I simply dream of climbing lower mountains and skiing across smaller ice caps or crossing deserts. So much of our world is still to be discovered, despite what the map-makers might say. I try to travel with less and less support. And I will never carry a telephone with me in the wilderness. To do so would mean destroying the sense of isolation and exposure that I seek. These are my self-imposed rules. We should never make rules for others; I have rules only for myself. I will spend half a year or more in the wilderness with just a rucksack – and nobody will know where I am going.

ABOVE Noyce and Lowe established Camp VII at 7,315 m (24,000 ft) on 17 May – their tiny tent is seen here tucked in behind a big serac – a large block of ice – and perched on a small ice shelf.

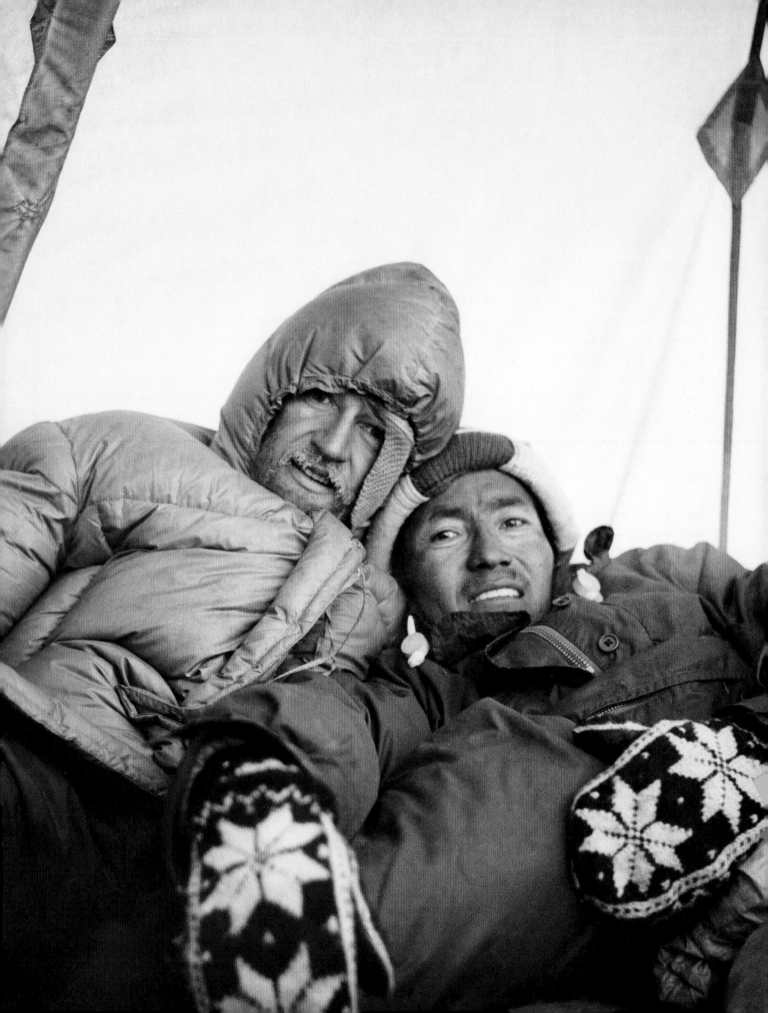

A WORLD OF POSSIBILITY

NORBU TENZING NORGAY

I still remember when I was young, sitting on my father's knee and first hearing the story of how he and Sir Ed climbed the highest mountain in the world. I was enthralled. The Khumbu Icefall, the Lhotse Face, the South Col, the Hillary Step – all names that have now become legend. I believe there could not have been two finer people to be the first on the sacred mountain than Sir Ed and my father. But it was their lives after Everest that would be their most meaningful achievement. On that morning on 29 May 1953 as Sir Ed stood on the summit, he described the view from the top: 'the whole world around us lay like a giant relief map'. On their return, the world was at their feet.

What Sir Ed chose was the path less travelled, one that would bring him real joy for the rest of his life. He epitomized the true meaning of giving, and never asked for anything in return. His dear friend George Lowe was a part of both this achievement and this feeling from the very beginning – a man with a heart equal in size to Ed's – and his contribution should not be forgotten. In May 1993, I was invited to England to represent my family for a week of events in London and in Snowdonia to celebrate the fortieth anniversary of the ascent. It was my first meeting with the team without my father. I fondly recall an evening I spent with George and his wife, Mary, hearing stories of George's own experience on Everest with my father. George and Mary are both very down-to-earth people who care deeply about the people of Nepal. They must have been Sherpa in their last reincarnation.

During my time in Britain, I thought back to the memorable trip I had with my father to the Khumbu in 1969, where I celebrated my seventh birthday on the slopes of Everest. It was the first time I had seen the mountain and it wasn't until my visit to Britain that I was able to appreciate fully what the 1953 expedition had accomplished and to learn what it meant to people who had followed their progress. My father never said, nor felt, that they had 'conquered' Everest, though. For him it was more an act of pilgrimage – a chance to climb closer to our god – but also a reason to remember what was important back down on the land below.

We Sherpa have deep respect for men such as George: for his friendship with our people and his dedication to give back to a part of the world that has meant so much to him. Over the years George and Mary Lowe carried the torch of the Himalayan Trust to keep Sir Ed's work going. Ed could not have done it alone, and friends like George and Mary dedicated their time and efforts to the cause. For my own part, I've never had a desire to climb Everest – twelve members of our family have now done it – and my father was very humble and never let the fame go to his head, or ours. So we had fairly normal lives. That said, I am very proud of my father, and in our family's small way we also try to keep his legacy alive.

The changes to Sherpa life over the past half century have been profound. When Sir Ed asked what he could do for the Sherpa, they said to him, 'our people have eyes but they can't see'. The transformation of the lives of two generations of Sherpa is staggering – with almost seven thousand students in sixty-three schools today, two hospitals, a dozen clinics, a million trees planted, safe drinking water systems, bridges and miles of trails built and repaired. And just as important, he was also sensitive to keeping centuries-old traditions alive, which are vital to our Sherpa daily life. Through my own work with the American Himalayan Foundation, I feel privileged to have worked alongside Sir Ed and his team for seventeen years.

LEFT George and Tenzing Norgay shelter from the fierce winds in a tent on the South Col, just a few days before Tenzing successfully reached the summit with Hillary in 1953.

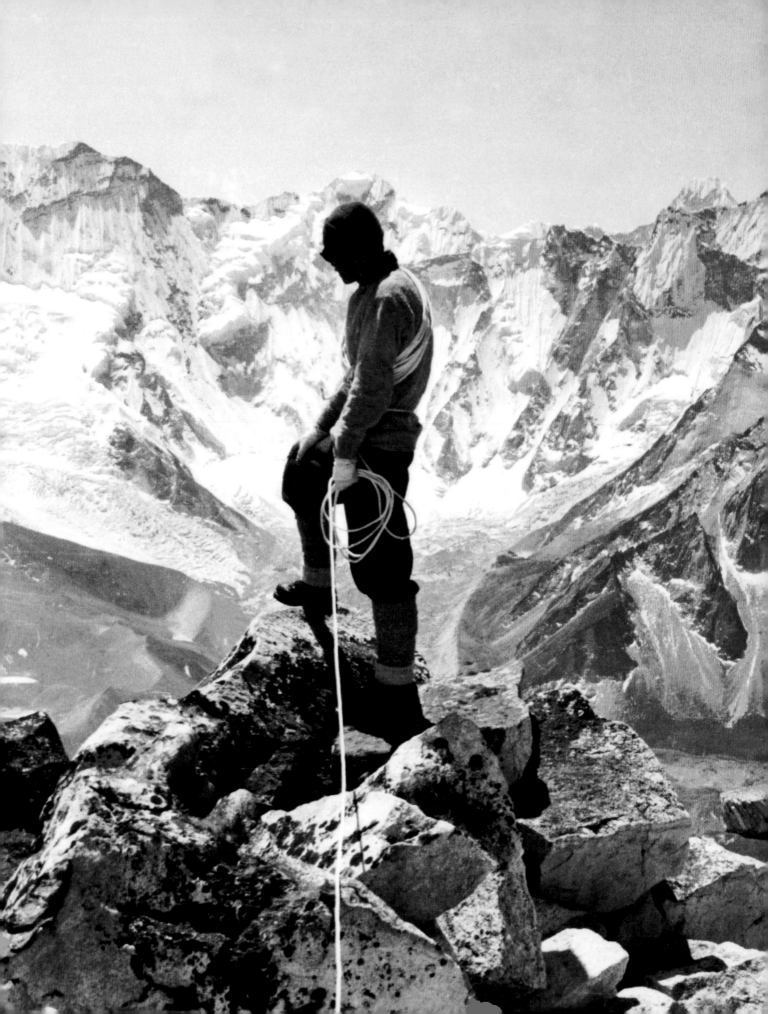

When we took off from Kathmandu en route to London as part of the fiftieth anniversary celebrations, the pilot made a special effort to get us close to Everest. I remember Sir Ed looking through the window with his distinctive smile, and pointing out the villages he had walked through on the first journey to Everest. Knowing Sir Ed, he was probably thinking of a new route up the mountain or how he could have made a school building larger so more children would have the opportunity to learn. Just as he described the relief map of the world from the summit of Everest, for the Sherpa and those inspired by his work, Sir Ed opened our eyes to a world of possibility. In this way, his life's work has affected us all.

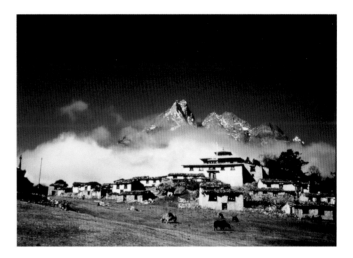

LEFT Under the cliffs of Nuptse the expedition discovered a glacier and a hidden mountain, which they climbed and called Chukhung Peak. Tenzing stands on the summit on 3 April 1953.

ABOVE Thyangboche Monastery, one of the most beautiful places in the Himalaya, is a place of much happiness for many people.

THE MODERN FACE

KENTON COOL

Everest is something special, a mountain that has had more said and written about her than any other. For those who dare tread on her slopes, rewards can be great, but the pitfalls greater. We all know what Everest is and what she stands for. Any climber who says that they have never dreamed of climbing on her mighty slopes is lying. Mention to the person sitting next to you at a dinner party that you are a climber and the question will always come up – without fail!

Everest is a mountain that has defined my life, more so than any other. As an elite guide, there was a period not long ago when I was spending more time at Everest Base Camp than any place in the world. Her pull is unquestionable, her beauty sublime.

But today's Everest is a far cry from the first forays of the 1920s. The teams back then had to endure a journey just to get to the base of the mountain that would have taken longer than a whole expedition nowadays. As history tells us, the first expeditions didn't reach the top, but they did lay down the gauntlet for all who followed. The 1953 guys came and carved their names into the history books. The rest of us just follow on. That said, Reinhold Messner's solo effort in 1980 – the first time Everest had been climbed alone and without oxygen – took the level of achievement even higher. After Messner, the mystery of possibility was gone; there remained only the question of whether *you* could do it too.

Some people view Everest as just another tick on the wannabe adventurer's list. It's true that Everest Base Camps on both the north and south sides can resemble a circus at times, with reporters, film crews, celebrity cricket matches, high-speed internet, bakeries, even whisky-tasting tents, all intermingled with climbers and trekkers who hope to fulfil their dream – whatever that dream is – by paying guides to help safeguard their ascents and make up for their lack of experience. But you can't simply buy success on this mountain.

When I'm asked about my special times on Everest, most people expect one of my summits to stand out, but in truth it's not. It's a solitary moment in the Western Cwm early one morning. I'm heading down as the first glimmers of light wash away darkness. The cold air stings my lungs. A thin veil of mist hangs above the glacier. My boots crunch the night-hardened snow, while the air is full of a million glittering particles playing tricks on my eyes.

The beauty is breathless, not a soul or a sound to break the spell. My limbs are tired from the preceding days, and though my mind is fixed on home, I'm totally enchanted by my surroundings. I wander down towards our Camp I, and as the mist clears the first of my Sherpa appear, making their way upwards. Sharing some flasked tea we chat like old friends would on a street corner, all of us relaxed and happy in this environment. Once finished we say our goodbyes and I head down to the circus of Base Camp, then on to home, back to what we call normal life. The moment was a brief one, but I treasure it as much as those times of hard graft and danger. I was in the company of my friends, in the most beautiful place on earth.

As for returning to normal life, well, what is normal after Everest? The modern face of climbing here is a world of commercial teams, Sherpa support, fixed lines and paying clients. That's the reality for most people who come to this mountain now, and it was almost inevitable that things would develop in this way. The world's highest point is an ambition for so many people, despite their skills not being sufficient to climb it alone, unaided. Being led to the top with vast support doesn't make someone a great mountaineer overnight.

Despite all the modern-day equipment, from the down-suits to satellite weather forecasting, Everest can still extinguish life in a second. The overwhelming obsession that some people bring here can very quickly turn into a lethal folly. In 2012, 19 May saw the worst day on the slopes of the mountain since the time in 1996 when a sudden storm caught the members of two commercial expeditions unawares. Eight people died in that 1996 tragedy; in 2012 four lives were lost, but it could so easily have been many more.

Thirty-nine expeditions were taking on the mountain in 2012, amounting to more than six hundred people. There was no sudden storm, just too many inexperienced people high up where the manageable risk is so finely balanced. The window of opportunity for reaching the summit, slim to start with, was closing rapidly. In the latter stages, in a 'traffic jam' that developed on the upper ridge, some people were climbing over dying men to reach the top; others ignored their cries for help, so determined were they in their own quest for success.

This is not the Everest that I have come to love. Another sad by-product of commercialism is the claim by people who've climbed Everest that they have conquered the mountain. No one conquers Mount Everest – she allows us to climb her. Pay her enough respect and be humble and we may reach the summit.

Very little would be achieved on Everest without the Sherpa. Climbing Everest in the modern, commercial manner would be all but impossible without their help. Behind almost every Western climber telling heroic stories about their ascent there will be a Sherpa working hard to make the dream possible. And throughout they are respectful to the mountain – in the offerings and the prayers they give, humble in her presence, proud to be on her slopes, careful not to offend.

I have nothing but respect for the team that I work with, their hard work, sweat and often blood spilt, never really asking for thanks in the task they do. These men have become my friends: friends I trust with my life on the mountain, and they are friends that I would risk everything for in return.

After so many years on the Nepalese side of the mountain I'd like to go north to Tibet, to tread where the early teams went, to journey through the valleys that they discovered. My desire doesn't extend to climbing the mountain from the north though. My curiosity is to explore, to look and absorb, to see what they saw, but I realize that to experience the same nearly a century on from the pioneers would be impossible. The world has changed too much.

But, will I go back to climb Everest from the south? After ten summits my love has not diminished – I don't hide the fact that I'm having a prolonged love affair with the mountain of my dreams. Nor am I ashamed to be part of the business of Everest. Despite the dangers that threaten us daily, I thrive working on her flanks, surrounded by people I value and admire, making the dreams of others come alive. Will I go back? Most definitely yes.

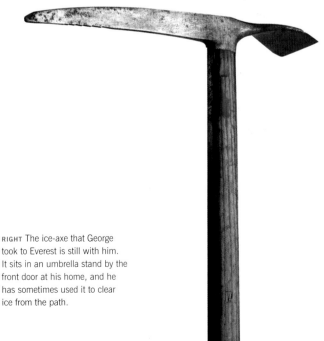

RIGHT The ice-axe that George took to Everest is still with him. It sits in an umbrella stand by the front door at his home, and he has sometimes used it to clear ice from the path.

EXTRAORDINARY THINGS

PETER HILLARY

George kept Ed Hillary laughing. When I think of George Lowe I think of his ability to tell stories and of laughter – a wonderful raconteur, who liked nothing better than seeing those around him entertained. For my father this was a big part of their long friendship.

George is my godfather and he told me lots of stories, and always with a mischievous smile on his face. He said once that his parents could not agree on his name so they called him Wallace George Lowe, with an unwritten deal that they would actually call him George because his father was adamant that 'over my dead body will you call him Wallace' – and so George it was. When his father died, George and his mother sat together at the funeral and as the organ music played at the end of the proceedings she looked at George and said, 'Wallace, I want to go home now'.

My father and George shared many expeditions together to the Himalaya and to Antarctica. They had a terrific rapport and enjoyed each other's company greatly, whether tied together on a rope on a snowy peak or sitting in a teashop at a remote road end before setting out on another adventure. For both of them the 1953 expedition really was that ultimate adventure. Climbing Everest was pushing the envelope of what we all thought was humanly possible; they climbed into the unknown and in so doing extended the frontiers for all of us.

That is why Everest is still so significant today, because the 1953 expedition demonstrated that if you are prepared to test the boundaries and work as a team you can accomplish remarkable things. And Everest really was the physical boundary for human beings; at 29,029 ft the air is so thin that an unacclimatized person would lose consciousness in a couple of minutes. It is extraordinary that the summit of the mountain coincides with our physiological threshold. Of course, when I climbed Everest in 1990 and 2002 we knew it could be done; after all, they had been there. George played a major role in that success.

On returning home from Everest my father married his sweetheart, my mother, Louise Rose. And they went on a whirlwind tour around the world for their honeymoon – with George too! I remember hearing how happy my father was during that time, having his bride with him and his best man. Apparently, while they were in London together they were invited to the RAF flying officer's club and with some relish George described to me how my father was invited to sign the book for tall-stories-and-true, up at the bar: 'I was at 29,000 ft without a parachute!'

When I was seven years old George gave me a book that I still cherish to this day. It was a large volume about our planet Earth, the solar system and the amazing universe beyond. I have maintained a fascination with science ever since and I hope I too can pass this on to my children. George inspired me and he was one of the reasons that I called my first son George.

George's own book, *Because it is There* – a title borrowed from the same rather marvellous line used by another George, George Mallory, before he went on his fateful expedition to Everest in 1924 – articulates something special about him. As my father put it, 'People do not decide to become extraordinary. They decide to accomplish extraordinary things.' For George, an unclimbed peak was an opportunity to go where no one had gone before and, equally, an uneducated child was an opportunity to teach.

For both Ed and George, expeditions gave way to the building of schools in the Everest region of the Himalaya. George helped found the Himalayan Trust UK, focusing on education, which was always his great passion: 'Giving something back to

LEFT Ed Hillary gives his trademark grin, and his wife, Louise Rose, with daisies in her hair, looks radiant as they leave the chapel of the Diocesan High School in Auckland, through an archway of ice-axes held up by friends from the New Zealand Alpine Club. George, behind them, was Ed's best man that day on 3 September 1953. A quiet wedding had been planned – in the end nearly two thousand people gathered outside on the street to cheer them on.

the people of the Himalaya.' In 1999 while I was sitting next to George and his wife, Mary, along with my father, in a small high-altitude monastery south of Everest, George turned to the film camera that was recording the event and ad libbed in his inimitable way, 'There is no end to the need here. There will always be people at the door. It is an uphill task. But that's been Ed's strength – uphill tasks. I've seen it on Everest and I see it still. He'll just keep plugging on, until he can't go one step more.' Well, George, much the same can be said for you.

ABOVE Ed and George on their way to a garden party at Buckingham Palace in 1953. They had already been to a cricket match at Lord's, and that evening dined with the Duke of Edinburgh. This was George's first visit to England.

RIGHT Following their lecture tour of America, in 1954 George and Ed waved goodbye to New Zealand once more and headed back to the Himalaya to explore the regions east of Everest.

THE RIGHT MAN

COLIN MONTEATH

George came into my life when he and Mary lived for some of the year at Diamond Harbour, on Banks Peninsula near my home in Christchurch, New Zealand. We talked much about his life in the mountains. On one occasion, when he was about eighty, his Mukut Parbat expedition came up after he spotted a framed photo in my library, showing a youthful George beside his three mates at base camp in the Garhwal Himalaya in 1951. Even though it was our 'other Ed', Ed Cotter, not Ed Hillary, who went to the 23,760-ft summit on what was New Zealand's first successful Himalayan expedition, it was this trip that led to Ed Hillary and expedition leader Earle Riddiford joining Eric Shipton's reconnaissance of the Nepal side of Everest the same year. This in turn led to George's invitation to join the Cho Oyu expedition in 1952, and then Everest in 1953.

George loved the low-key Mukut Parbat expedition. Even as an eighty-year-old you could still sense the thrill he got from going to the Himalaya for the first time, and of applying skills learnt on big New Zealand climbs such as the first ascent of the long, pinnacled ice route, the Maximilian Ridge on Elie de Beaumont. Apart from reminiscing about George's favourite haunts in the Southern Alps where he cut his teeth, we also talked about other places dear to our hearts – Antarctica and Nepal's Barun Valley. I encouraged George to reflect on his participation in the 1955–58 Commonwealth Trans-Antarctic Expedition, and also on the 1954 'East of Everest' Expedition, still one of New Zealand's most successful trips as it notched up many first ascents. We also shared an interest in what was the Soviet Pamirs, for I had climbed the 24,600-ft Pik Kommunizma in 1986, whereas George had been the first New Zealander there in the 1960s, when he climbed with John Hunt.

Inevitably, our talk drifted to Everest itself and his involvement with directing the film *The Conquest of Everest*. Although Tom Stobart was the official cameraman and Alfred Gregory the main stills photographer, it was George who played a crucial role in obtaining both still and movie footage high on the Lhotse Face and the South Col, both difficult places to operate safely with camera gear. In 1984 I had been employed by a television company to operate a lightweight video camera on the Tibetan North Face, so we discussed the changes in camera equipment since the 1950s. Naturally, compared to the relative ease I had changing film cassettes, George remembered the problems he had faced to thread film into heavy cameras and, while operating in the cold, to make sure the brittle film didn't shred on the sprockets.

Even though the Swiss had been almost to the summit of Everest in 1952 and 'the way was open', the 1953 trip was still a wild adventure that demanded good decision-making and real teamwork. And, with obligations to sponsors, bringing home good images was crucial to the overall success of the expedition; in this, George's role had been vital – simply the right man for the job. I can relate to the excitement George would have felt high on the Lhotse Face, where, balanced on crampons on icy terrain, he captured others climbing gingerly towards him.

Both George and I have had the privilege of being on Everest when there was no other expedition present – in my case we had the Central Rongbuk Valley to ourselves. Everest is a sacred mountain set in a very sacred landscape. Skiing up to the North Face every day with just a small band of friends, then launching on to an immense cold mountain – without support from Sherpa or bottled oxygen – leaves the senses stunned, even some thirty years on. When George and Mary prepared to leave that night,

RIGHT Many hours on an expedition are spent quietly sitting inside a tent, where there are always letters to be written or useful chores to be carried out. Here George is mending one of his jumpers.

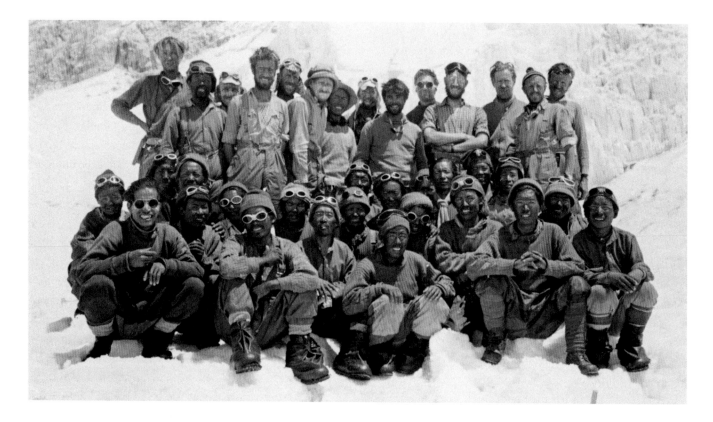

I made a passing comment about the present-day overcrowding and what appeared then to be a lack of moral standards among some modern climbers on Everest. I'd heard stories of climbers moving past others who were struggling, doomed but still alive – dead men waving for help, but finding no assistance as others pursued the summit. George simply shook his head in pity and disbelief.

Both George Lowe and I share a passion for polar and mountain photography, so, in saying goodbye, knowing we would probably never see each other again, we talked about Herbert Ponting's and Frank Hurley's imagery from the Heroic Age of expeditions to Antarctica. These were the men who went with Scott and Shackleton. These were the men, in fact, in whose footsteps George would follow when he too went South. Inside Hurley's tiny darkroom at Commonwealth Bay, the words 'near enough is not good enough' are scratched on the wall in pencil. Having admired George's own photography throughout the years, I felt that this was a suitable motto for his remarkable life of adventure. He smiled at the thought.

ABOVE A group photograph of all the members the 1953 Everest Expedition, both Sherpa and climbing team, taken shortly after the return to Camp IV.

IN THEIR FOOTSTEPS

TOM HORNBEIN

In 1944, when I was thirteen, I discovered mountains. My vision of the world changed from that of a climber of trees in our yard in St Louis, to discovering the beauty of the high places of Colorado. I consumed all the literature on mountaineering that I could find in the local library, from Richard Halliburton's *Book of Marvels* to classics like *Scrambles Amongst the Alps*. My bible was James Ramsey Ullman's *High Conquest*, a history of mountain exploration. As I read about the early attempts on K2, Nanga Parbat and, of course, Everest, I savoured the exploits of a breed of humanity that seemed larger than life. George Mallory and Sandy Irvine were mythic figures, vanishing into a mysterious mountain heaven. One of Ullman's most tantalizing questions back then was whether a person could even survive at the summit of Everest, much less climb there.

By the spring of 1953 I was completing my first year in medical school. When word of the first ascent of Everest hit the news in the States, I remember well the two competing emotions it triggered. The first was a mix of awe and elation that two human beings had finally stood on the top of the world – and had returned to tell their tale. The second, which I had not anticipated, was a sadness that with Hillary and Tenzing's success some of the mystery had vanished.

When John Hunt's *Ascent of Everest* appeared in America not long after, I couldn't put it down. I was struck by the meticulous organization and planning he brought to the endeavour, and also how much this was truly a team effort to get just two people to the summit. I read then, of course, about George Lowe and his remarkable time on the Lhotse Face, followed by the carry to the high camp above the South Col in support of Ed and Tenzing. The interplay of teamwork and commitment remains as vivid in my memory now as then.

But even with my fertile capacity for fantasy I never imagined that I would find myself following in the footsteps of these, my teenage heroes. I was to be a member of the American Mount Everest Expedition that followed a decade later, organized and led by Norman Dyhrenfurth. On 1 May 1963, Jim Whittaker, accompanied by Tenzing's nephew, Nawang Gombu, became the first American to climb Everest, taking the same route up the South-East Ridge. A small offshoot of the main expedition, us so-called 'West Ridgers', consisting of Al Auten, Barry Corbet, Dick Emerson, Willi Unsoeld and I, had gotten seduced by trying a new and unexplored way – the West Ridge.

On 22 May Willi and I reached Everest's summit at about 6.15 in the evening, up what is now known as the Hornbein Couloir. We then proceeded to descend that South-East Ridge, soon in darkness, eventually catching up with Lute Jerstad and Barry Bishop, who had summited from that side a few hours earlier. Not able to see our way down to the camp above the South Col, sometime after midnight we hunkered down for an unplanned night out. We were somewhere above 28,000 ft. In addition to climbing a new route, Willi and I had completed the first traverse of a major Himalayan peak.

I can't resist a small observation about the differences in style between those two expeditions. The 1953 approach was one of thoughtfully organized and deployed resources, particularly the team's energy, towards a single goal. We Americans were a bit more laissez-faire, simply taking advantage of whomever was most able at the moment, ignoring the possibility that we might be running collectively on empty when it came time for the final push. We got away with this approach in part because of lessons learned by those who went before and showed us what could be done – and how – plus a helluva lot of luck.

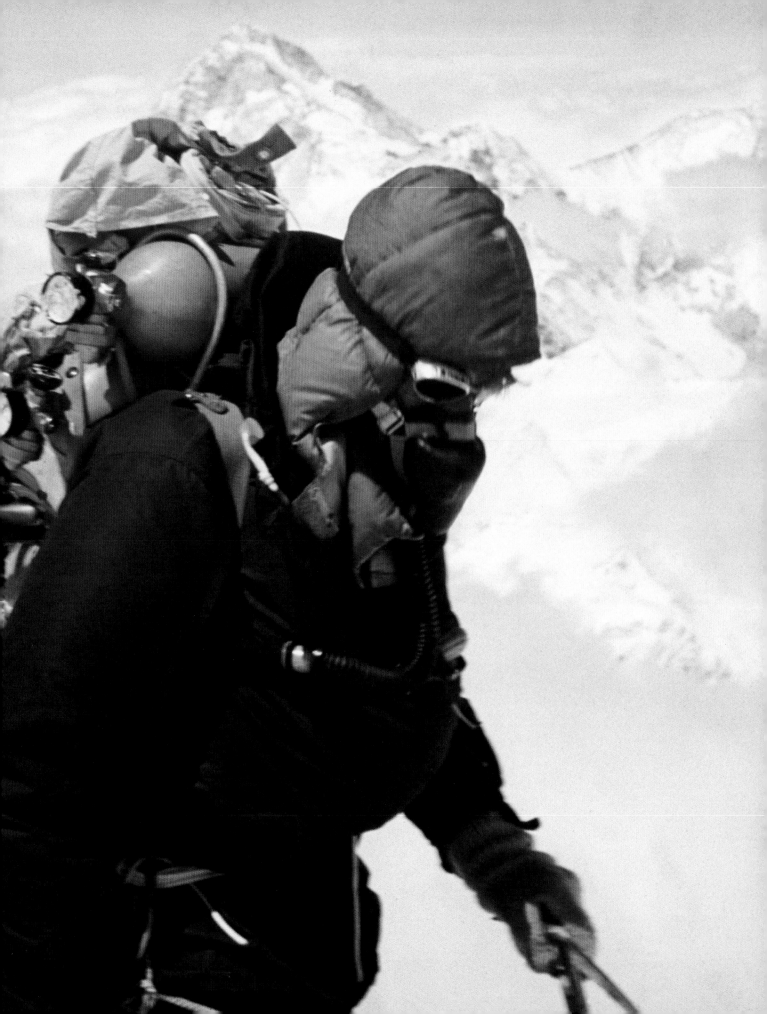

ABOVE On 2 June the march home for the 1953 team began. It rained – the first rain they had experienced in two months. That evening they shot off mortar bombs in honour of Queen Elizabeth and sang songs around the fire.

With the fiftieth anniversary of our 1963 ascent, and the sixtieth for George Lowe and his team – of which George is the only man still with us – I am grateful to them for the gift of style, tenacity and just plain fun with which they inspired the lives of us, the next generation.

I look back on half a century since Everest and marvel at how being there has touched and shaped my life. I suspect it was similarly so for the 1953 team. Willi loved to liken climbing Everest to having the Ancient Mariner's albatross hung around your neck. The fame is inescapable, whether you wish it so or

LEFT Ed Hillary at 27,200 ft on the South-East Ridge, the day before his successful ascent.

not. Our climb was no longer a private affair. I came home to begin my career as an academic physician, a clinician teaching anaesthesiology and an aspiring physiological researcher of how high altitude affects breathing. My professional career was as full of uncertainty and doubt as had been our climb on Everest. I just wanted Everest to get out of the way so I could pursue another passion. Of course, it did not.

The allure of Everest has only grown in the decades since our climb. We hadn't changed the mountain – the falling snow has obliterated many times over all signs that we ever stood there – but so much would change for those who followed on from us. I can't speak for those men and women today who travel the world to go to Everest and put one foot before the other to its summit. But I can say how blessed I feel to have been born at the right time to be able to be in that special place when it was still a lonely and committing adventure.

And now, in the early stages of my ninth decade, settled once again into the place where I first met mountains, it seems as if all the pieces have come together to a still challenging yet more gentle time in life. We who remain and remember go on, our inspiration and vitality mellowed but intact, enriched by moments intensely shared. The sum total of Everest fame has provided many gifts of friendship, of touching the lives of others and being in turn similarly touched.

Yet, the pleasure is more in the playing than in the winning, more the climb than the view from the top. I would not have sought, nor guessed, the ways in which our climb of Everest has helped define all that has come to pass for me, mostly for the better. I think – and hope – it proved similarly so for George Lowe, and so many others who have come under the thrall of this, the highest point on the planet we call home.

MARVELLOUS SPIRITS

STEPHEN VENABLES

I first met George Lowe at a meeting of the Mount Everest Foundation management committee in 1990. As the youngest person in the room, keen to stir things up a bit, I queried a proposed grant to a team of Kiwis attempting Everest. The mountain had been done to death, I insisted, and this lot had nothing new to add; the money could be better spent elsewhere. But I hadn't reckoned with the fierce loyalty of the chairman, George, to his compatriots. He simply brushed my objection aside and announced, very firmly, that we would support the New Zealanders.

I could have been offended, but George wore his authority with such gracious charm that you had to like him. He was equally gracious, three years later, when he gave up the best part of an evening so that I could interview him for an article to mark the Everest fortieth anniversary. It was then that I first realized the rich diversity of his career, from trainee teacher in New Zealand, to headmaster of the famous Grange School in Santiago, to schools inspector in Derbyshire. But of course we talked mainly about his climbing, and in particular about those golden years of expeditioning in the 1950s.

Two qualities emerged. One was the exuberant energy of a young man seizing joyfully every opportunity that came his way. The other was his uncommon loyalty, in particular to his oldest climbing companion, Ed Hillary.

Consider the situation in July 1951. Four men return, exhausted but triumphant, to the Indian hill station of Ranikhet. On their very first Himalayan outing they have claimed the first ascent of a fine 7,000-m peak. Out of the blue comes the invitation to extend their holiday and join the great Eric Shipton on a reconnaissance to Everest – only the second foreign party ever to enter the high valleys of the Solu Khumbu. Two are invited and

it is Riddiford and Hillary who have the money, clout and sheer force of personality to seize the prize. Lowe and Cotter return, disappointed, to New Zealand.

A lesser man might have wallowed in bitter recrimination, but not George. On the contrary, he simply seized his chance the following year, making up for lost time on the Cho Oyu Expedition and proving himself so indispensable that he was inevitably invited to join the big show in 1953. There, as Hillary allied himself with Tenzing Norgay, it became obvious that George stood little chance of going to the summit himself. But again, with that same gracious loyalty, he made the most of his supporting role, helping Hillary and Tenzing establish the highest camp in history, before dropping back to the South Col, where he welcomed them back the next day. As Boswell to Hillary's Johnson, it was George who broadcast to the world his famous off-the-cuff comment, 'Well, George, we knocked the bastard off'; as a lifelong friend, it was George who worked tirelessly to support Hillary's philanthropic projects in Nepal.

He showed the same loyalty to his expedition leaders. His affection for Eric Shipton was palpable and, like most of the 1952 team, he was outraged when Shipton was sacked from the 1953 show. However, talking to me forty years later, George confessed how he had been won over totally by the man brought in to replace Shipton. Perhaps he was just toeing the party line, but I think he believed genuinely in John Hunt's team ethos.

Of all the images of George in 1953 I have two favourites: one is of him with a broad smile, clowning in tartan shirt beside the Dudh Kosi, with huge cream magnolia blossoms in his hat; the other, sadly never photographed, is of him halfway up the Lhotse Face, succumbing to the attrition of altitude, asleep with a half-eaten sardine dangling from his mouth.

RIGHT With a large magnolia in his hat and a cup of tea in hand, George Lowe rests for a moment on the approach journey to Everest, in the rich forests and steep gorges of the Himalayan foothills.

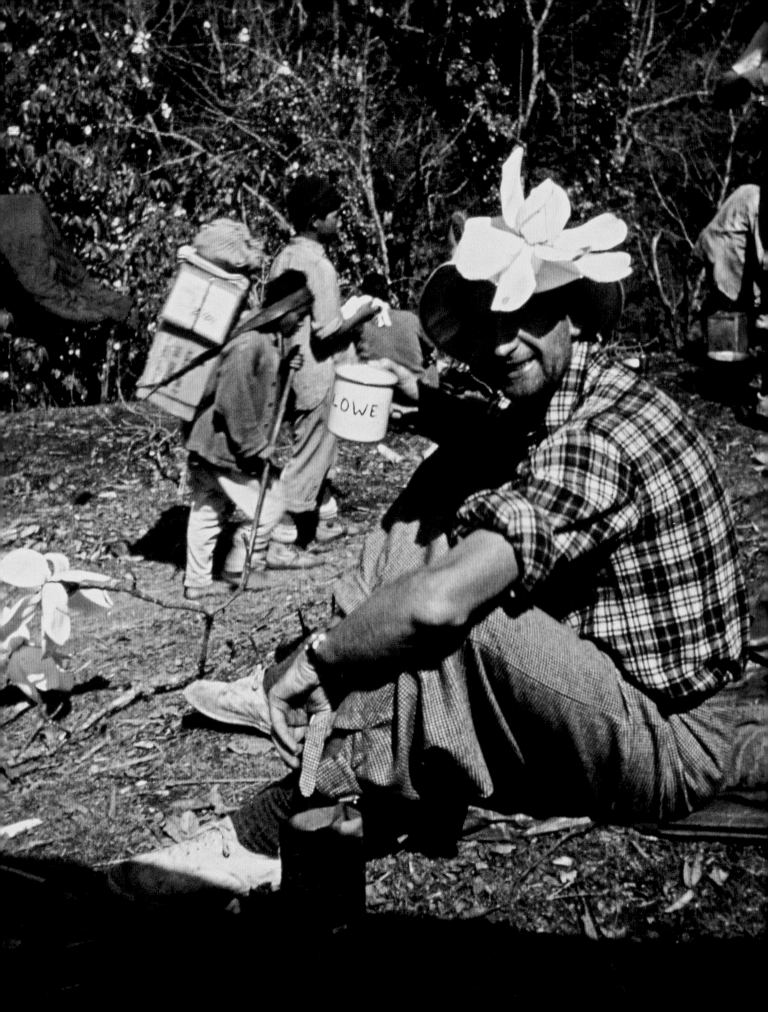

After Everest he returned several times to the Himalaya and, of course, played a key role filming the great Commonwealth Trans-Antarctic Expedition in 1955–58. However, I think his greatest achievements were on the 1952 Cho Oyu Expedition. Because of Shipton's concerns about straying into Chinese-occupied Tibet, the team barely set foot on Cho Oyu itself. Instead, they ranged far and wide, covering an astonishing amount of high country, then still totally unexplored. The highlight was George's crossing of the Nup La with Ed Hillary and three very nervous Sherpa. Despite dangerous rockfalls, hideous icefalls and lethal semi-concealed crevasses, they made it safely over this remote pass, from where the two New Zealanders, like a couple of naughty schoolboys, trespassing deep into Chinese territory, romped down to Rongbuk and all the way round to the old pre-war Camp III beneath the North Col.

Even after returning to Nepal from that prodigious trek their appetite for adventure was not sated, as they finished the expedition by making the first ever crossing of the three cols between the Khumbu and the Barun Valley. Having recently myself led a party through that wild country, with its difficult passes over 6,000 m, I can only marvel at the nonchalance with which Lowe, Hillary, Evans and Shipton, assisted by a few Sherpa, pioneered the crossing in 1952. I also marvel at the chutzpah of the two New Zealanders trying to speed things up towards the end of the journey by taking to their air-mattresses and rafting down the mighty Arun River. It was a crazy thing to do and they came within a whisker of being swept to their deaths in a massive whirlpool, but the world would be a very sad place if there were not wise, generous gentlemen like George occasionally doing crazy things.

RIGHT George Lowe moves up through deep snow on the Lhotse Face towards Camp VIII in 1953.

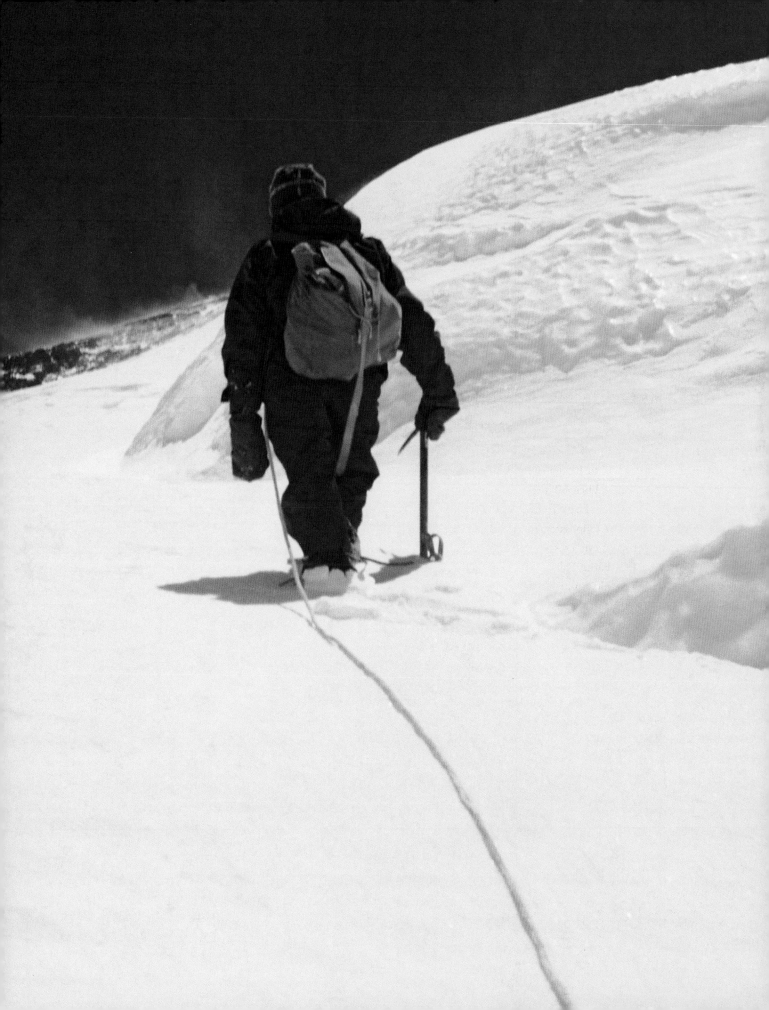

WHEEL OF LIFE

DOUG SCOTT

Everest never meant much to me until I actually climbed it. For years it was in my mind, though simply a name, a label for the highest place, as remote from my understanding as the South Pole or the Moon. As a schoolboy, I was taken with my classmates to hear John Hunt talk about the first ascent. For me this was not to be an epiphany, awakening primal desires to achieve similar feats. All I remember of that occasion was receiving a clout across the back of my head from the master in charge, telling me that if I didn't stop larking about I would be sent out of the hall.

Much later on I came to know Everest and I began to appreciate the significance of that pioneering ascent and just why it has become such a legendary story of human endeavour for all time. That was only after I came to meet many of the climbers of that first ascent and know some of the secret places on the mountain for myself.

They had left family, friends and jobs to spend months away, to go where no others had been before. On all those early expeditions, and right up until the advent of the satellite phone, the climbers really were up on that mountain without distraction, since there was so little chance of communication with the outside world. On their quest they worked together, took risks, faced uncertainty on a daily basis and all the time looked out for each other. It's only through caring for each other like this that mankind has been able to develop and thrive.

Expedition members who exemplify such traditional values – living in harmony and freedom with one's fellows, avoiding quarrels, thinking of the group before one's self, with a light touch, being courageous, giving your all to achieve a common goal – on the highest peaks or at the uttermost part of the planet crossing polar deserts, deserve to go down in the annals. They

are remembered with pride and wonder for having been part of that heroic and largely happy band of brothers roped together in fact and forever in the folklore of our race.

The company of climbers who came together to make the first ascent of Everest employed all those traditional values during their climb. From down at the base of the mountain, in the massive jumble of moving ice of the Khumbu Icefall, right up to Camp IX around 1,000 ft from the top, the whole team worked selflessly to put the strongest pair in the best position to go for the summit.

Down in the Icefall, Mike Westmacott kept the route open, all the time in danger from collapsing serac and imploding crevasse, day after day. George Lowe at the front spent nine days at work on the Lhotse Face, and after a short rest went back up to find a safe site for Camp IX, the highest there had ever been. George had also volunteered to take the high-altitude film footage, and all the shots above 22,000 ft were created by him. Those of us who have been up in regions where there is only one third of the oxygen left in the atmosphere will know how important it is to conserve energy, and not to waste breath on extra movement, or even thinking, other than making the next step count.

George was determined not only to film as high as possible but also to see his New Zealand compatriot and great friend, Ed Hillary, well placed to make the first ascent of the highest point, even if history determined that Hillary should be accompanied by a Sherpa. Nothing could be done about that, however frustrating it was for George, now so fit and acclimatized. He knew that none of the great peaks of the Himalaya would have been climbed without the support of these men. Out of the ranks of the Sherpa, living in the shadow of Everest, came Tenzing, with

LEFT This superb Mani wall, a vast boulder in fact, is near Taksindhu, Nepal. All true Buddhists must pass on the left side of these Mani walls. 'Om mani padme hum', repeat the inscriptions in a mantra of compassion: 'Hail the jewel in the lotus'.

all the motivation and skills of the climbers who came from elsewhere, and with equal claim to be on that first ascent. John Hunt honoured that set of circumstances, not because it was politic but because it was the right thing to do.

The beauty of the smaller, alpine-style expedition is that everyone has the chance to reach the summit, or if not the summit the highest point reached. On the big, siege-style expeditions usually only two are chosen for the top and the rest go home wondering what might have been. This was the case on our South-West Face expedition of 1975, when despite a supreme effort in breaking through the Rock Band, Nick Estcourt and Paul Braithwaite missed out on the summit of Everest and never knew the ultimate satisfaction of completing the route and all that comes from doing that.

The big expedition will always require strong leadership, which I and others have at times found difficult – to be receiving orders from miles away down a walkie-talkie. There is always the worry that politics, friendships or personality differences will determine who gets to go out front and ultimately who is chosen for the summit. Occasionally, and especially after a bout of illness, there are displays of token heroics – carrying extra loads, breaking records between camps. On the alpine-style expedition there is no need to impress the leader, even if there is one.

That apart, the Everest expedition of 1953, and for that matter our South-West Face expedition of 1975, exemplified the best of the genre. The book that Chris Bonington wrote after our success actually became a bible to some. The leader of the expedition that first put an Indian woman on the summit actually went to sleep with *Everest the Hard Way* under his pillow every night at Base Camp. Both expeditions were of classic proportions in terms of organization, leadership and execution.

They were expeditions into the unknown, with great uncertainty as to the outcome. Yet, against the odds, the goals were achieved, but only because of individuals overcoming feelings of their own self-importance to knuckle down and support their comrades with encouragement and by looking out for each other.

❧

Everest is no longer a place for the lucky few. Since 1986 the Nepali government has removed all restrictions on those who want to climb it – in fact, anyone who can pay for it can now go, regardless of experience. Commercial guiding companies employ mainly Sherpa to fix a continuous line of rope all the way up the Lhotse Face to the South Col, and from there all the way up to the summit. With that virtual handrail in place, climbers can ascend Everest with far less experience and skill than previously, to the extent that comparative novices, on a short leash, can be taken to the summit between two guides.

Thanks to Jon Krakauer's book, *Into Thin Air*, a personal account of the Everest disaster of 10 May 1996, we are brought in close to the worst day ever on Everest, when eight climbers died. Krakauer was one of 240 climbers and Sherpa from fourteen expeditions occupying a sprawling city of tents on the Khumbu Glacier. Among their number were men and women with little climbing experience, relative newcomers to the sport who had paid experienced Himalayan guides up to £42,000 to get them to the top. One major contributing factor to the unfolding tragedy was the bottleneck of people along the upper South-East Ridge, particularly at the Hillary Step. Bad weather had been curtailing activity, until suddenly a window of opportunity arrived and a horde of guides and clients set off together,

resulting in chronic delays that meant many of them suffered the consequences of a rogue storm that blew in hard and strong. The storm lasted throughout the night and into the next day, leaving several people dead and others severely frostbitten.

Although Krakauer had paid to go on a commercial Everest expedition he was himself an experienced climber, and yet he too succumbed to the dangerous syndrome of guide dependency. He tells us how, for safety's sake, a responsible guide will always insist on calling the shots, for he cannot afford to allow each client to make important decisions independently. Clients have to give up their usual self-reliance and personal responsibility, a state of affairs that he says will haunt him for the rest of his life when he recalls 'the ease with which I abdicated responsibility – my utter failure to consider that Andy might be in serious trouble'. He is referring to Andy Harris, a guide who was suffering from hypoxia, a lack of oxygen. If that can happen to a serious mountaineer, then it is obvious that the effect on the novice client is going to be at least as dramatic, if not more so.

There have been instances of commercial groups of climbers being aware that others were in a state of collapse and yet not going to their assistance. The media had a field day over the solo climber David Sharp who was found dying 1,000 ft from the summit of Everest on the North Ridge in 2006 but was ignored by at least forty others, many of whom realized he needed help but gave none. 'The good Samaritan principle is dead among climbers' said some newspapers.

So often it is the Sherpa who will go that extra mile to help the foreigner in distress, and not just because they are stronger and more acclimatized. The gallant but fatal attempt by three Sherpa to save Dudley Wolfe on K2 in 1939 comes to mind. And in the autumn of 1979 it was Sundare Sherpa who sacrificed

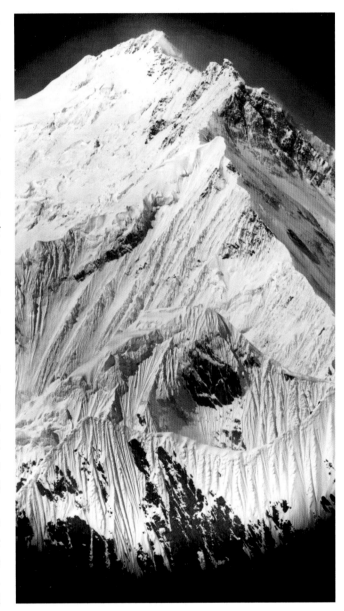

ABOVE The summit of Everest and its impressive North-East Ridge, photographed by Sandy Wollaston on a glass-plate camera during the reconnaissance expedition in 1921.

his fingers and toes in an attempt to rescue Hannelore Schmatz after she collapsed at the South Summit of Everest – many more similar tales could be told.

The Sherpa to a degree seem to be more in touch with their basic humanity; their conscience is not overlain so much by ambition. They know that to be co-operative rather than competitive is a preferable state, and they learn this from an early age. This is reinforced in many ways as their main tool for survival in a sometimes very hostile environment.

A wall painting that can be seen at the entrance to every Buddhist monastery is the Wheel of Life. The mural depicts Yama, the god of death, hideous and uncompromising, glaring down at the visitor. In his hand he holds a mirror for all to see themselves. With its rich symbolism, the Wheel of Life acts as a constant reminder of the causes of human problems. At the hub of the Wheel is an explanation of the roots of our suffering – our own failings. There is a pig representing blinkered ignorance, a cockerel for selfish cravings and a snake for anger and aggression, each running on endlessly into the other. In our ignorance we become attached to our desires for fame, fortune and power over others. As soon as one set of desires is gratified, more are pursued, and anything or anyone that seems to thwart their attainment incites our malice in return. Understanding this cycle of human weakness helps the Buddhist hill people of the Himalaya, and us too, to try to avoid these pitfalls.

ↄ⅃

Looking back, I can see that climbing Everest was a life-changing experience. I returned home with greater confidence and consideration for others. My spirit was lifted and my perceptions were realigned. I returned a more humble man, too, knowing that I was one of the lucky ones to survive.

At the more basic level of having to earn a living, things certainly became easier once I became known as the first Englishman to the top of Everest and the first to climb the South-West Face. This became apparent immediately upon my return in lots of different ways. A small example – I decided to treat myself and buy a new radio for my Ford Cortina. After all the publicity the dealer recognized me and said, 'We cannot have our Everest heroes paying full price!' I could not argue with that.

With regard to the future direction of my climbing, going three times to the South-West Face of Everest gave me the opportunity to learn how to handle myself in the thin, cold air. On the last occasion, in 1975, Dougal Haston and I completed the route to the summit but did not arrive until 6.00 p.m. and stayed there for about an hour. On the way down the Hillary Step our head torches failed, leaving us no alternative but to bivouac at 28,700 ft. We managed to survive nine hours in the snow cave we dug – without sleeping bags, without oxygen and without getting frostbite. The experience certainly widened the range of what – and how – I would climb in the future. The lesson I took from Everest was that if I could survive an unplanned night out there I could probably risk doing that anywhere, given sufficient snow to dig myself a small hole.

So, this was my Everest epiphany, not a grand moment of awakening perhaps, but it was a significant gift for me to bring away. I was able to climb many more high mountains after Everest thanks to having experienced the sanctuary of a simple hole in the snow. My Everest experience was not some sort of heroic moment conquering a mountain, but something more useful altogether.

RIGHT One of George Lowe's favourite photographs of Ed Hillary on Everest – just a typical day in the Icefall. There is no summit shot of Hillary. Tenzing didn't know how to use a camera, and, as Ed joked, it didn't seem like the right sort of place for a lesson. 'You know George,' he said, 'I'm probably the only Everest climber in the world who doesn't have a big summit photograph of himself above the mantelpiece – and it doesn't bother me one bit.'

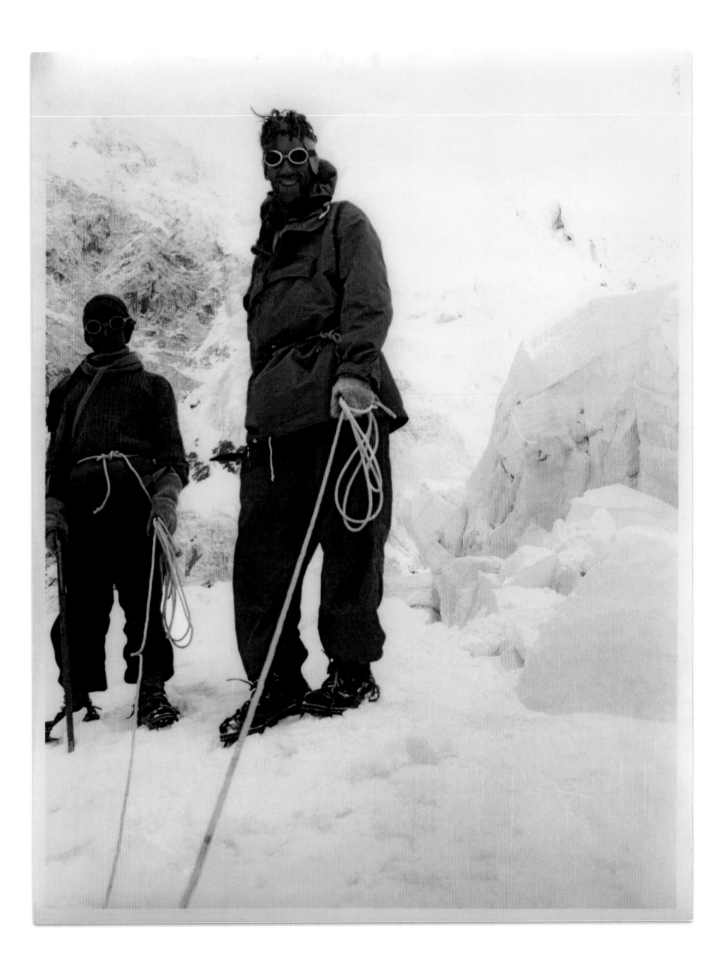

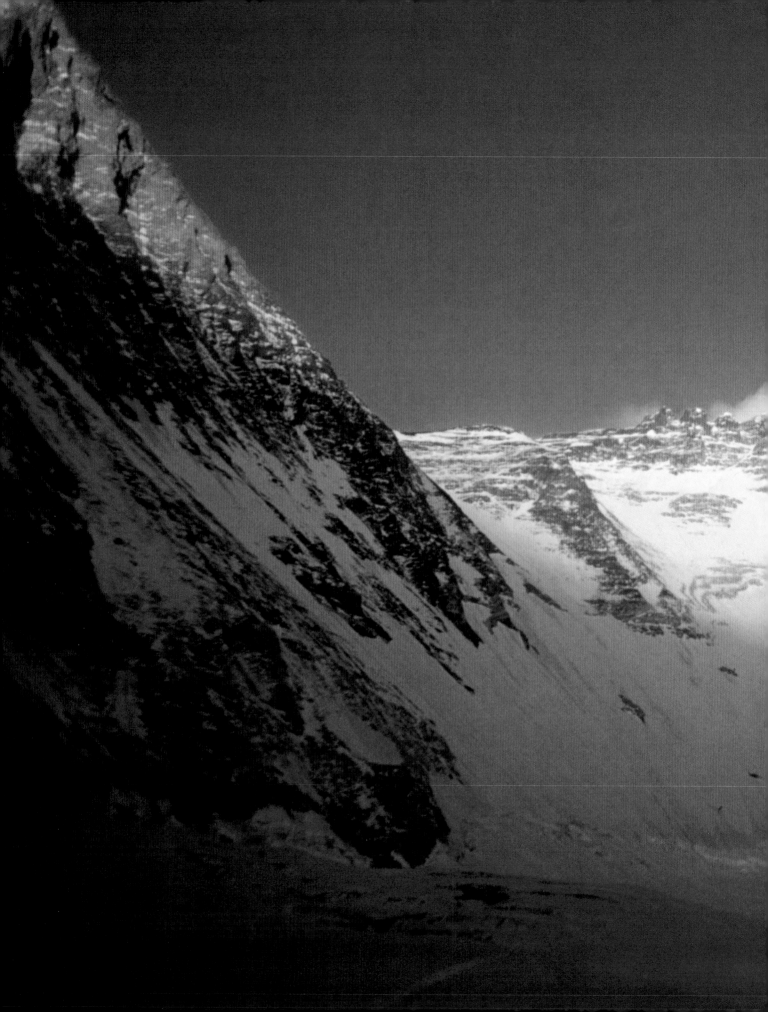

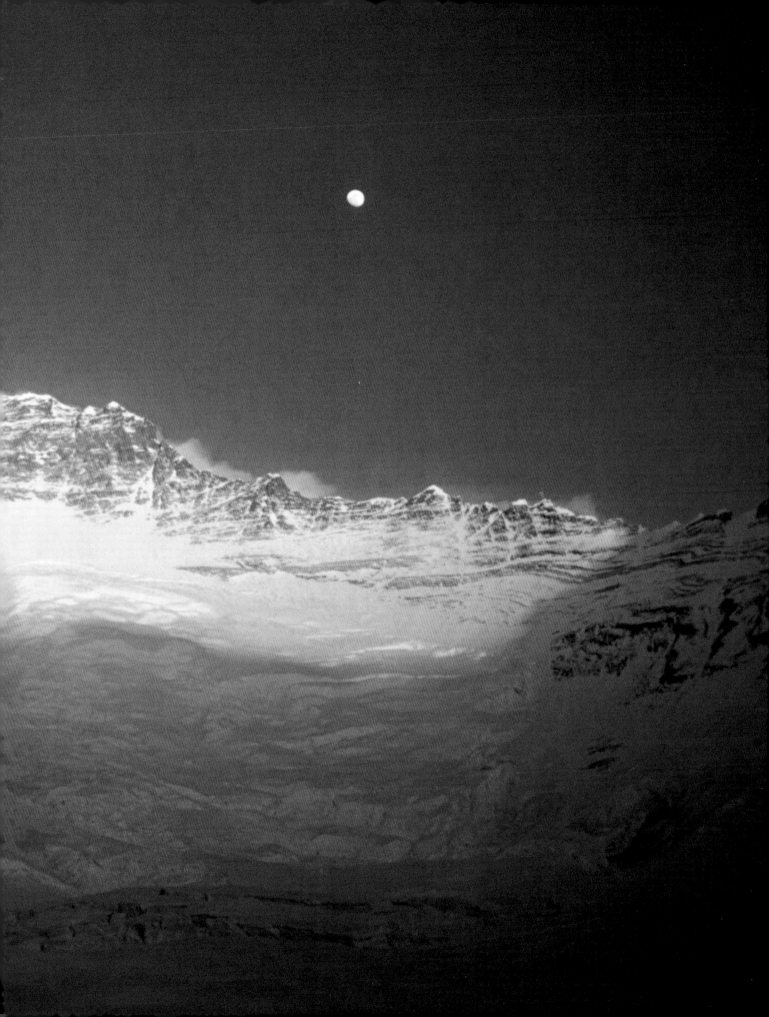

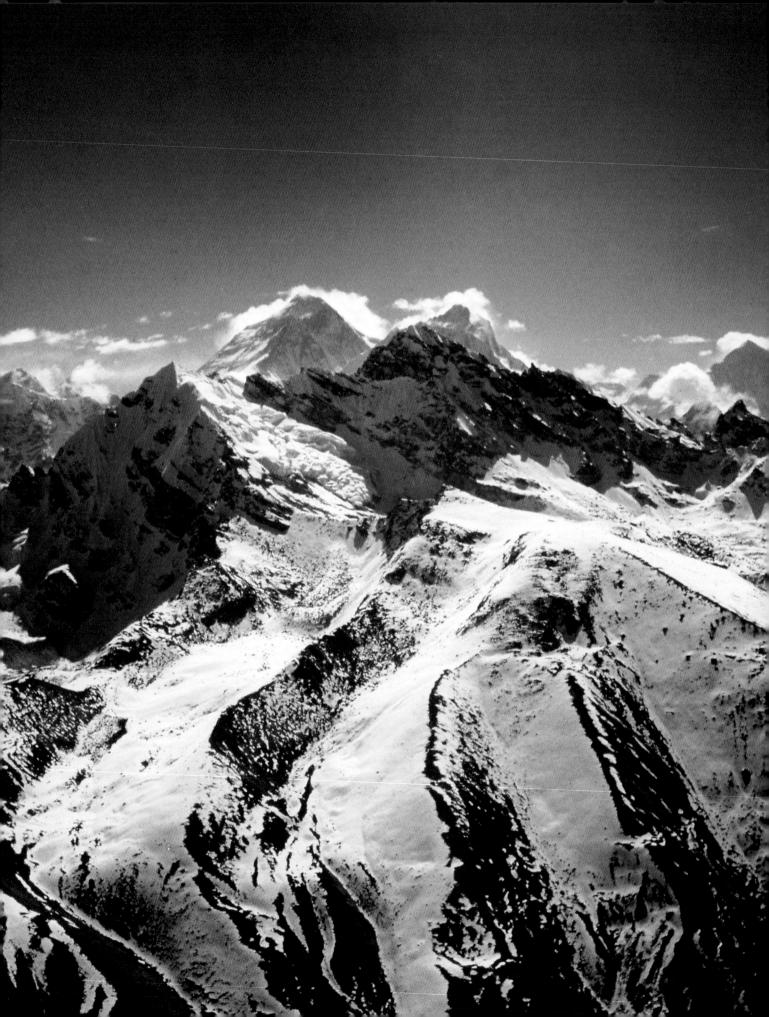

JUST THREE PICTURES

JAN MORRIS

Among his friends, colleagues and acquaintances the general reputation of Wallace George Lowe – George Lowe to you and me – is probably that of a brave, friendly, honest, tough, mountain-climbing New Zealander. It is a just reputation, and true. However, from my own visual memory, after sixty-odd years of contact with the man, I like to pluck three images in particular that illustrate extra facets of a subtle personality.

❦

The first picture comes to me from the early weeks of the 1953 British Everest Expedition, the first to reach the summit, to which I was attached as correspondent of *The Times*. Nothing particularly newsworthy was happening on the day I have in mind, but I was wandering around our Camp III, at 20,000 ft or so, wondering what to write about, when I noticed two tiny figures, far, far away, 3,000 ft higher on the face of the mountain Lhotse. This was on the expedition's planned route to the summit, and through my binoculars I could see that two men were hard at work on the snowface, stamping and cutting and digging some kind of a track. They were muffled against the cold and the wind, and they were working slowly and painfully in the thin air of 23,000 ft.

They seemed to me like two allegorical friends up there, working in a mystery play. Only later did I learn that they were George Lowe and the Sherpa Ang Nyima. They were spending a full week on that desolate mountain face, assiduously preparing a way towards the summit, an Asiatic and an Antipodean working together, all alone in that high white solitude; and for me the vision, now forever preserved in my subconscious, exemplifies not just the fortitude of George Lowe, but his gift of comradeship too.

My second memory-glimpse is also of Everest, but now the circumstances are very different. This time it is 29 May 1953, in the very last days of our expedition, and I am at Camp IV, at about 21,000 ft, with John Hunt, our leader, and a few of the British climbers and Sherpa. The day is brilliant, all seems blue, white and crystal clear, and we are awaiting the return of Tenzing Norgay, the most celebrated of all the Sherpa, and Ed Hillary, another New Zealander, from their attempt to reach the summit – the climax of our adventure. George Lowe has climbed up there, far above his old work-place on the Lhotse Face, to meet them and see them safely down, and I am here in the mountain sunshine of the Western Cwm to learn whether they have made it to the top. If they have, I have it in my power to make the pair of them two of the most famous men on earth.

LEFT Everest, Lhotse and Makalu crown the skyline, photographed as the Expedition left the Khumbu in 1953.

PREVIOUS Sunset over Lhotse, with the moon behind. When the weather was kind like this, the Western Cwm was a truly magical place to be.

And here they come! We rush up the snow slope to meet them, grizzled Hunt in the lead, a cluster of us slipping and sliding around him, with me in the middle already planning my night's dispatch. Here they come! Ed and Tenzing, still roped together, look exhausted, almost dazed, but leading them down to meet us is George Lowe, and he looks radiant. He has always walked proud, with an almost military bearing, and now, with his ice-axe in his left hand, like a cocky colour-sergeant, he is giving us an exuberant thumbs-up with his right. They've done it! Everest is climbed, mankind has reached the summit of its planet, and George Lowe is its stylish, pleased and proper herald.

And here's my third retrospection. This time we are on the other side of the world, in Maryland, or Virginia, or perhaps California – I forget exactly where. I am with George Lowe, Ed Hillary and Charles Evans, our deputy leader on Everest, on a lecture tour in the United States to commemorate that first climbing of the mountain.

We (or rather they, because I am only there as a kind of spokesperson) have been treated like heroes, with banquets and honorary citizenships and presidential receptions, and in my memory now I see the four of us lined up to shake hands with a wonderfully generous public somewhere or other in the Great Republic. There is Ed, the hero of heroes, shortly to be immortalized on postage-stamps and dressed in antique fineries as a Knight of the Garter. There is Charles Evans the brain surgeon, soon to be knighted too as Principal of Bangor University. There is me, looking sheepish but undeniably pleased with myself.

And there is George, leaning forwards slightly to offer his hand to a glowing matron. He is laughing, perhaps at a joke of hers, perhaps at a sally of his own, and she is laughing too. What does this image suggest to me? Why, it reminds me that George Lowe the mountaineer is a man of sweet charm and courtesy. In an age when the very word is going out of fashion, he is a gentleman.

<div align="center">∾</div>

So what? What have my memories contributed? Nothing perhaps. We are back where we started, with the well-known fact that Wallace George Lowe is a brave, friendly, tough and honest mountain-climber, from New Zealand.

RIGHT When George returned to his hometown of Hastings, New Zealand, in August 1953, he was overjoyed to see his family again. He was driven up the main street in a civic cavalcade of open cars. The sky rained with ticker-tape and paper confetti and he was then sent to have this portrait taken. The following day he rode his bicycle back along the road and, much to his relief, was totally unrecognized.

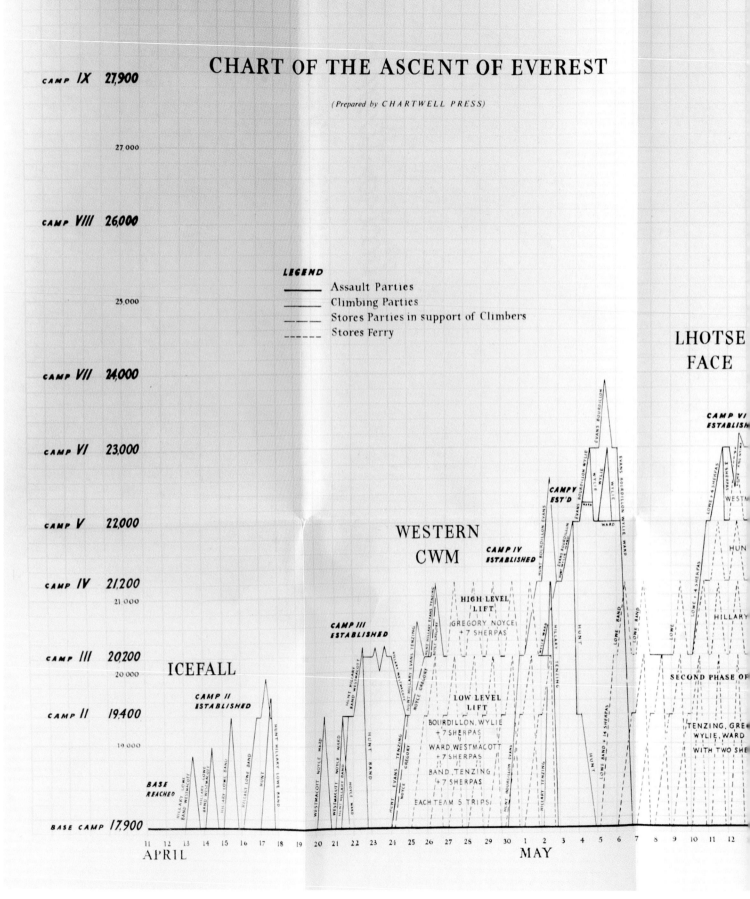

CHART OF THE ASCENT OF EVEREST

(Prepared by CHARTWELL PRESS)

LEGEND
- Assault Parties
- Climbing Parties
- Stores Parties in support of Climbers
- Stores Ferry

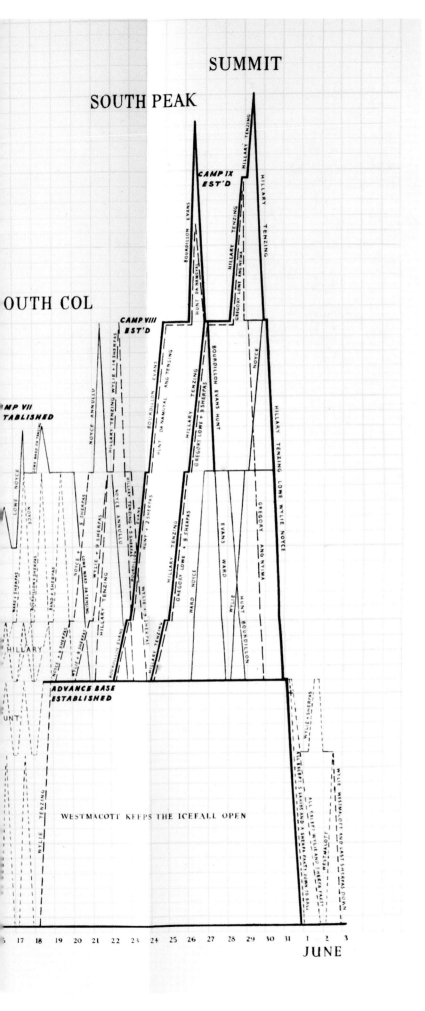

A chart of the ascent of Everest, which shows in the clearest possible way the tremendously complicated logistics required in order to place two men on the summit that day in May.

FOLLOWING Basil Goodfellow, an experienced mountain photographer and Secretary of the Joint Himalayan Committee which launched the expedition, gave advice on how to get the best results on Everest. Few on the expedition could claim to be really skilled photographers. These are the typed instructions he gave to George. John Hunt summed up the high-altitude art of photography well: 'Taking pictures upwards of 25,000 ft, in fifty degrees of frost, often delicately balanced on difficult ground, with a murderous wind blowing, a heavy load on your back and an oxygen mask on your face, requires, indeed, a good deal of resolve.'

PAGE 231 Climbing the steep ice of the Lhotse Face above Camp VII – a photograph that was always one of George Lowe's favourites. This part of the climb was a hard job indeed.

PAGE 232/233 Contact prints of original photographs from the New Zealand 1951 expedition to the Garhwal Himalaya and the 1953 Everest ascent.

EVEREST 1953

SUGGESTIONS TO PHOTOGRAPHERS

Equipment

(1) Get to know your camera really thoroughly. You should be
able to get it out, open, set and ready, and to use it almost by instinct.
Practice this in the dark till you are sure.

 If your camera is new don't hesitate to practice with it
on the voyage out, getting the films developed on board until you feel
quite at home with it.

(2) Keep your camera clean. The inside should be cleaned out
about once a fortnight since nothing makes dust like bumping about in a
sack. Clean it either by tapping it (with the back off, and opened if
it is a folding camera) on to a clean sheet of white paper till no more
specks fall. Or, better, by blowing the dust out. Don't use your
breath, which is full of droplets; use a lilo pump or the jet of air
from a lilo being let down.

 The lens should be cleaned only rarely and with great care,
preferably with special cleaning tissue. A little dust on the lens does
not matter but fingermarks should never be allowed. The same applies
to glass filters.

Approach March

(3) Exposures need watching, especially in villages with
buildings in shadow, and in or near forest where shadows are very deep.
Exposure meters intelligently used are most useful; it is safest to err
on the side of overexposure if there are any dark or shaded parts of
the scene.

(4) Valley scenes need fairly heavy filters. Forest
foregrounds are best with green or medium yellow filters. Avoid orange
or red filters unless you want extreme contrast in cloud scenes. But
in the foothills this contrast rarely gives satisfying pictures. It is
permissible however to use deeper filters if the sun is right behind you.

Upper Valleys

(5) The higher the altitude the lighter the filter, going to
the palest yellow above the snow line. Never take a mountain landscape
in full sunlight without a filter; all brilliance is lost. (There is
no need for filters at dawn and dusk as the light is yellow anyway.)

(6) It is generally said that a lens hood is indispensable.
It is certainly better to use one when possible. But when climbing, a
lens hood is a complication which can be dispensed with. Of course the
sun must never be allowed to shine directly on the glass surface of the
lens; it can be shaded with a companion's hand, or even with your own.

(7) If you have interchangeable lenses, remember that to make
the most of a subject in a mountain setting, e.g. a camp, chorten, or
group with a background of fairly distant peaks, use a long-focus lens
and stand well back. The mountains then look their real height.
(André Roch's superb photos at Thyangboche are examples of this.)

(8) In all landscapes, and other photos where there is no
hurry, rest the camera if possible, even with exposures as short as $^1/_{50}$ th
second. Or lean your shoulder against something, or sit with your
camera held in both hands and your elbows steadied on your knees. It
is extraordinarily hard to hold a miniature camera really steady, and
remember that the best negatives will be enlarged to 24" size.

(Continued - Page 2)

(9) For the best pictorial effects in landscapes, never take photos during the six midday hours. The sun then will be up to nearly vertical, and a high sun gives landscape photos the effect of being taken on a dull day. The best time is from 1 to 3 hours after sunrise and before sunset, when the shadows are long.

Above the Snowline

(10) For scenes wholly on snow exposures should be cut down by about one stop in full daylight. As stated, use a very light yellow filter; but if detail of snow texture is important use a medium yellow filter if you don't mind the sky coming out black.

A deeper filter also will make the most of scenes where clouds are the principal feature.

Climbing Pictures

(11) Simplicity is now vital. It is best, once the sun is up, to set your camera to a standard and keep the settings unchanged. The latitude of Panatomic X film is enough to look after all ordinary variations, whether due to shooting against the light or darkness due to much shadow or rock.

If you are certain that your shutter is as fast as it says, use $^1/_{200}$ at f6.3. Even at this speed it is difficult to hold the camera steady enough when out of breath or in wind.

(12) "Action pictures" are very much more interesting and more convincing than the old-fashioned posed pictures. To be certain of getting action shots, keep your camera slung round your neck, preferably inside your outer clothes (to stop the shutter freezing up). Accustom yourself to getting the camera out, taking off a glove, opening the camera (shutter, stop and if possible focussing should have been set beforehand) and shooting the picture while on the move without checking the movement and rhythm of the party. On easy ground one can sometimes catch up the other man ahead on your rope by 10 feet and gain a few seconds to take a picture of him still in motion without his knowledge. Obviously, however, this gets more difficult with higher altitude.

Separate parties climbing in close proximity naturally provide good opportunities of mutual action pictures.

Colour

(13) Compared to black and white, colour film is much less versatile and more difficult to use.

Exposure must be exact, or not more than half a stop out at the most. It is best to work according to the tables supplied with the film.

Below the Snowline

(14) Do not be deceived, by the brilliance of the light and distance, into cutting exposures down; in clear air the shadows are correspondingly deeper. I have found it best to use the same exposures as at sea level.

Nevertheless it is most difficult to be certain; few cameras are really accurate either as to stop markings or shutters. So with a subject of which a good colour photo is really important take three shots, one at the calculated exposure, and one half a stop either side; there is plenty of film.

(15) An ultra-violet filter is absolutely essential for all shots above about 6,000 ft., otherwise (on Kodachrome) all of the subtle

(Continued - Page 3)

colours of distance, and all snow, are overlaid with bright violet.

Kodaks now recommend a 1.A filter for daylight Kodachrome, and Ilfords a Q filter for Ilford colour. If you plan to use colour you must have one or both these filters before you start - or get them in Bombay.

Above the Snowline

(16) Above the snowline colour is very tricky. Obviously, there is often no colour in the scene except blue, and black and white film deals with monochrome better. Colour should not be relied upon for vital photos high up but should be used only to supplement black and white.

This does not apply of course to high camp scenes, where there is likely to be plenty of foreground colour.

(17) Whereas a black and white negative will give you unlimited prints and slides, colour photos only give you one picture, as colour copies are not satisfactory. This is another reason for taking several shots of all really good scenes. It will then be possible to make up several sets of colour pictures which members of the expedition are sure to want afterwards.

(18) Accurate use of the viewfinder is most important with colour. With black and white a tilted skyline, or too much foreground, can be put right in the enlarger. But with colour you get all you take. So fill the frame, and hold the camera level.

It is wise to check that your viewfinder is really accurate by taking careful black and white photos on the voyage out.

General

(19) However much mountain scenery and mountain shapes appeal to the climber, one mountain looks just like another to the layman. What the public wants is pictures of people, especially of the climbers. There will be a demand for camp scenes, shots of climbing action, oxygen gear, scenes in storm and wind, shots giving an impression of hardship, and all that. Whatever the inhibitions, an effort should be made to bring these sorts of pictures back (on stills as well as on the ciné film).

Equally scenes of villages and of native peoples appeal, though they are getting a bit hackneyed now.

(20) Good landscapes require care with composition. There is no short cut to learning about this. If time is permitted one could learn from the masters at the National Gallery, but as time is short there is something to be said for taking a book of "the world's best pictures" on the voyage. Or at least one or two good collections of mountain pictures (André Roch and Frank Smythe).

(21) The outstanding scene at or near a camp or village repays patience; choose your best viewpoint and compose the picture. Then come back to the place to take the photo in the morning or evening when the light is right.

(22) Don't shoot off indiscriminately in the hopes of one good picture in every dozen. Good pictures are made the other way, by choosing your subject with care and by being quite certain that your camera will get it right in one. Nevertheless take a couple for luck (or three in colour).

The above does not apply to action pictures during climbing; with these the chances of error are many, and the more taken (within reason) the better.

28th January 1953 B. R. Goodfellow.

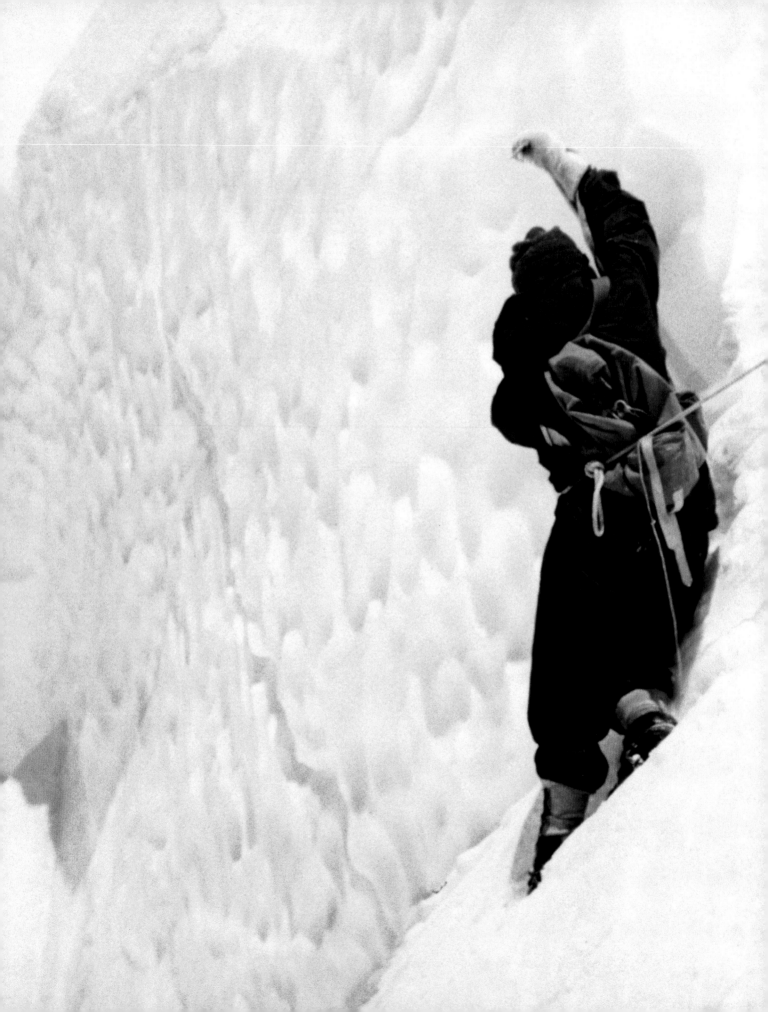